3

LIGHT & COLOUR
TECHNIQUES IN
WATERCOLOUR

COLLINS

LIGHT & COLOUR
TECHNIQUES IN
WATERCOLOUR

Practical Step-by-Step Projects

HarperCollins*Publishers*

Front cover: Louise Hill; back cover: John Lidzey;
page 1: Shirley Trevena;
page 3: Joseph Milner Kite/Bridgeman Art Library;
page 7: Gillian Burrows.

First published in the UK in 1998 by
HarperCollins Publishers, London

Based on *The Art of Drawing and Painting*
© Eaglemoss Publications Ltd 1996

A catalogue record for this book is available from the
British Library.

ISBN 0 00 413331 5

Printed in Singapore

Contents

Part 1

PAINT WITH EXPRESSIVE COLOURS

Introducing colour

Every painting has colour as one of its main ingredients – the challenge for any artist is how to handle it successfully.

We all have a colour sense which is uniquely our own and is reflected by the colours in our home, the colours we like to wear, and so on.

These subjective likes and dislikes trigger an immediate response in you when you look at the colours in a painting, and of course when you choose your own colour schemes.

Composing with colour

Everything has a colour – even if it is only black or white – and the challenge for all artists is how best to interpret the colours around them with the paints on their palette.

Colour is an important part of any composition. This is not just because of the emotional qualities of colour – it is also because of the powerful physical effect colours can have. Composing successfully with colour requires a good grasp of why – and how – colours can affect one another.

Colours are often described as being either 'warm' or 'cool.' The warms are yellow, red and orange while the cools are blue, violet and green. (Remember that the terms 'warm' and 'cool' are relative – there are warm blues and

cool reds.) The idea of colour temperature is based on an emotional response rather than a physical reality, but is invaluable to the artist. Warm colours appear to advance towards the viewer while cool colours recede. You can exploit this – and create an illusion of space in a picture – by putting cool colours in the background and warm ones in the foreground.

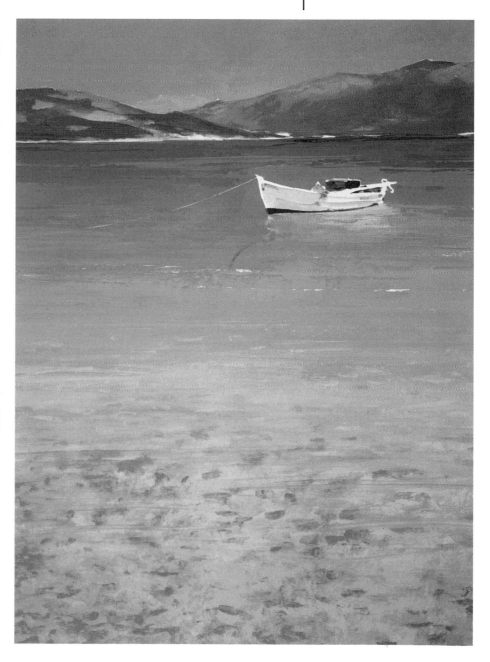

▼ **Masterly use of warm and cool colours is the key to the sense of depth in this painting.**
'Clear water – Greece' by Donald Hamilton Fraser RA. Oil on paper, 21 x 15in

The language of colour

Every colour has three qualities: hue, tone and intensity, and the everyday word 'colour' combines these three qualities.

Hue is a colour's name – red, yellow or blue, for example. A colour's lightness or darkness is referred to as **tone**. Adding black to a hue makes it change gradually towards dark; adding white changes it gradually towards light.

The gradations towards dark are called **shades**, the gradations to light are called **tints**. Both shades and tints describe tone.

Intensity refers to the brightness or brilliance of a colour. A hue of strong intensity seems vivid, while a hue of low intensity appears dull. Dull, in this sense, doesn't mean dreary – it is simply the opposite of bright.

The colour wheel

One of the most useful devices for understanding colour is the colour wheel – a circular diagram designed to show not only how colours can be mixed to create others but also how they are related to each other.

The three key colours on the wheel are the **primaries**: red, yellow and blue. These are important because they are 'pure' colours. This means that they cannot be mixed from any other colour combination.

Between the primaries on the wheel, you find orange, green and violet. These are called the **secondaries** because each one is made by mixing two primaries. Red and yellow produce orange; yellow and blue give green; red and blue create violet. By mixing any primary with an equal amount of the secondary next to it, you create another group – the **tertiaries**. Blue and green, for example, make blue-green.

Technically it is perfectly possible to mix an infinite range of colours from the three, pure primaries by blending them in varying amounts. But this isn't really practical for artists because it takes far too much time.

▼ This basic colour wheel shows the primary and secondary colours. Primary red, yellow and blue are separated from one another by the secondaries – orange, green and violet. The colours in one half of the wheel – red, orange and yellow – are 'warm.' 'Cool' green, blue and violet make up the other half.

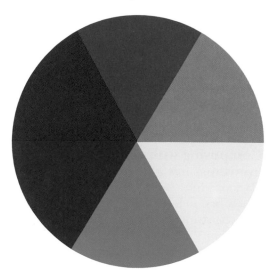

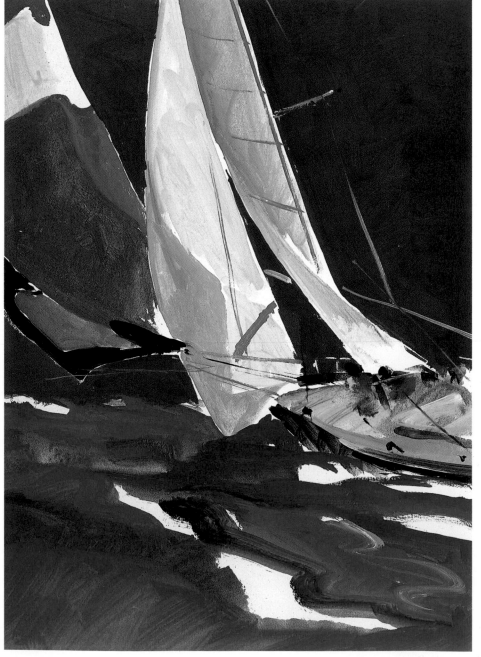

▲ In this detail from the previous page, the tiny touches of almost pure red, blue and yellow – the three primaries – instantly draw your eye. In the same way, the yellow hull (left) carries your eye into the heart of the picture.

◄ Action and excitement explode from this painting. The vibrant colours in the top half of the picture produce great energy and tension – enhanced by the surprising crimson of the sky.
'Spinnaker' by Donald Hamilton Fraser RA. Oil on paper, 19 x 14in

Using a limited palette

Limiting the number of colours you use is an excellent way to learn about colour – and colour mixing – and helps you improve your painting skills all round.

If you're a beginner, you'll be surprised at the wide range of colours achievable with just three or four paints. And because your colour mixes are all made from the same hues, they harmonize well together. Using a limited palette doesn't mean restricted painting. In fact, many artists prefer to work with just a few colours.

Using fewer colours gives you more control over your mixes. It's easier to remember how you made them, and to avoid the messy, muddy colours that come with using too many hues.

A limited palette also encourages you to think about the arrangement of tones in your painting.

For this flower painting, our artist chose three primaries – permanent rose, cadmium yellow and cobalt blue – ranging from warm to cool. These allowed her to produce a wide variety of cool, warm and neutral colours.

She began by applying masking fluid to areas she wanted to keep white or paint later on, so they didn't get spattered, and then used the wet-on-dry technique for the sharp, defined edges of the flowers and leaves, and wet-in-wet for the background and blended tones.

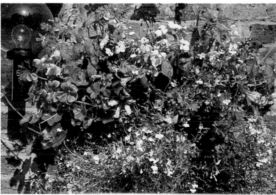

▶ **The set-up** This cheerful basket of flowers gives plenty of variety in tone and colour. If the whole basket seems a bit daunting, then try just part of it.

Before you start, experiment with mixing as many colours as you can from the cobalt blue, cadmium yellow and permanent rose.

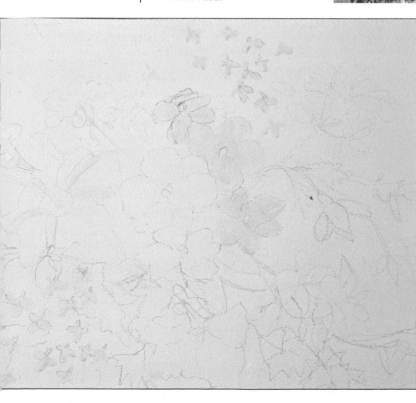

◀ **1** Lightly draw the outlines of the flowers using soluble coloured pencils or a 2B pencil. (If you use the pencil, you can carefully erase any lines still showing at a later stage.) Don't try to draw every flower. Choose a few of the main ones and concentrate on those. Take time to get the composition right as the painting could otherwise become very muddled.

Use an old brush to apply masking fluid to all the areas you want to keep white or paint towards the end (such as the blue lobelias and the three flowers just to the right of centre). Rinse the brush thoroughly in soapy water immediately after use.

Tip

Old brushes
Don't throw away worn, old brushes. Use them to apply masking

fluid, instead of ruining your new ones. Make sure you wash your brush out thoroughly in soapy water straightaway or in paraffin if it has already dried.

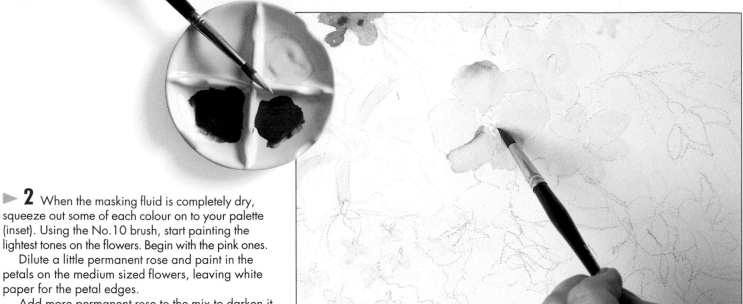

▶ **2** When the masking fluid is completely dry, squeeze out some of each colour on to your palette (inset). Using the No.10 brush, start painting the lightest tones on the flowers. Begin with the pink ones.

Dilute a little permanent rose and paint in the petals on the medium sized flowers, leaving white paper for the petal edges.

Add more permanent rose to the mix to darken it for a second tone. While the paint is still wet on the paper, use the tip of your brush to drop a little of the darker colour on to areas of some of the pink flowers so that it spreads. These can stand for shadows. Vary the intensity of tones a little on some flowers. For cooler pinks add a touch of cobalt blue, or a touch of yellow for a warmer pink.

▶ **3** Working wet-on-dry, put in some darker shades for the centres of the remaining pink flowers. Use a less dilute permanent rose for this.

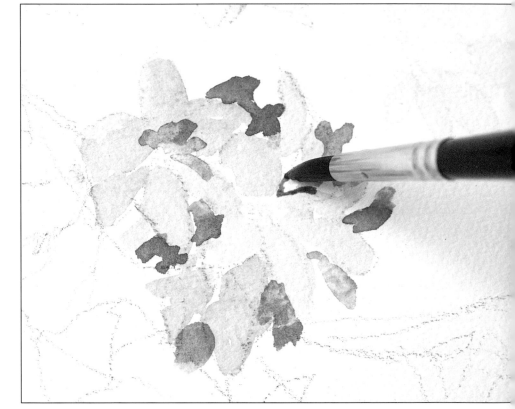

4 Rinse out your brush and paint the yellow medium sized flowers in the same way – some wet-in-wet, some wet-in-dry. Use very dilute cadmium yellow for the first tone, intensifying the mix for the second.

For the nodding yellow flowers towards the right, add a tiny touch of permanent rose to make the richer, darker tone of the shadow inside the petals. Add as many tones as you like, but try to keep it simple.

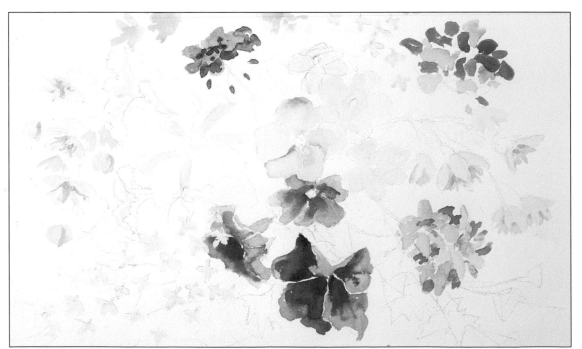

◀ **5** Now begin working on the large petunias, doing exactly as you did on the other flowers, adding the darker tone wet-in-wet. For these, mix permanent rose with a little cadmium yellow, adding more permanent rose for a darker mixture. Leave areas of white paper to define the edges of the petals.

6 Remember to stand back and assess your progress from time to time to see what you need to do next.

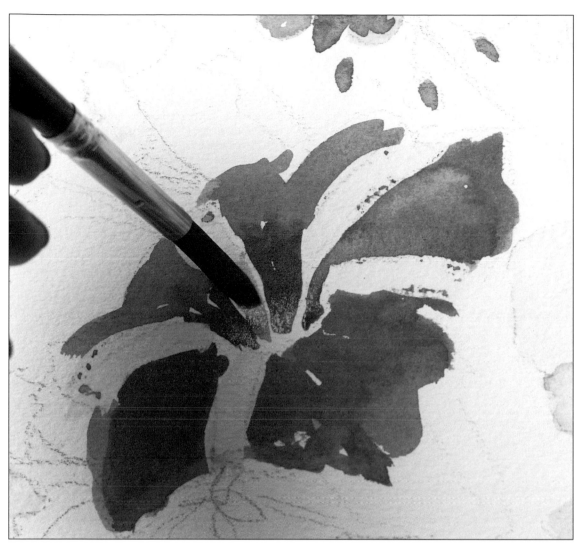

◀7 Paint in the darker tone on the petunias where the petals curve in towards the centre. Use a mixture of permanent rose with small amounts of yellow and blue.

▼8 Now start on the leaves. Use cadmium yellow with a blob of blue to make the lightest green tone, adding more blue for a darker tone. Use the tip of your brush and the wet-in-wet technique to suggest leaf veins and shadows.

Paint in the stalks of some of the flowers with the No.3 rigger brush, using yellow and blue with just a touch of permanent rose.

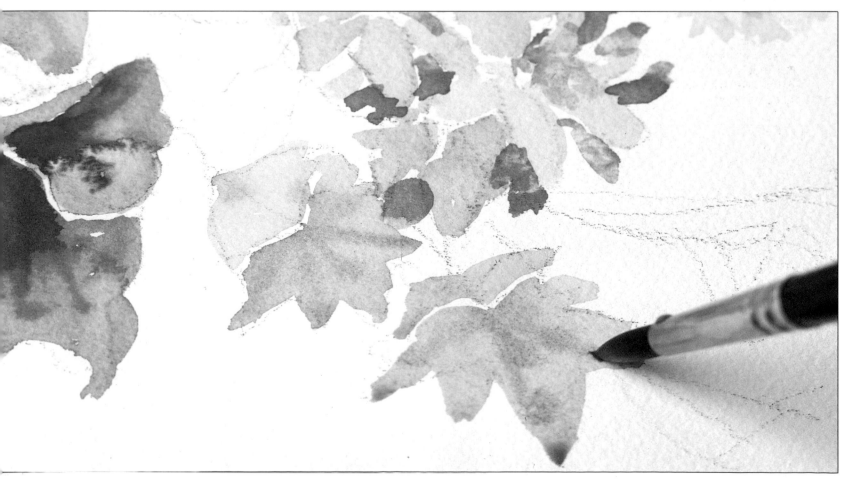

9 For the background, use mixtures of all three colours to make soft washes. Load your No.10 brush with water to dampen the background, ready for the first wash. Work around the flowers and over the edges of the paper so you don't leave a hard line.

For the light parts of the background on the left, use well diluted cadmium yellow. Use the tip of your No.10 brush to paint in between the flowers.

Add more blue and permanent rose for a darker mixture around the petunias. This darker tone hazily suggests the stems behind the petunias. Wait until the wash is a little drier before using the tip of the brush to touch in the background stalks more precisely with a darker mix.

10 If the unpainted background has dried, wet it again with a clean brush. Add a little more blue to cool the mixture for the background in the bottom left hand corner.

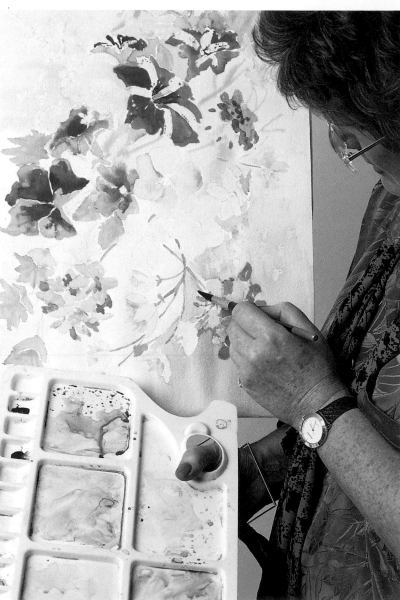

11 For the warm red background wash on the top right, use cadmium yellow mixed with permanent rose and a touch of cobalt blue. Tilt the paper so that the background colours run into each other slightly, diffusing any edges. Lift off any excess paint with a piece of kitchen towel.

12 Mix some cobalt blue with a little permanent rose for the hazy background in between the masked-out lobelias. With your small brush, put in some background stalks, then add veins to some of the leaves. Mix all three paints until you arrive at the greenish brown colours you need.

◀ **13** Wait until the paint is thoroughly dry and then gently remove the masking fluid, rubbing it off with your fingers or a soft eraser.

▼ **14** Mix some cobalt blue with a little permanent rose and touch in the petals of the lobelias.

While the paint is still wet on the paper, add some more permanent rose to the mixture to make a mauve tone and drop a little wet-in-wet on to the tip of a few petals so that the paint spreads. Leave the centres clear. Vary the tones by using different strengths of blue on some flowers.

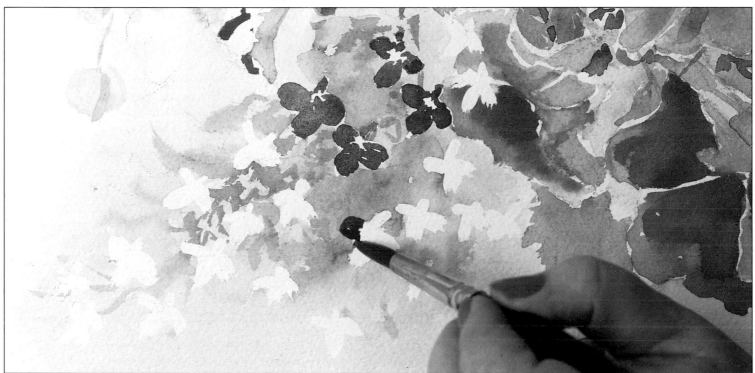

▶ **15** Mix a little permanent rose with just a touch of yellow to make a soft pinky grey and paint in the three palest flowers on the right of centre. Use the white of the paper for the lightest tone. Now touch in the centres with undiluted permanent rose and blue.

Add the centres of the lobelias too, first making sure the paint on the petals is dry. Just dab the very tip of your brush on to the paper. Use the same mixture as for the petals, darkening it with permanent rose and cobalt blue.

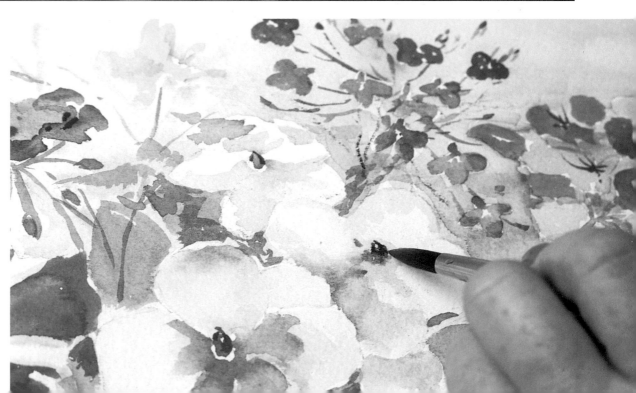

Tip

Watercolour blocks
When your painting is dry, never tear it out of the watercolour block. Instead

insert a palette knife in the small ungummed patch. Then, carefully break the gummed seal around the edge of the block, working all round in one direction only.

◀ **16** Add the stalks with your small brush, using mixtures of all three colours. Put in extra finishing touches to balance the painting and fill in any background gaps.

▼ **17** The final image is charming and full of energy. The skilled use of colour and tone makes it hard to believe it was painted with only three basic colours.

Using a selective palette

Although it's wonderful to have a mass of colours in your paintbox, it's often worth limiting yourself – you'll find a selective palette can give your painting more cohesion.

You've already seen what you can do with a very limited palette consisting of just three primary colours but often you'll want to use more. It takes skill to mix up a range of good colours from the primaries, and if you're new to the idea you can spend more time mixing than painting.

You don't, however, need to rush out and buy dozens of extra colours. Using a *selective* range has great advantages. For a start, your painting is much more likely to harmonize, particularly if you let the colours flit over the painting. You're also less likely to have jarring elements because you aren't tempted to dip into colours which have no business being there. Of course, experienced artists often limit the colours they use automatically, even if they have a huge range on the palette in front of them, but for beginners it can help to be selective from the start.

The range of colours you select should suit your subject, mood and style of painting. Choose only the colours you think you really need – you can always mix them to make new ones.

For her painting of the Australian bush (overleaf) our artist chose strong colours to capture the light, hot atmosphere and the vegetation of the area. Her palette comprised cadmium yellow, two reds and two blues plus a good strong green and one earth colour. To these she added two inks to increase the vibrancy of the painting.

In rendering this scene, our artist maintained a freshness which is often lost when working from a photograph in the absence of natural light. She avoided this problem by making a note of the colours on site, so it didn't matter if they were changed by the photographic process. In addition, she worked fairly quickly, without breaks, combining many techniques with a spontaneous approach.

▼ **A carefully selected palette of blues, greens and greys plus a basic yellow is all you need to paint a landscape like this one. As usual in transparent watercolour, the white of the paper provides the highlights.**
'Amberley Chalk Pits, Sussex' by Roger Sampson, watercolour on paper

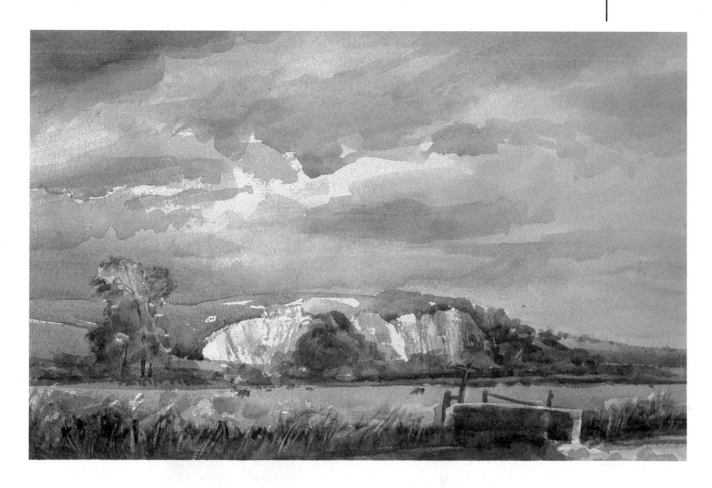

Australian landscape

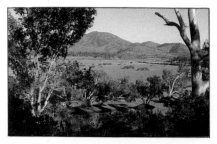

▲ **The set-up** Our artist used a photograph and some quick colour references as her starting point. She made the colour references while on site, in case the colours in the photograph didn't come out true to life.

YOU WILL NEED

- A 770 x 570mm (30 x 20in) sheet of 140gsm stretched NOT Bockingford watercolour paper
- A drawing board
- Gummed tape
- Two jars of water
- White china plate or palettes
- A craft knife
- Pencil eraser
- Hair dryer
- Masking fluid
- Kitchen roll/paper towels
- HB pencil
- Four brushes: ½in flat, No.6 round wash, No.4 round and an old brush for the masking fluid
- Seven watercolours: cadmium yellow, cadmium red, permanent rose, Hooker's green dark, cerulean blue, French ultramarine, burnt sienna
- Two Ecoline inks: olive green and ice blue

▶ **1** Lightly pencil in the main elements of the landscape. When you're happy with the composition, use masking fluid and an old brush to block out areas you wish to leave white, such as the stems of the bushes and the tree trunks. Clean the brush immediately in warm, soapy water.

Mix ice blue ink with French ultramarine and cerulean blue, adding plenty of water. Fill in the sky with your wash brush, starting at the top and adding more water as you go down – this line of lightest blue on the horizon helps to create a sense of distance.

About three-quarters of the way down, dab your brush into a touch of permanent rose to create a sunset mood. Blot off any excess water with some kitchen paper and blend over the hills so you don't create a hard, unnatural edge.

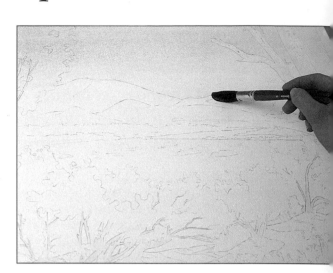

◀ **2** Add a touch more blue ink to your wash and use it to paint in the rivers, aiming for a flat finish to suggest still evening water. Take the colour to the very edges so that when the foliage is laid on top, the river can be seen through it. Again, blot with kitchen paper if the painting becomes too wet.

For reflections in the water, use the clean ½in flat to lift off a little blue.

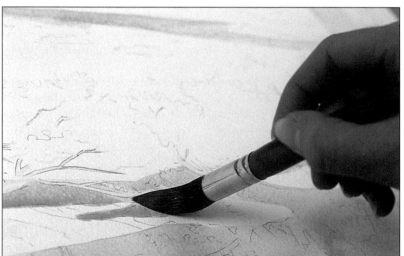

▶ **3** Use the wash brush to apply a loose wash of burnt sienna to the mountains. Working wet-in-wet, dot in a little cadmium red, mixing straight on to the paper. This darkens the mountains and sends them into the distance. Quickly dab on some ultramarine and Hooker's green to suggest the gum trees on the mountains. See how they have already taken shape.

4 When you move on to a new area and don't want the colours to bleed into each other, make sure that the first colour is absolutely dry. A hair dryer is handy to speed things up.

When the rivers are dry, apply a wash of burnt sienna to the land, including the islands in the river. While this is wet, add extra touches of burnt sienna to the main land area to create a marbled effect.

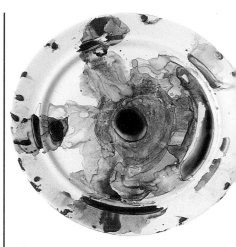

▲ An ordinary white plate makes a perfectly acceptable palette, although you'll need something deeper if you want to mix large washes.

5 When the mountains are dry, add more details with the same four colours used earlier – burnt sienna, ultramarine, Hooker's green and cadmium red. You can have a lot of fun with this, turning and dabbing the brush freely to create interesting colour combinations. Leave to dry, then soften and blend the colours with clean water. If the mountains create a hard line where they meet the sky, soften the edges when dry with clean water too, using your ½in flat.

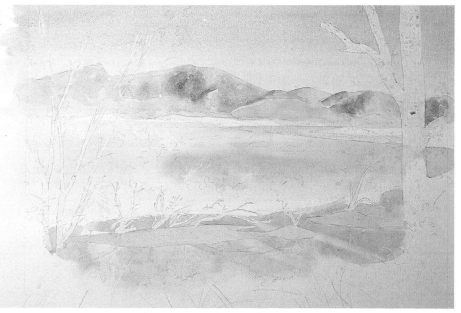

6 Deck the hills in greenery with your ½in flat, using mixes of Hooker's green, cadmium red and olive green ink. Rinse your brush, then add clean water to blend the edges into the plain.

Now you can have some fun flicking paint to give an impression of scrubby foliage. Charge your ½in flat with paint and flick it at the paper with your fingers from about 6in away. Use less water where you want more detail. This natural-looking effect helps add form and dimension to the hills.

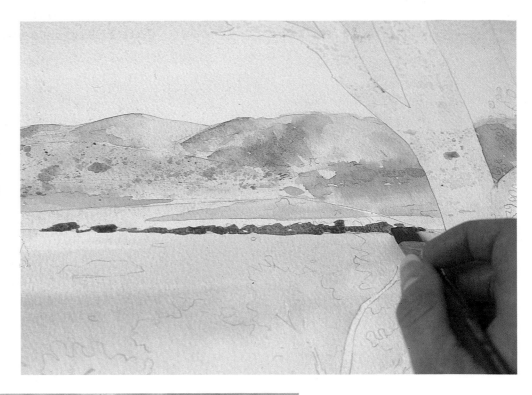

7 To create darker greens, add more ultramarine to the mix; add more cadmium red for warmer greens. Where the foliage is dense along the side of the river, use a strong, dark green wash and your flat brush, wet-on-dry.

Once the specked hills are dry, add more details with the same washes.

Tip

When accidents happen

In step 4 you can see that our artist accidentally washed blue over an island in the foreground. To rectify this she lifted off a little colour with the ½ in flat, then cleaned the brush and scrubbed over it again to lighten the tone. You can use this method to rectify any mistakes you make — but you must act quickly, before the paint has a chance to dry.

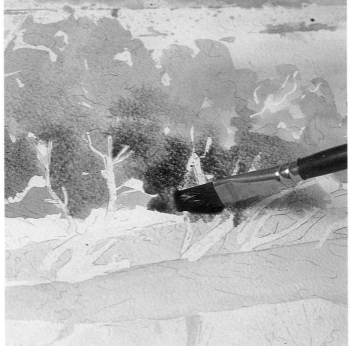

8 Here's another chance to experiment with your palette. Be bold in your approach and work quickly to maintain freshness. For the eucalyptus bushes in the foreground, dampen the paper, then drop cadmium yellow on to the sunlit areas and ultramarine on to the shadows, wet-in-wet. You can work freely because the masking fluid protects the bush twigs from the paint.

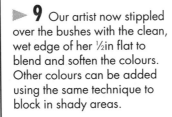

9 Our artist now stippled over the bushes with the clean, wet edge of her ½in flat to blend and soften the colours. Other colours can be added using the same technique to block in shady areas.

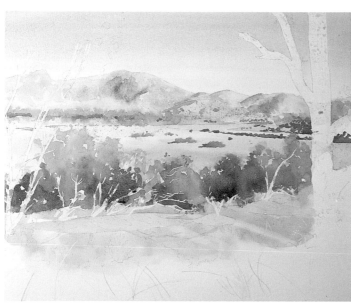

◀10 Stand back and look at your painting. See how the different techniques have created depth and texture. Notice, especially, how the clear water blending has created atmosphere and the way the blues combine to send the mountains back into the distance.

▼11 Now start work on the foreground. Dampen the paper with clean water, then use a fairly dry brush to dab in strong blue and green washes. Aim to create a variety of tones and textures, adding green ink for vibrancy, and ranging from wet to dryish paint.

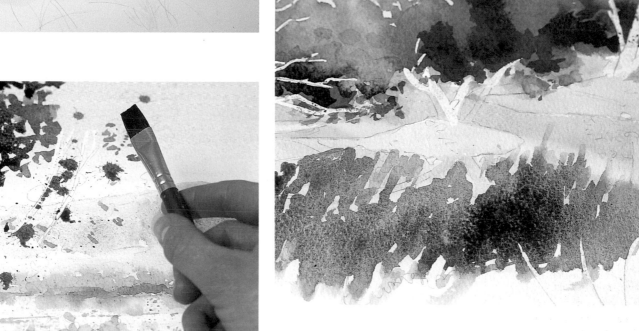

▲▶12 Add shadows to the river by dampening the area with water, then adding pure ultramarine with your ½in flat. Add cadmium yellow to areas which need lightening, then dampen your brush in clean water and use it to blend the edges of the colours.

Use your greens – mixed from Hooker's green, ultramarine, cadmium red, cadmium yellow and burnt sienna – to paint the leaves of the gum tree (above). Dab on some colour with your ½in brush, then spatter on more colour with a fairly watery mix to suggest individual leaves (right). Work into the splatters, wet-on-wet, adding cadmium red for darker areas and cadmium yellow for lighter ones.

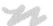

13 Carry on working into the tree foliage wet-on-wet, adding olive green ink for darker shades and softening the edges of the foliage with a clean, wet brush. Use the sides and flat edge of the brush for greater variety. Finally, paint in the fine lines of the branches with olive green ink, making use of the flat edge of the brush.

Notice how you can create a wide range of greens by remixing the colours of your palette. All the greens go well together because they have the same sources.

14 Now work on the foreground foliage again, dampening the paper so that you can work wet-on-wet. Don't be frightened of dropping in pure colour, such as Hooker's green dark, shown here, to create exciting combinations.

15 To create the shimmering reflections of low evening light, our artist used a clean, wet brush to scrub off colour, then dabbed the area with kitchen paper.

Stand back and assess your painting, then refine any areas which you think need work.

▶ **16** Now comes the exciting moment when you can remove the masking fluid – but first make sure that the painting is completely dry or you will smudge it. Use a hair dryer if necessary to accelerate drying.

Rub off the masking fluid with clean fingers, then erase any unwanted pencil lines. The eraser may lighten the surrounding paint colour, but you may wish to use this to your advantage.

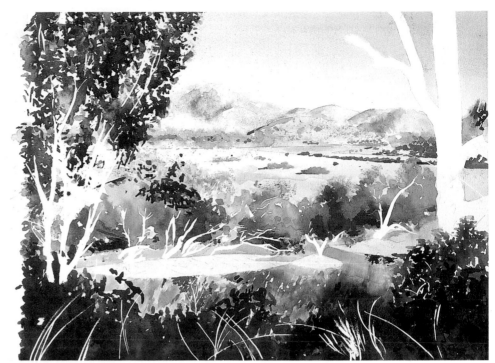

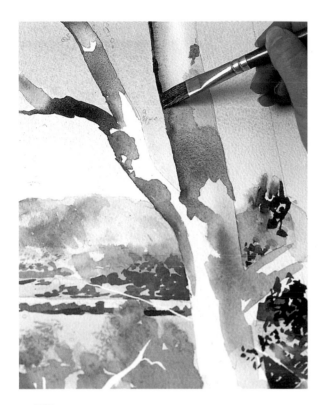

▲ **17** Mix various warm purple washes of ultramarine and burnt sienna with clean water, then use your ½in flat to block in the colours of the trunk on the right, starting with the lighter areas. Make bold use of your brush, changing the angle to create different lines. Work into dry areas, then work wet-in-wet. Our artist used the edge of her brush to put in the shadow on the side of the trunk, blending it with a little water.

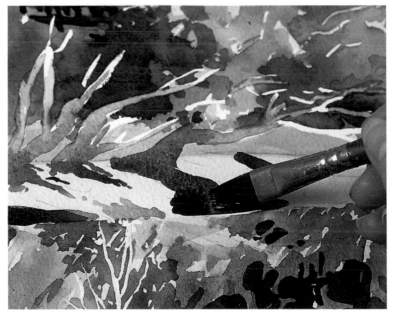

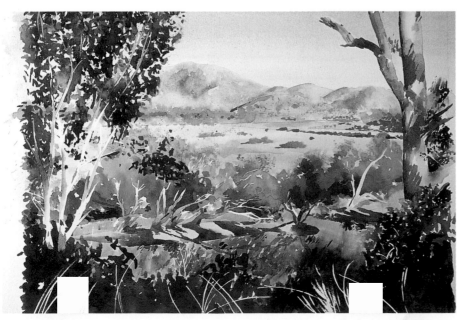

▲ **18** Use burnt sienna to add shadows to the islands and the branches of the bushes on them. Add ultramarine to the mix for areas of deep shadow. The contrast with the light areas creates the impression of bright sunlight.

◀ **19** Now work on the trunks of the trees on the left, using a watered-down mix of the same colours. For fine lines you can use the flat edge of the brush. Leave plenty of white showing through, but blend the paint at the ends of the trunks where the masking fluid creates hard lines. Work quickly, moving the brush to and fro, wet-on-dry to blend the colour.

20 To paint the wispy foliage in the foreground, use your No.4 brush and a mix of ultramarine and cadmium red with olive green ink. Rest the side of your hand on a dry area of the paper to steady it while you add the foliage with swift, flowing movements.

Now charge your brush with burnt sienna to define the tree trunks on the left and touch in shady leaves. Change to the ½in flat to paint the unmasked grass in the foreground with olive green ink and cadmium yellow.

21 While the paint is still wet, add burnt sienna and yellow highlights to the grass. Load your brush with cadmium red and add touches of pure colour to the grasses. Let it blend into the wet burnt sienna.

Add any final details you wish, but be careful not to overwork things. If in doubt, leave the painting for a while so you can be more objective about it.

22 Finish by scratching in fine lines of grass with the end of your brush or a craft knife, working from the bottom up with swift movements.

See how much variety has been created with just a few colours. Some washes have been enriched when dry by going over them with another wash; others are marbled by adding pools of colour to the wet paint, letting them blend on the paper. The ink adds more depth.

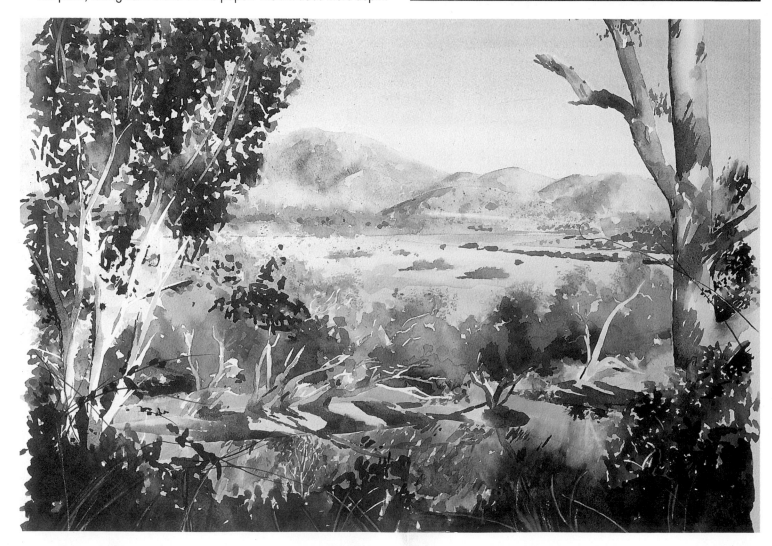

Using whites creatively

When it comes to snow scenes, the paramount problem is how to render the white of the snow itself. Advance planning is essential.

In traditional transparent watercolours, white paint isn't used at all. To portray something white, you must use the white of the paper. You can mask out areas with masking fluid, tape or torn paper, or scratch paint away gently with a craft knife on small areas – highlights for example. The traditional way, though, is simply to leave areas blank by painting around them.

Leaving the blank areas in the right place and making them look solid and three-dimensional takes practice and careful planning. It's not a case of *leaving* white so much as *using* it. The aim is to make the whites an integral part of the whole picture. Think of your blank areas as positive shapes, not negative spaces. When you paint the surrounding darks, you're giving the whites form and shape at the same time – effectively, you're painting two things at once. Imagine the white as a colour on your palette. Consider what areas you would make white if you were painting it on, and create that shape as you paint around it. Plan where your whites will be from the start. Once you've applied a wash, there's no going back.

Valuable white

Since it reflects most of the light bounced on to it, white has a strong visual impact. It has a certain sparkle that makes it appear to expand. (Darker colours absorb light and seem to contract.) The brilliance of white areas next to deeper tones is even more striking by comparison.

You could say that one measure of a watercolour artist's skill lies in how well he or she handles white. The sparkling clarity of well-planned whites complements the beautiful translucency of watercolour paints and gives life and brilliance to your work.

▼ **In a snow scene like this, it's absolutely essential to plan your whites with extreme care. Notice how the artist uses darker washes to give the snow form – on the chalet roofs, for example, where the thickness of settled snow is seen clearly against darker surrounding tones. On the hill, the sweeping white streaks show not only sunshine through trees, but also the gradient of the slope.**
'Mountain village' by Polly Raynes, watercolour on paper, 594 x 420mm (23½ x 16½in)

Snow on the mountain

Our artist worked from a skiing holiday snapshot for this painting. Follow the steps below, or work from your own sketch, snapshot or a magazine, using our demonstration as a guide.

Snow scenes demand extensive use of white paper – you're forced to make it an important element in the composition. Our artist used a limited palette of violets, blues and earth colours, and really allowed her whites to stand out boldly.

Remember all the time that you're painting the snow and rocks simultaneously. Be aware of all the shapes you're making, both with the paint itself and with the negative spaces you create in between your brushstrokes.

1 Sketch in the main elements of the composition with your 2B pencil, indicating the shapes of the rocks and main shadows on the snow. Then mix up a large wash of cobalt blue and ultramarine and apply it to the sky with your Chinese brush, saving some of the wash for later. Pick out the shapes of the rocks as you paint the sky. While you work across the page, keep the edges of the washes very dilute so they don't dry to leave hard edges.

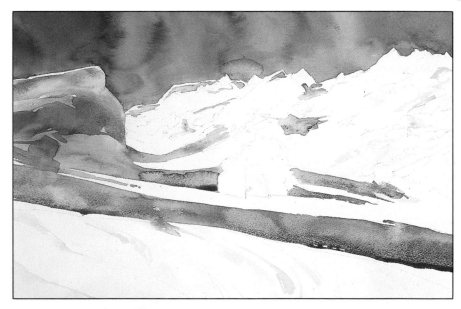

2 While you wait for the sky to dry, add a little violet madder and some clean water to the sky wash for the lightest shadows on the snow. Paint these with your Chinese brush, making sure you give the shadows crisp, clear edges. Follow the slopes of the mountain with your paintbrush. Leave a thin white edge along the horizon to suggest the light reflecting on the snow.

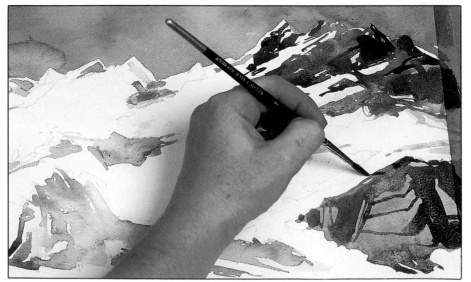

3 Mix three washes for the rocks: the first with raw sienna and burnt umber; the second using the same two colours, but adding Vandyke brown and burnt sienna; the third combining violet madder and indigo.

With the same brush, paint the rocks on the right (or left if you are right-handed) using the first wash for the lightest tones, the second for the darker. Work wet-in-wet then wet-on-dry. Use the tip of the brush for fine details. Don't forget to leave the paper blank for highlights and snow. Then use your No.4 round brush to add the third wash in places (working into semi-wet paint) for the dark, purply shadows.

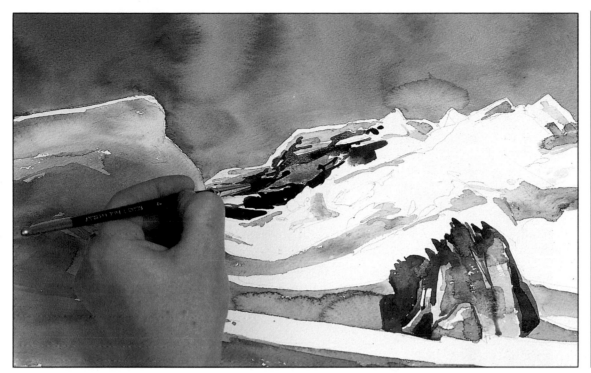

Tip

Planning ahead
Mapping out beforehand where to leave the paper unpainted is crucial. Make a quick tonal sketch before you start, roughly indicating where you want your white areas to be. You can then refer to this valuable guide as you paint.

4 Paint the rocks in the middle of the picture in the same way. Use your No.4 brush to pick out the cracks in the rocks with fine strokes. Add some of the sky wash to the foreground rock to suggest the reflection of the purply shadows on the snow.

Remember the rules of perspective and make smaller marks for the distant rocks, and freer strokes in the foreground.

5 Wait for the paint to dry. Take advantage of the drying time to stand back and assess your progress. Already the white of the paper takes on the appearance of snow, and the crisp, sharp shapes of the darker tones against the white make a pleasing contrast.

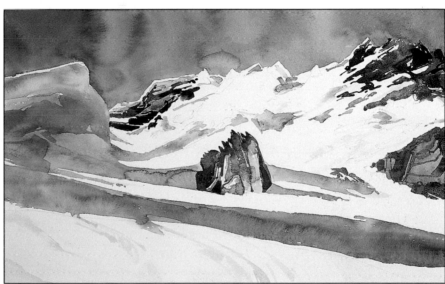

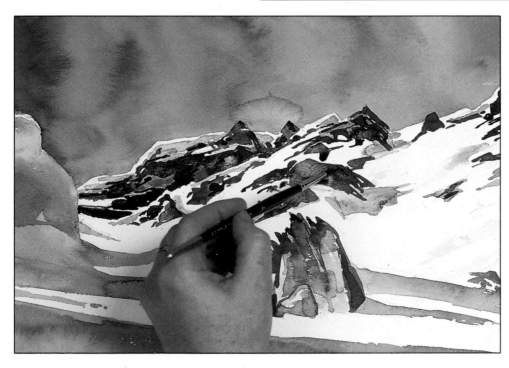

6 Make a variety of brown washes based on sepia and Vandyke brown for the central area of rocks. You can darken these with either indigo or violet madder. Overlay washes wet-on-dry to build up the layers of the rocks, keeping to the No.4 brush since this is quite a detailed area.

▶ **7** Now paint the remaining rocks (to the left) with a mixture of Vandyke brown and violet madder, adding indigo to darken it in some areas. Work around the painting, deepening shadows and strengthening the colour of rocks where necessary by adding a little more paint over dry areas.

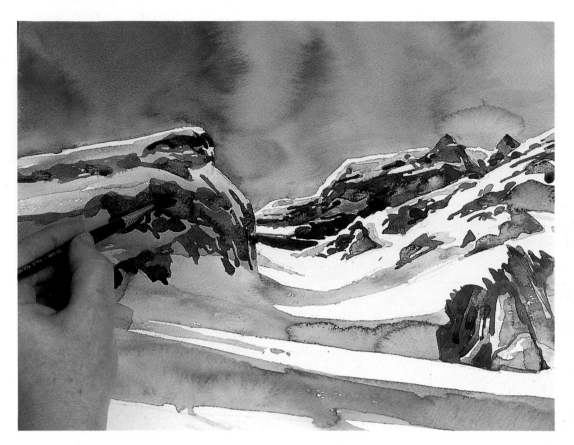

▼ **8** The white areas in the final painting set the mood, singing out against the cool shadows and dark tones and suggesting cold, sunny weather and the depth of the bright white snow. All the main characteristics of watercolour are here – transparent paint and the melting quality of washes flooding into one another, contrasting with crisp outlines and the stark, brilliant white of the paper.

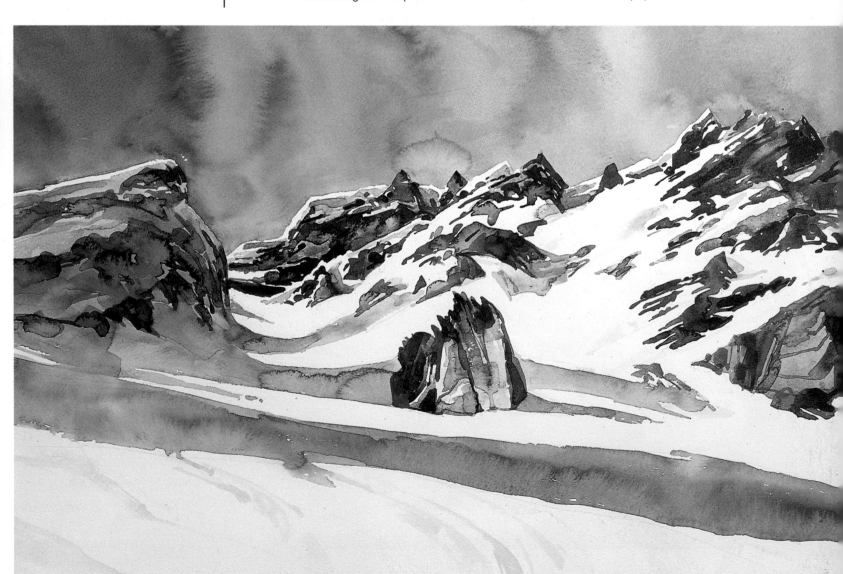

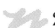

Getting to grips with green

Green is the most important colour in the landscape painter's palette, and causes the most problems. Ready mixed greens are useful but in no way give the range you need to capture the colours of nature.

There are in fact two aspects to this problem – the first is learning to see, recognize, and analyse the colours you see. The second stage is translating what you see into paint.

The proprietary (ready mixed) greens
A typical box of paints probably offers you one or two of the following: sap green – a bright grass green; viridian – a bluish bottle green; and terre verte – a greyish green. All these colours are highly transparent. Other commercially available greens include Hooker's green which is an intense bright green, olive green which has a yellowish tinge, and oxide of chromium which has a greyish quality and is less transparent than the other greens. Manufacturers have their own ranges and may use different names for similar colours. You may also find that a sap green produced by one manufacturer is slightly different in hue from that produced by another.

Using a limited palette
There is a lot to be said for working with only a few colours – artists call this a limited palette. Paints are costly but there is another good reason for restraint. If you start with just a few colours you can really get to know them. You will be forced to experiment with mixes to get the range of colours and tones you need. If you have a big

selection, on the other hand, you may become lazy because you don't really need to explore the range of each colour. And rather than finding exactly the right colour, you make do with an approximation just because it's there in the tube or pan.

There's no substitute for experimenting with the colours in your paintbox so that you really get to know them. In this way you become so familiar with your colours that you can use them without having to think about it. You can then focus on the really important thing – the subject in front of you and your interpretation of it and response to it.

Ways of making greens
There are three ways of finding the greens you need for a landscape painting such as the one overleaf.
● Use any one of the commercially available greens, or create more by modifying them.
● Mix your own range of greens.
● Overlay a wash of one colour with another.
By combining two or more of these techniques you can make a huge variety of greens.

▼One way of making a green is to mix a yellow and a blue.

▼Another way is to use proprietary (ready mixed) tube or pan colours.

▼Yet another way of arriving at a green is to lay a yellow wash over a blue one.

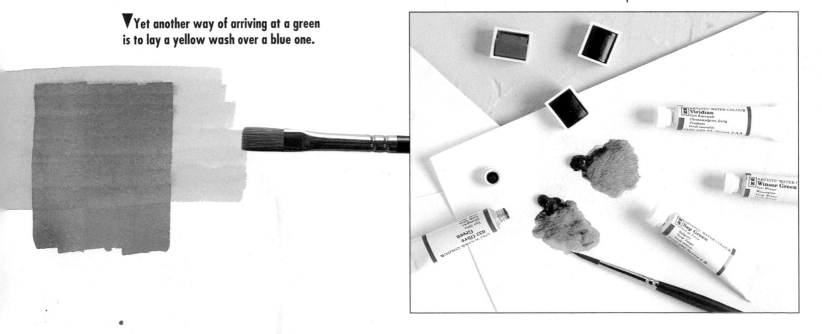

Mixing greens – an exercise

To create the greens for the lush summer landscape on the following pages, the artist used six colours: sap green, Hooker's green, cadmium yellow, cobalt blue, burnt sienna and raw umber. (He also used a seventh colour – cerulean blue – for the sky.)

Select pans or tubes of the six colours, several sheets of paper, two jars of water and nos. 9 and 10 brushes. You need lots of room for mixing – a large white palette, several mixing saucers, or a couple of slant tiles.

Start by getting to know your colours. Mix a wash of the first one and lay down a patch of it. Now dilute the wash with more water and lay that beside the first patch. See how many tints you can achieve. Then see what happens when you overlay these with another wash of the same colour. Work quickly, don't bother about being too tidy, and above all enjoy yourself.

When you really know these six colours, explore some mixes. Begin with cobalt blue and cadmium yellow which gives a good green. Start with a 50:50 mix, but then see what happens when you increase the proportions of each colour in turn.

Try these mixes – the artist used some of them for his Sussex Downs landscape.

Green A – mixed from 50:50 cobalt blue and cadmium yellow

Green C – a lot of cobalt blue with just a touch of cadmium yellow

Green B – made by mixing green A with Hooker's green (a proprietary hue)

Green D – sap green with a little cobalt blue

YOU WILL NEED

- ☐ *Box of 12 half pan watercolours*
- ☐ *One No.10 and one No.9 round brush*
- ☐ *A sheet of previously stretched A3 watercolour paper*
- ☐ *Three jars or bottles of clean water*
- ☐ *The following seven colours: cadmium yellow, cobalt blue, sap green, Hooker's green, raw umber, burnt sienna, cerulean blue*

On the Sussex Downs

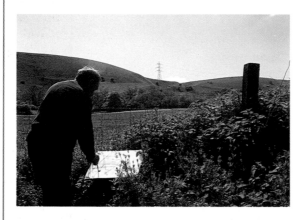

▲ **The set-up** The artist travelled light – he didn't have an easel, so propped his drawing board with the ready-prepared, stretched paper on the foliage on top of a bank. He worked directly, without an initial drawing.

Watercolour is ideal for recording the delights of the countryside – light, portable and fast drying, it allows you to work directly from nature, recording the fleeting effects of light and weather.

This painting was made directly from the subject – the rolling Sussex Downs, glimpsed through a gap in an overgrown fence in the height of summer. The artist parked, grabbed a bag containing his kit and scrambled up the bank.

Using his box of 12 pan colours and a No.10 brush he worked quickly, starting with broad washes of colour, then some wet-in-wet – leaving the painting to dry for a moment in the sunshine. Then he applied more colour wet-on-dry, concentrating on the greens in the landscape, squinting to focus on particular areas and assess the differences between one green and another.

▶ **1** Start by laying in a flat wash of dilute cerulean blue for the sky with the No.10 brush, then leave it to dry. It must be dry before you paint the hills, so you get a crisp horizon line. Then mix a blue-green from cobalt blue, cadmium yellow and a little Hooker's green and lay in the broad forms of the hills.

On the right hand side use cadmium yellow with a touch of cobalt to create the bright green where the sun catches the top of the hill.

Add more yellow and water to the basic mix for the yellowy-green in the foreground. Leave to dry.

Don't worry if yours don't match – all artists have their preferred colours.

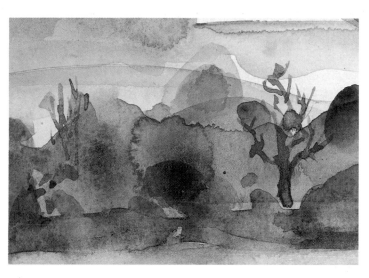

Green E – a lot of cobalt blue with just a touch of sap green

Green G – cobalt and Hooker's green with a touch of burnt sienna

Green F – cobalt blue with a touch of Hooker's green

Green H – 50:50 cobalt and Hooker's green with raw umber

▲ Using a loaded brush, the artist applied a rich mix of Hooker's green, cobalt blue and burnt sienna with great precision, allowing the paint to pool and puddle so that it dried with crisp edges which beautifully describe the clumps of vegetation.

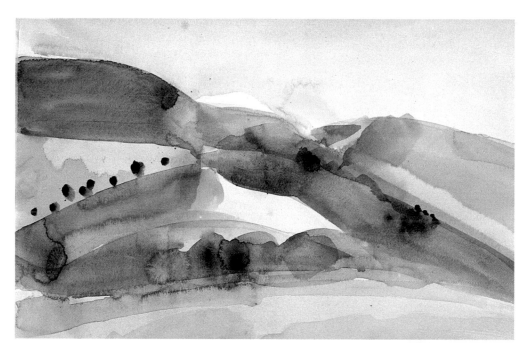

◄ **2** For the darker tones you need a variety of mixes: cobalt blue with a little cadmium yellow, sap green with cobalt blue and cobalt with Hooker's green. With a well loaded brush, lay broad swathes of intense colour for the darker tones along the crests of the hills and in the copse at the foot of the slope.

Add clumps of bushes using a mix of sap green and cobalt blue: a dark greyish green. On the right touch in the bushes on to the damp paper so the colour bleeds into the surrounding colour. Lay in the row of bushes on the left with a loaded brush, this time working on a dry surface to create crisp shapes.

3 Warm the foreground with a dilute wash of raw umber, then a band of burnt sienna for the cultivated ground on the far side of the field.

▶ **4** In this detail you can see the complexity of the picture surface, with overlapping washes of colour, some with crisp edges. The artist used the No. 9 brush and a yellowy mix of cadmium yellow and cobalt blue for the side of the downs.

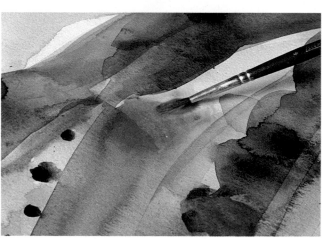

Tip

Expand your mixes
You might find it interesting to add another blue-green mix, using cobalt blue, but this time adding lemon yellow which gives you a much brighter apple-green. Another rich, clean dark green uses Prussian blue 50:50 with raw umber.

▲ 5 To develop the vegetation area even further, use the No.10 brush to lay a band of a rich yellowy green across the foreground to strengthen that area and make sure it takes its correct position in space.

Use a rich mix of Hooker's green, cobalt blue and burnt sienna for the base of the distant hedgerow.

▲ 6 Continue putting in the hedgerow with your dark mix. In this area the paint is used to describe the forms of the trees and bushes in the copse and hedge. The artist worked carefully here, using a loaded brush and an intense mix of colour. He is still using the No.10 brush – relatively large for the job – but the very tip makes a neat point which allows him to create fine detail.

▶ 7 Add a touch of raw umber/cobalt blue to the yellowy green to create a dark tone and use to draw the gaunt, branching form of a tree which appears to be dead and leafless. Use the same mix to indicate the trunk and branches of small trees.

▼ 8 Complete the painting with details added in a mixture of dark greens – the fence posts curving over the crown of the hill, for example, and among the clump of trees on the right.

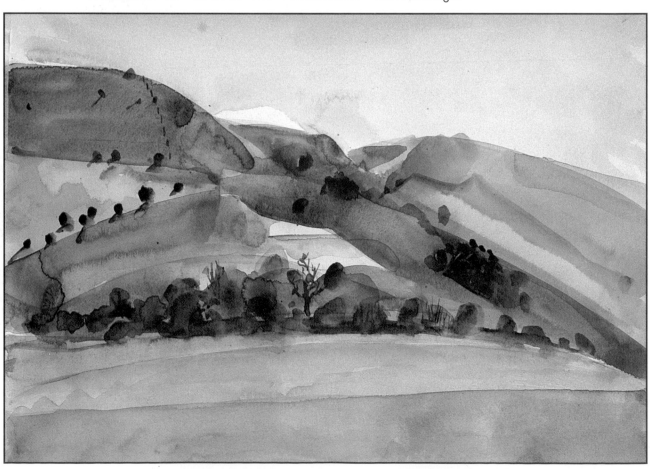

Exploring the colour red

Red – in all its variations from orange to purple – is a most striking colour, and a very useful one in the artist's palette. Our project helps you make the most of this colour in your paintings.

Sometimes, it's a good exercise to focus on a particular colour range so that you can really explore it in all its various combinations.

By following our project, you'll discover that red isn't simply red – there can be warm reds, cool reds, pink and orange reds, and reds that are virtually purple. Set up a still life incorporating a range of reds so you can get to grips with this exciting colour. The project will help you learn to mix the many reds with a limited palette.

It's vital you don't taint your mixes, so keep two jars of water, one for mixing colour, and one for cleaning your brushes. Change them frequently.

▼ **This detail shows how the artist skillfully places blue-reds in the background to make the area recede. She also uses close tones here which again help to keep the background in its plane behind the main action.**

▼ **The colours of the fruit enthusiastically remind us that these items are the main focus, with the blue-red plums, the aggressive scarlet apple and bright orange.**

◀ **The variety of reds in this painting give it a rich, complex and decorative surface, with a touch of complementary green for harmony and balance.**

'Red Apples in a Fruit Bowl' and details above by Shirley Trevena, watercolour and gouache on paper, 24 x 19in

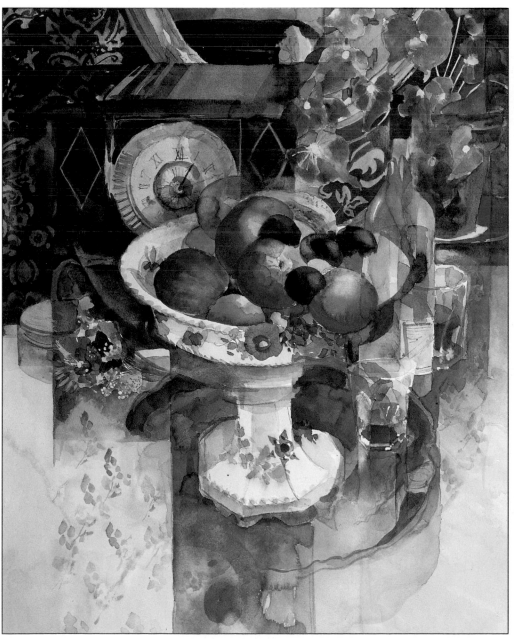

Making mixtures

Burnt sienna, cadmium red and cadmium yellow deep combine to make this warm orange.

For this striking cool red, mix alizarin crimson with French ultramarine.

Cadmium red on its own provides you with a strong, warm red that advances.

An exercise in mixing reds

The aim here is to explore the spectrum of the colour red from sunrise to sunset using a relatively limited palette. Our artist used only three reds, two blues and a yellow alongside green and grey as a contrast.

Before you begin your painting, look at the set-up and try mixing the different reds you'll need. Combine varying amounts of red with blue for a range of cool reds through to purple (a cool blue-red). Mix red with yellow in the same way to travel through a warmer variety of reds to hit orange, a warm yellow-red.

For more variations, mix both blue and yellow with a cool red, say, alizarin crimson, then a warm one such as cadmium red, and finally a gentle pink-red, rose madder for instance.

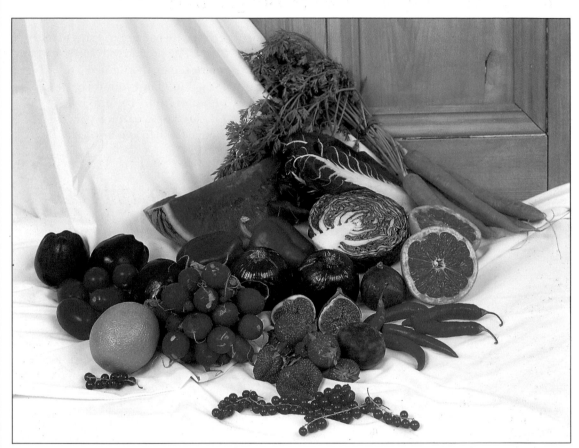

▲ The set-up Nature provides us with every conceivable shade of a colour – whether it is red, blue, yellow, green or any other. For this painting, our artist picked a variety of red fruits and vegetables which gave good scope for exploring a range of reds.

Use alizarin crimson, a cool blue-red to make background areas gently recede.

A good addition to your palette is rose madder, which is one of the range of delicate pink-reds.

Burnt umber is another useful hue. Mix it with alizarin crimson or a blue for some useful neutrals.

Mix rose madder with ultramarine for this rather transparent, recessive, cool purple-red.

Combine ultramarine, cerulean blue and alizarin crimson to create this useful mauve.

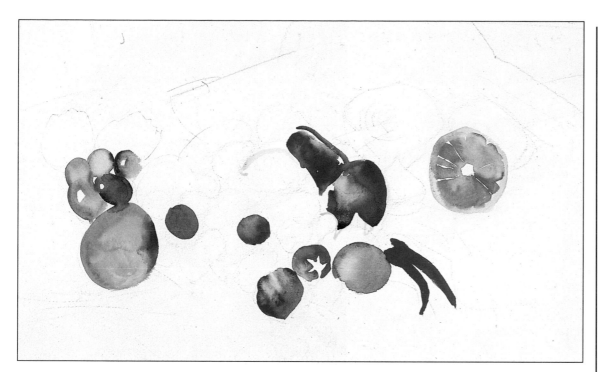

▲1 Draw the composition with the pencil. Mix some pale reds to start off individual objects. For graded tones, our artist brushed over an item with clean water, then laid the local colour into this so it flared and found its own shape. (When you lay in water, leave some paper untouched for highlights.)

Notice how the orange (left) has a cooler red on the right side to explain how it curves into shade.

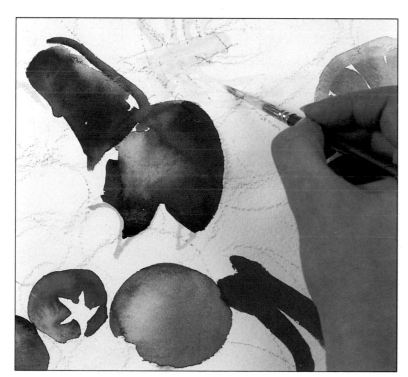

◄2 Use the old brush and some tinted masking fluid to mask out the central stems of both cabbage and raddichio. These strong, pale shapes will make a pleasing contrast to the reds, so it's a sensible idea to mask them out early on.

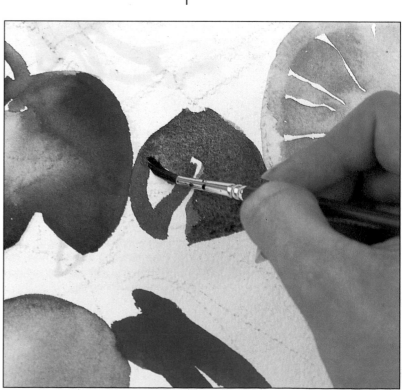

►3 Look closely at the set-up – the figs and onions are different shades of purple. Having chosen quite a reddish purple for the onion, our artist went for a bluer mix for the deeper coloured fig. It provides a good contrast to the bright yellow-orange of the grapefruit skin.

Paint the fig, ensuring you work around the outline of the chilli pepper stalk in front.

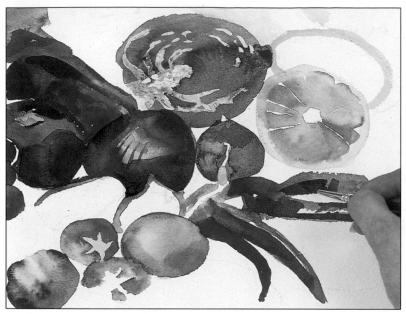

▲**4** Don't finish one area at a time. Develop different parts of the picture, applying base washes (as on the cabbage and watermelon). Warm colours advance and cool ones recede, so if the local colour is warm (as with the orange), use cool shades to emphasize form. Start to introduce textures. Give the onion to the right a few stripes to indicate the lines of its skin.

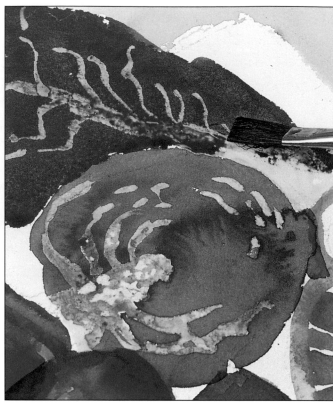

▲**5** Apply a yellow base wash on the carrot tops. Then, making sure the masking fluid is dry, wash over the raddichio.

Notice how the reds in this section are mostly blue-reds. In some areas our artist mixed on the palette; in others she overlaid one colour with another to create the hue she wanted.

◄**6** Introduce a touch of singing orange for the carrots on the right. They balance the orange on the left, and provide a good contrast to the adjacent mauves (red-blues), violets and purples (blue-reds) – see step 5.

Don't neglect the background. Suggest the wood panel with a pale wash. Use the chisel brush to paint up to outlines.

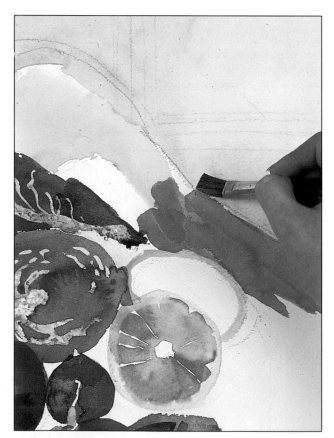

►**7** Use clear masking fluid to mask out some pale stalks in the carrot tops. Later on, you'll paint over the area in green, then remove the masking fluid to reveal yellow stalks. Our artist decided to use clear masking fluid this time, not yellow, which would be hard to see on the yellow wash underneath.

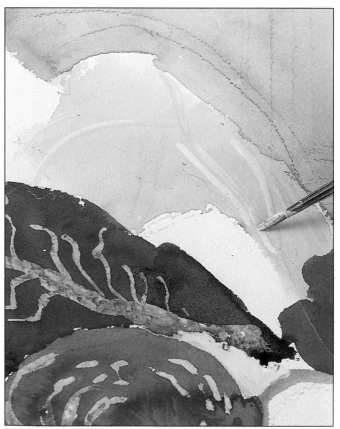

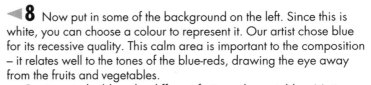

8 Now put in some of the background on the left. Since this is white, you can choose a colour to represent it. Our artist chose blue for its recessive quality. This calm area is important to the composition – it relates well to the tones of the blue-reds, drawing the eye away from the fruits and vegetables.

Continue to build up the different fruits and vegetables. Notice how, on the watermelon, a few dabs of a cooler red perfectly indicate the seeds embedded in the flesh of the fruit.

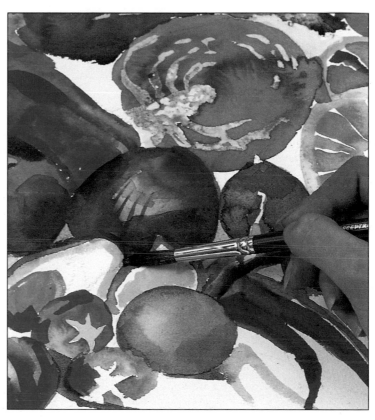

9 For some shadows between objects, use a deep, recessive blue. Here, it creates a strong contrast between the onion and cut fig in front, making the fig advance.

Put in fabric folds and their shadows with neutral mixes. First hood your eyes to assess their tones.

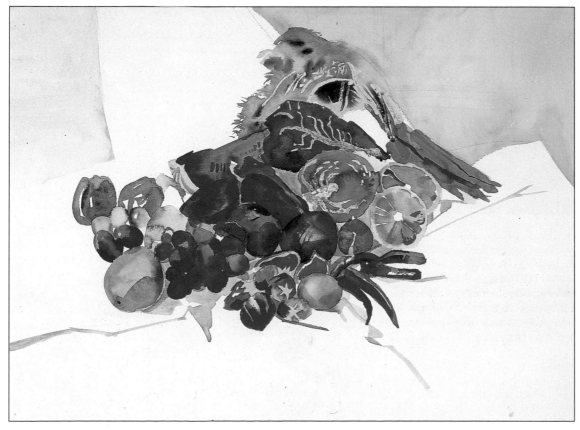

10 Now add the leafy carrot tops with varying greens. You can now see how the masking fluid has worked – the image created is of a jumble of yellow and green stalks. This green shape is important to the composition – it provides an area of relief from the explosion of red beside it. Also, green and red are complementaries. Show the separate carrots, using a cooler, recessive red to stress the spaces between them.

Stand back and look at your progress. With so much work on the fruits and vegetables, and so little on the background, the image looks as though it is floating in space. To remedy this, give the corners of the painting their due attention.

◄11 Use the edge of a strip of torn card dipped in paint to print some more fabric folds. Vary the tones you use for the folds to create more interest. In other background areas, use the straight edge of the ruler to guide your brush for straight-edged folds. These contrast wonderfully with the irregular marks printed with the card.

◄12 When you overlay washes, make sure the base colour is completely dry to keep your colours clean.

Use a piece of torn card to print the dark pattern on the cut cabbage, bending the card to catch the shapes. This gives a good impression of the surface texture. Continue to build up the shadows.

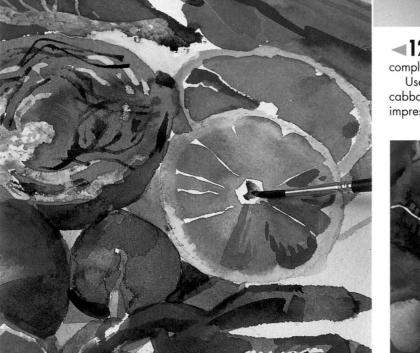

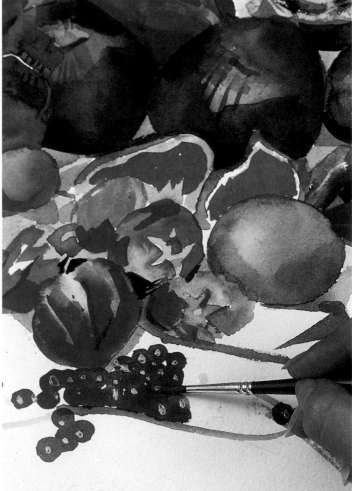

►13 Look at the redcurrants in the set-up – they each have a tiny highlight. Mask these out with tinted masking fluid before painting in the redcurrants. With tiny objects such as these, it's essential to count them to help you with scale. For example, how many redcurrants to one strawberry?

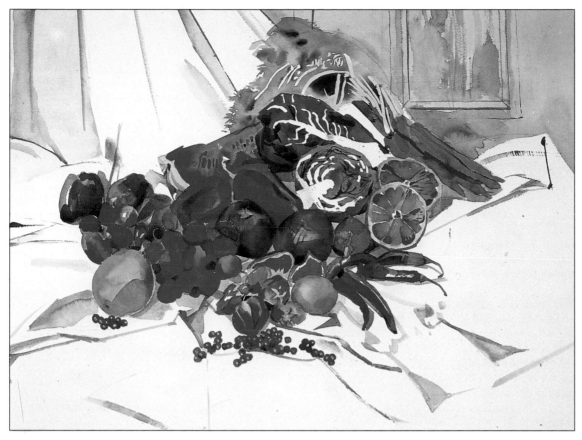

◀14 Paint the panel edges of the pine door. Make these as straight as possible – use your ruler to guide your hand. Try to indicate the texture of the wood as you build up this area.

Notice how crisp the rhythms of the fabric folds are. They have been carefully composed to provide a good contrast to the organic curves of the fruits and vegetables.

▼15 Finalize the green carrot tops by painting the ends of the stalks with feathery marks.

Peel off all the masking fluid. Our artist now employed the technique of sgraffito, scratching away the paint with a craft knife for whites of a different quality to those that were masked out.

▼16 Print another fold with the palette knife. Look at the printing around the painting – some marks are crumbly and recessive, while others are crisp or delicately curved, like the trailing carrot roots here. Notice how every mark in this area is well placed to leave a stark white area which relieves the activity of the rest of the picture.

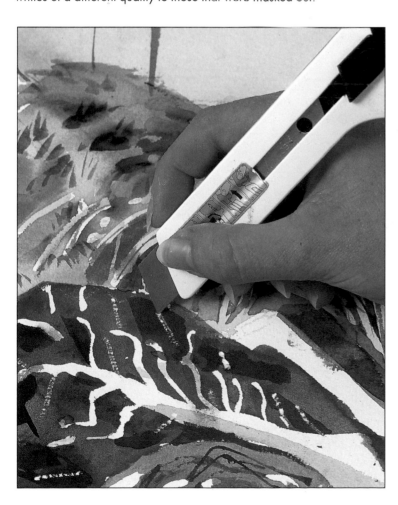

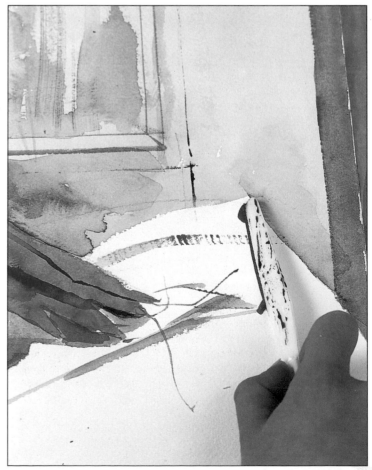

▶ **17** Our artist felt she'd made this shadow a little too strong, so she softened it by rubbing it gently with a piece of fine sandpaper. This also creates a lovely, mottled texture.

Work around the painting, making finishing touches as you see fit.

▼ **18** Although the point of this exercise was to explore mixing and using reds, the composition was well considered, producing an exotic, exciting picture at the end of the day.

There are solid areas of intense red, smaller areas of bluish or yellowish reds, and some lovely textures and rhythms. There are interesting cameos – the strawberries with their seed pattern, for instance. And there seems to be a natural order, with the largest items at the back, the smallest ones at the front. Notice also the blue-red rhythm within the arrangement – running from the raddichio down through the cabbage and turning to the figs and onions, then across to the apples on the left.

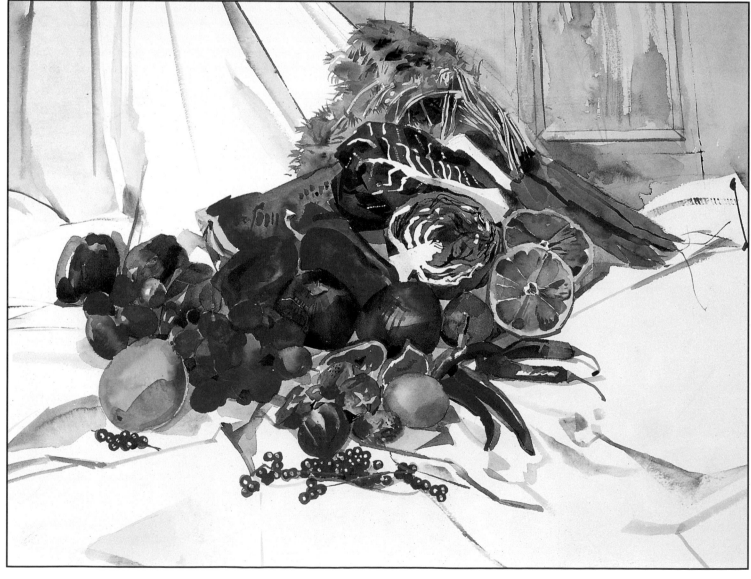

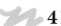

Earth colours

The versatile, yet subtle nature of delicate earth colour mixes is ideal for capturing this Cornish low-tide harbour scene, gloriously rich in ochres, umbers and browns.

Earth pigments provide some of the oldest colours known to man – they were used on ancient cave paintings for bold depictions of animals and men. And some of the natural pigments arc still used today. Although synthetic equivalents of these colours are now being made, many artists still prefer the muted quality of the genuine pigment.

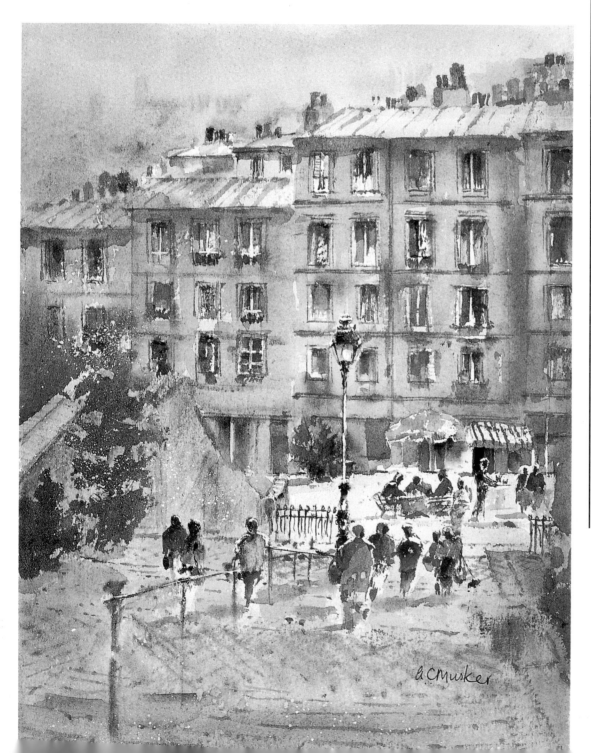

Principal earth colours

Raw sienna

Raw umber

Yellow ochre

Terre verte

Burnt sienna

Burnt umber

Vandyke brown

Venetian red

◄ **Here, raw sienna and raw umber predominate, with blended mixes uniting the other colours in the painting.**
'A Paris Café Scene' by Alison Musker, watercolour on paper, 15 x 10in

YOU WILL NEED

- ☐ Sheet of 21½ x 15in, 140lb Rough NOT watercolour paper
- ☐ A 24½ x 18in sheet of mounting board; spray mount
- ☐ 2B pencil; putty eraser
- ☐ Watercolour palettes
- ☐ Jars of clean water
- ☐ One ⅞in flat brush; five round brushes – Nos.2, 4, 5, 6 &12; one old No.1 brush
- ☐ Masking fluid
- ☐ Twelve watercolours: olive green, raw sienna, burnt sienna, burnt umber, Indian red, rose madder alizarin, Winsor blue, cobalt blue, cerulean blue, French ultramarine, cadmium red deep and cadmium yellow

▼Our artist made his colours from mixes of raw sienna (1), burnt sienna (2), burnt umber (3), olive green (4), cobalt blue (5) and Indian red (6). A is made from 1 + 4 + 6; B is made from 1 + 2 + 5; C is made from 1 + 4 + 5; D is made from rose madder alizarin + 5 + 6; E is made from 3 + 4; F is made from 1 + 2 + 4; G is made from 1 + 4; H is made from 3 + 5; I is made from 1 + 5; J is made from 3 + 5; K is made from 1 + 2 + 4; L is made from 1 + 4 + 5.

Earth colours are complex – often slightly muted or neutralized versions of primaries or secondaries. So yellow ochre is a neutralized yellow-orange, for example, and Venetian red is a soft, brownish red.

They are wonderful colours to use; intense but never garish, they can produce some highly useful mixes. Indeed, they have a place on every artist's palette, whether it's for rendering the soft colours of a young girl's face or the rich shades of a summer landscape.

In the demonstration that follows, our artist started off with washes of raw sienna with a little blue, green or red added. He always begins his landscape paintings in this way because the watery raw sienna washes not only knock back the rather off-putting white of the paper, but they also make a good base for the colours to be laid on top. He sees raw sienna in almost everything, especially rocks, wood and earth. If it's a sunny day, he adds some blue to the raw sienna to brighten the key.

You'll notice that our artist doesn't use yellow ochre – he never does. He prefers to use raw sienna instead; it's a slightly browner, more transparent version of yellow ochre. This is his personal preference – you might like to try it out to see if you prefer it too.

Our artist's painting was of the harbour at Porthleven, Cornwall on a cold morning in March. Earth colours are perfect for such a scene, when the colours appear rather muddy. He used 140lb Rough watercolour paper with a slightly waxy surface that resists the water and allows the paint to sit on the surface, creating pools of colour. These dry with crisp edges, while the pigment within the pools often separates and granulates to create an interesting grainy texture. He stuck tracing paper to the mounting board around the paper which he used to try out each colour.

Porthleven harbour – low tide

The set-up Our artist began with two photos. He made two sketches, then a large drawing which combined both views. He glued his paper to mounting board, spraying the back of the paper and the board with spray mount (glue), then pressed them together under a weight for an hour or two – it's quicker than stretching the paper and provides a sound base to work on. Work with a slightly raised board, so the paint runs down the paper and pools at the edge of each brushstroke.

▶**1** Draw in the composition with the 2B pencil. Then, with an almost colourless mix of Indian red, cobalt blue and raw sienna, wash over sky, house and hill with the No.12 brush. Work fast and keep things watery.

Change to the ⅞in flat and add more raw sienna, cobalt blue and water to the wash, brushing it down over the walls. Apply a little cerulean blue over the boats and add more raw sienna, cobalt blue and some olive green for the shadows on the sea bed.

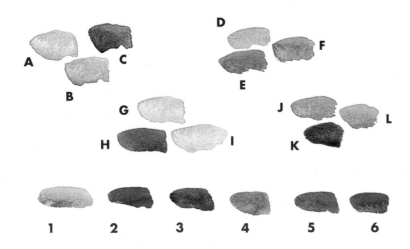

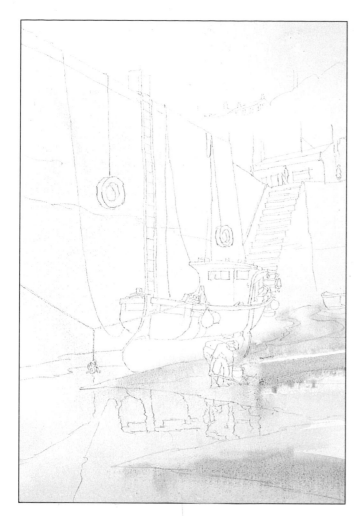

◄ **2** Dab off paint from the houses with kitchen roll/paper towels, then leave the painting to dry. The colours lighten as they dry. Apply masking fluid with the old No.1 brush on all the boat ropes and those on the wall to the left of the ladder (leave the ones to the right unmasked), the tyres, ladder, flag poles and masts on the angling shop. Leave to dry. Wash your brush thoroughly.

▼ **3** Paint the chimneys, roof and windows of the houses at the top with cobalt/Winsor blue, using the No.4 brush. Run a clean wet brush below the bottom edge of the houses and paint the house front with pale raw sienna and Indian red, letting the colour spread gently on to the hillside. Continue on the hill with a very light wash of raw sienna and Indian red, dropping in touches of cobalt and olive green along the top, allowing it to spread into the sky. As you move down, drop in more cobalt and Indian red (separately so as not to muddy the colours). Darken the colour at the foot of the hill.

Apply a pale wash of burnt sienna/olive over the roof of the shop, leaving bits of white here and there. Leave a white strip and add more raw sienna under it, along the wall, letting it run down (watch out for the figures). Darken the same wash for the side of the building and wash a thin mix of raw sienna and ultramarine over the windows.

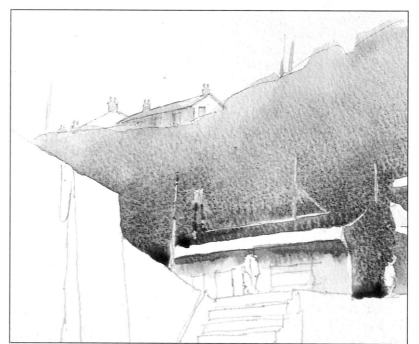

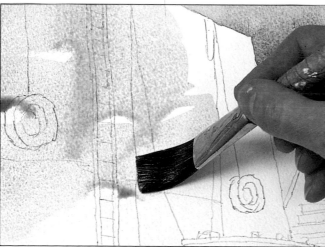

▲ **4** Use the ⅞in flat brush to paint the harbour walls with a very loose wash of raw sienna and olive green with a touch of burnt umber and cobalt. Let it run down and collect in pools at the edge of the brushmarks, leaving flat breaks like slits here and there to suggest old bricks. Run a darker streak over the ladder.

► **5** Dash some horizontal washes of the mix on to the sandy bed on the foreground right, adding more cobalt along the top edges and letting it spread down to suggest the waves on the sea bed as the tide comes in and out.

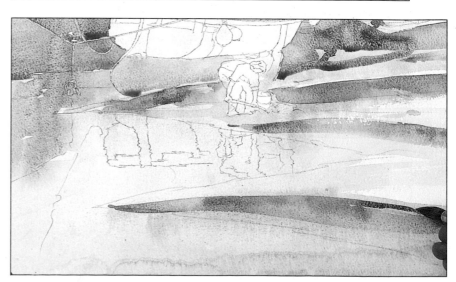

Tip

Let it spread

To give a particular area or object a natural outline rather than a hard painted edge, wet the shape or area first with a clean, wet brush. Then put the paint on in the middle of the shape and allow it to spread gently to the edge of the wet surface by itself.

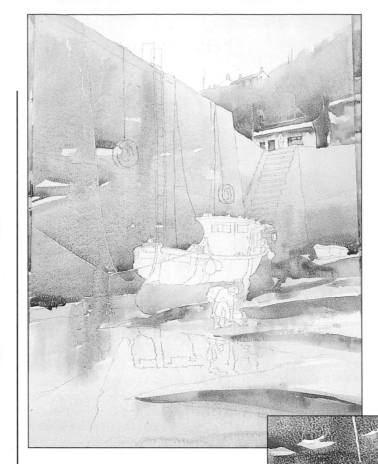

◀**6** Paint over the walls and most of the foreground with different strengths of raw sienna/olive, adding more burnt umber with a touch of cobalt to darken the foot of the wall on the left, and more cobalt with a little burnt umber for a bluer wall at the back right. Let this very wet paint run down and gently pool to make interesting edges with denser pigment. Change to the No.5 brush and paint around the boat and figure. Paint the keel and build up the shadow under it.

Leave the painting to dry. Now put some masking fluid on the ropes to the right of the ladder and a few trickles coming down in odd places from the top of the wall. Leave this to dry too and clean your brush at once.

▶**7** The colours and texture of the sludgy harbour walls determine the whole atmosphere of this picture, so it's essential the paper is totally dry to hold the brushmarks. Paint the individual bricks at the top of the wall on the left with the No.12 brush and a mix of burnt umber, cobalt and a little raw sienna. Lay the brush flat to paint and work down, varying the strength and colour of the mix – adding more cobalt or burnt umber. Then zigzag the brush around to break up the brick pattern a little.

Leave some strips bare of paint and let other areas run and spread. Drop in blobs of Indian red or raw sienna for rusty tones, and suggest the tidemark with a nearly black ultramarine and burnt umber mix.

Change to the No.5 brush and paint around the boat. Then, with barely diluted ultramarine and burnt umber, paint some dark strokes on the wall below the tidemark to suggest craggy gaps between the bricks.

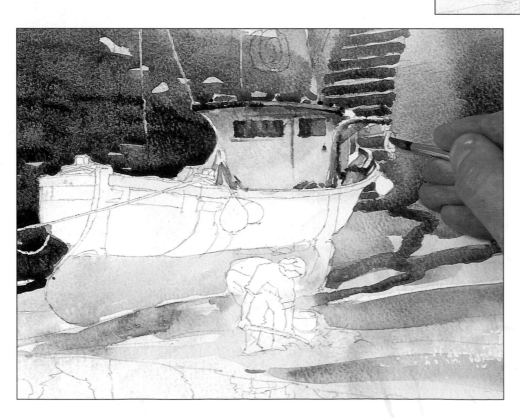

◀**8** Run a clean, wet brush across the front of each step then paint it with burnt sienna, raw sienna and cobalt, varying the colours. Leave thin gaps and link the steps here and there.

The wall on the right is hazier, so drop small amounts of Indian red and cobalt into the wet base colour. Darken it with burnt umber as you go down. Brush on water for the muddy trails then paint over them with this mix, letting the paint gently flow into the water.

Next thinly wash raw sienna on the boat wheelhouse, adding burnt sienna for the shadow under its roof. Cleaning your brush for each colour, drop in areas of rose madder alizarin and cerulean blue to suggest sunny white paintwork. Paint the parts on the roof with cerulean and a spot of raw sienna. Then paint the deck on the right with a pale blue mix of cobalt, rose madder and burnt sienna.

9 Use the tip of the No.4 brush to pick out more shadows on the wheelhouse roof with burnt umber and cobalt. Carry on with these colours, painting through the windows and adding a little cadmium yellow to suggest the curtains in the wheelhouse.

Paint the stern with a blue wash of cobalt, raw sienna and burnt sienna. Use cobalt and burnt umber for the rudder blade and lots of rusty raw sienna along the hull under the rail. Paint the keel with a muddy mix of most of the colours on your palette, keeping the colours dense and uneven. Model the boat, highlighting its graceful curve by layering the shadows and rust, letting the paper dry between each layer.

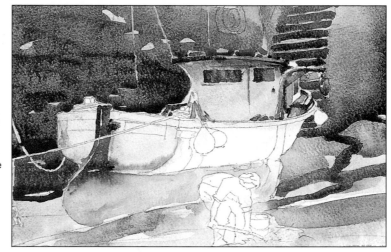

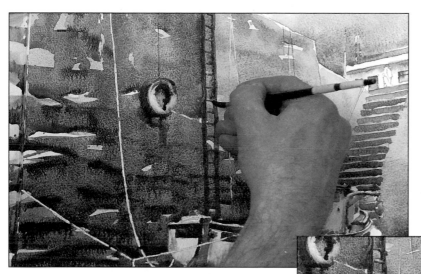

10 Rub off the masking fluid from the ropes, ladder and tyres. Paint the tyres with olive, burnt sienna, ultramarine and raw sienna, building up the shadows underneath to help place the tyres against the wall. Let some colour bleed down the wall and lift out colour from the tyres with a wet brush to model their form. Paint the ladder in the same way with a similar colour mix. Lift off paint for the highlights on the rungs, but watch out for the change in direction with perspective.

11 Using the No.12 brush, wash in very wet layers of cerulean, cobalt, raw sienna and a touch of rose for the muddy water in the foreground. Paint a darker wash at the foot of the side wall with raw sienna and cobalt, adding some burnt sienna to build up the shadows under the boat.

While the foreground is drying, use the No.4 brush to paint the smaller boat with alternate thin washes of raw sienna and cobalt. Apply a pale cobalt undercolour for the stripe around the top, going over it with layers of rose madder alizarin, with burnt sienna over the top.

12 To work up the murky foreground, loosely wash in a very wet mix of raw sienna, burnt umber and cobalt, allowing streaks to run down, forming dark pools along the edge of the waterline. Paint round the edge of reflections in the water carefully, making them delicate and wobbly.

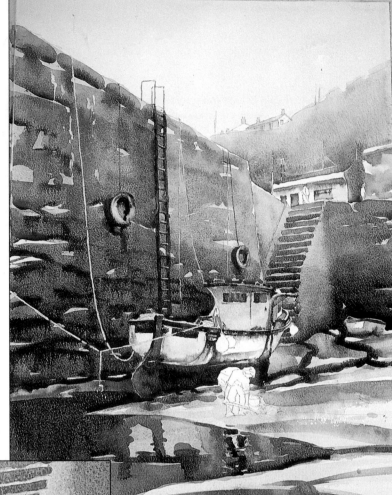

►**13** Continue to lay wet washes on to the water in the foreground. The darkest tones are mixed from burnt umber and ultramarine. Use a loaded brush and a variety of sweeping, gestural brushstrokes to create the areas of darkness on the left of the picture area. Then spatter the paint to suggest pebbles on the right.

Going back to the wall, put in the handrail at the top of the ladder with a neutral colour, using the No.2 brush.

◄**14** The angles and lines of the whole composition draw the viewer's eye in to the pink and purple fenders sitting against the white of the boat – our artist thought this made the picture. So paint them carefully with the tip of the No.4 brush, giving them graded shadows and highlights. Use a mix of rose madder alizarin and raw sienna with hints of burnt sienna for the pink one, and a mix of cobalt, rose madder alizarin and ultramarine for the blue one.

►**15** Rub off the remaining masking fluid and put touches of colour on these exposed areas. Using the fine No.2 brush and some raw sienna, cobalt and cadmium red, make the ropes dark where the background is light and vice versa.

This picture shows clearly the way the pigment has separated and settled in the wet washes to create a pleasing textured effect which captures the quality of pebbles, rock and masonry.

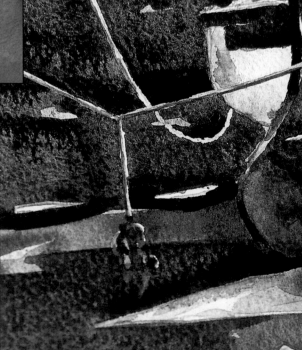

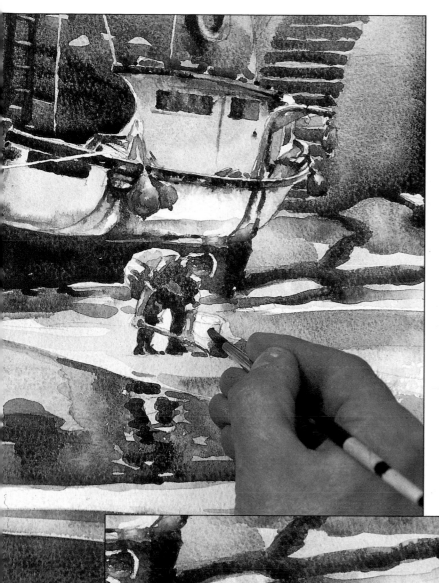

◀16 The central figure digging up worms is a vital focal point in the composition and requires some fine detailing.

With the No.2 brush, paint his skin with varying strengths of cadmium red deep and cadmium yellow, lifting out highlights with the clean wet point of the brush. Mix raw sienna and a touch of cobalt for the hair.

Use cadmium yellow and raw sienna for the light parts of the shirt; cerulean, cobalt and rose for the parts in shadow. The trousers are a mix of cobalt, olive and raw sienna (make this stronger for the boots); the bucket, spade and heap of mud are all in varying strengths of a mix of raw sienna, cobalt and rose madder alizarin.

Tip

Keep your washes watery

Watercolour dries naturally to a lighter hue, so to make the rich earth colours here you must apply several very wet washes. It's important to allow each layer to dry properly as you go along to prevent all the colours running into one another. If you use a hair dryer to hurry things along, be careful not to scorch the paper or blow the wet paint out of shape.

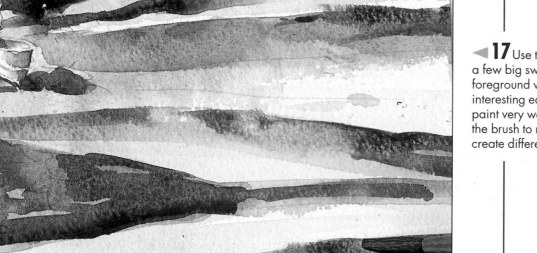

◀17 Use the No.6 brush to make a few big sweeps across the right foreground with a variety of interesting earth colours. Keep the paint very wet and twist and turn the brush to make varied marks and create different textures.

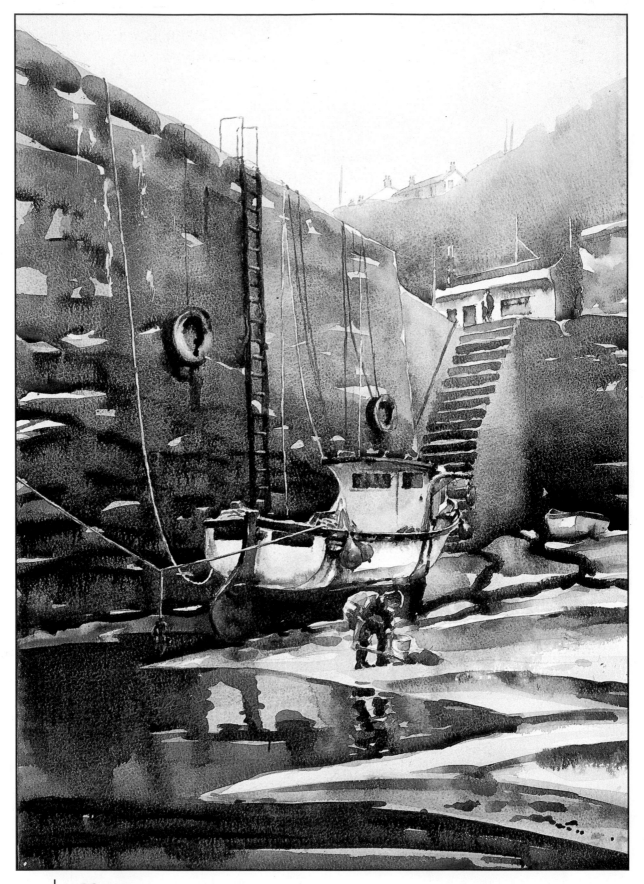

▲**18** Finally, suggest the figures at the top of the steps with a pale, watery mix of rose, cadmium red, cobalt and raw sienna.

Our artist painted this picture with four main colours: raw sienna, burnt sienna, burnt umber and cobalt. Raw sienna predominates – he used it in nearly all the colour mixes, giving the painting its overall colour unity. He has succeeded in bringing a strong, three-dimensional quality to the picture, emphasizing light and space. The paint textures and tones convey a real feeling of the damp, muddy scene – you can almost smell the sea.

Complex colour mixing

Colour mixing often daunts the amateur artist. Here's how one artist goes about recreating the many colours she sees.

Colour mixing is one of the most fundamental techniques of painting, but you won't find much written about it in art books. This is because, quite simply, it is something you have to try for yourself. You can read about it all you like, but you'll never get a feel for it, nor understand it, unless you actually do it.

Some colours – such as viridian – are very strong, and need to be added to a mix only in very small doses to have an effect; other colours, such as terre verte, are relatively weak, and can be added more generously. You'll only really understand these things by experimenting.

Having said this, there is a certain logic involved in colour mixing which you can pick up by studying how other artists work. In the demonstration which follows, our artist mixed some very complex colours. These would be difficult for you to duplicate exactly, but it is interesting to see how the artist went about recreating what she saw.

Start with the nearest colour you have to the one you want to mix, then tint it with tiny amounts of your other palette colours. Keep modifying the mix until you get the colour you want – you may even come across some surprising but appealing mixes along the way. If you've added far too much of one colour to your mix, the simplest thing is to start again – even experienced artists mix colours which don't turn out as expected.

It's also important to remember that there can be many ways of mixing the same colour – experienced artists can mix up more or less the same colours from two different palettes. So if you haven't got the tube of paint you think you need, or the same colour that one of our artists used, then don't panic – just try the mix using the alternative colours on your palette.

▼ Mix A is the deep red of the chenille rug; our artist based it on alizarin crimson with a just little ultramarine and sap green added.

A

◀▼ B is a dark, purplish brown mixed from black, sap green, alizarin crimson and ultramarine; C is a leafy green based on sap green, Prussian green and lemon; and D, the rich green on the rug, is mixed from viridian, yellow ochre and a little cadmium lemon yellow.

B

C

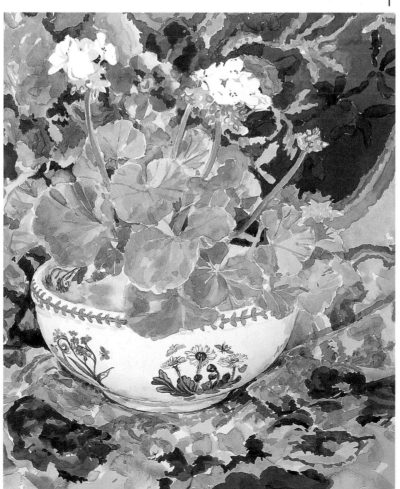

D

White geraniums in a white bowl

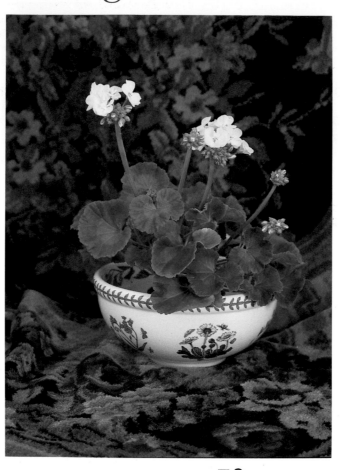

Our artist is inspired by the decorative qualities of Edouard Vuillard's paintings (he lived from 1868 to 1940). So to capture a similar feel of pattern on pattern in her painting, she chose a highly ornate flowery chenille rug as the backdrop for a still life of white geraniums. The idea of combining fresh, painted and woven flowers in the same still life also appealed to her.

◀ **The set-up** This set-up of white geraniums in a white bowl against a vibrant background created an interesting challenge. In pure watercolour white items are left blank, with perhaps a light wash for shading, so the artist had to paint them by putting in the colours around them – painting the negative shapes.

Another problem was that plants change during the day, and certainly over the course of several days. Since it is difficult to adjust watercolour, the plant was left until the second day.

▼**1** Our artist started without a preliminary pencil drawing; try this for yourself. With the No.3 round, indicate the shape of the bowl in a very thin neutral wash – ultramarine, raw sienna and a little alizarin crimson. Add more blue for cooler, darker tones at the bottom of the bowl.

The ellipse of the bowl must be correct, so work carefully and slowly. Probably no one will notice if the plant leaves are out of proportion, but it will be glaringly obvious if the bowl is wrong.

Now plot the colours on the chenille rug. You judge the shape and size of the bowl by the positions and sizes of the patterns on the rug.

▼**2** Continue working on the chenille rug around the bowl. For the dark green on the rug try a mix of sap green, yellow ochre and cadmium yellow deep with a touch of alizarin crimson. Use viridian/raw sienna for the brighter green, adding cadmium lemon yellow for the palest green.

For the reds on the cloth start with alizarin crimson/ultramarine, removing colour with a clean, wet brush if it's too strong. Add cadmium red for warmer shades. For the orange on the left of the bowl, add cadmium yellow deep to the warm red mix.

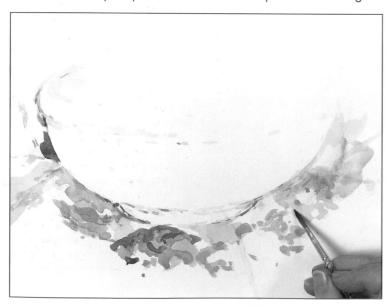

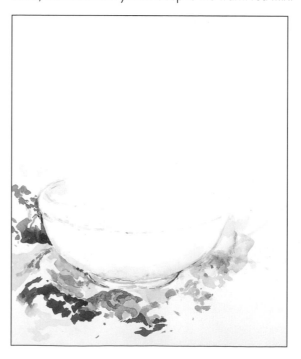

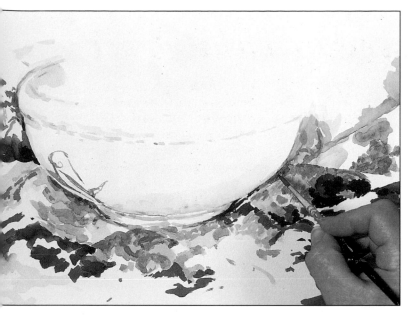

◀ **3** Ultimately you will show the curving form of the bowl by the careful positioning of pale shadows and by the angle at which the motifs are placed. At this stage our artist tentatively put in some leaves on the left motif. See how it makes the bowl curve under. Use a thin mix of cerulean blue, raw sienna and ultramarine for this. Apply the same wash, thinned with more water, to shade the centre bottom of the bowl.

Tidy up more areas of the rug which touch the sides of the bowl. Here our artist is using a green mixed from yellow ochre and viridian, lightened in some places with cadmium lemon yellow.

▶ **4** Now turn your attention to the daisy motif, painting it with careful precision. Draw in the leaves first with the tip of the brush, then fill them in using a dark green mix of sap green and viridian tinged with alizarin crimson for the darkest areas.

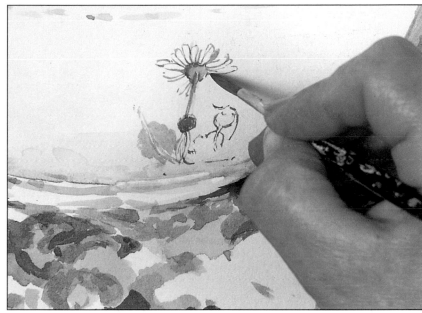

▼ **5** Work up the daisy motif to its finished state and put in the butterfly above it with a mix of alizarin crimson and cerulean blue. Our artist painted the motif very accurately – both to show the shape of the bowl and to emphasize the contrast between the painted flowers and the real ones in the bowl.

At this point the picture was left overnight to give the whole of the following day to work on the flowers and leaves.

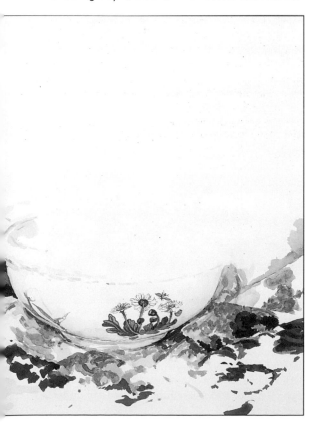

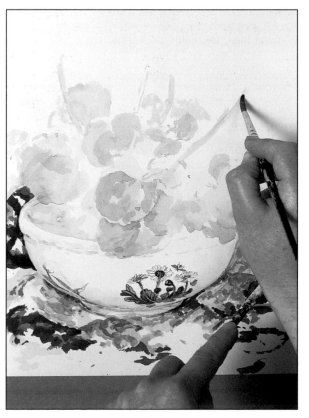

◀ **6** Mix a dark brown for the pattern to the left of the bowl – use black, sap green, alizarin crimson and ultramarine. Add a pink mix made from rose madder and cadmium orange and use neat alizarin crimson for a deep red. Add grey shadows inside the bowl with a thin mix of raw sienna and French ultramarine.

Now work on the leaves with the No.5 round, using watery mixes of sap green, Prussian green and lemon, and adding other colours for variation where necessary. (Place your drawing board flat for this so the paint doesn't run down the picture.)

Overlay some areas with more green to give the leaves greater depth and form. Lightly stroke in the flower stems.

7 It's often better in watercolour to paint your subject by putting in the negative shapes around it. Our artist used a mix of alizarin crimson, ultramarine and a touch of sap green behind the flowers on the right, leaving the leaves and flowers blank.

If you do paint the positive shape, start with pale washes so any errors can be modified. Here our artist first put in the stem on the right in pale green, then repositioned it by painting the negative shapes in her red-blue mix to push it farther to the right. She refined this new position with an even darker red-blue mix. Use a clean, wet brush to soften the colour at the top right.

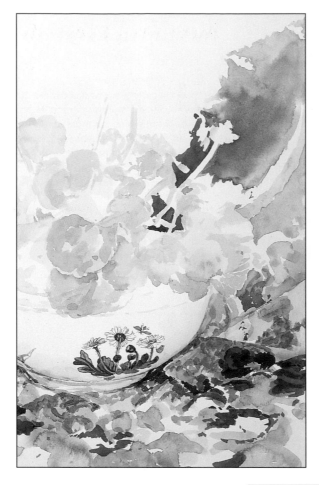

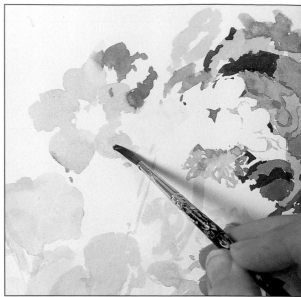

8 Work your way across the picture behind the flowers and leaves with a thinner wash of the red-blue mix. Use a mix of cerulean blue, ultramarine and Prussian green for the blue at the top left of the picture, and cadmium yellow laid over alizarin crimson to make an orange (see below). Here our artist is using the thin red-blue mix to put in a flower on the chenille rug.

9 You can see how the pattern on the cloth is building up, enabling the bowl, flowers and leaves to take shape. Use a mix of cadmium yellow and alizarin crimson to make the orange colour on the right, with pure cadmium yellow in the centre.

Work up the leaves a little more with a mix of sap green and orange for the warm green of the flower buds. Try using the No.5 brush when you paint the far leaves to create larger, more general brushstrokes.

Put in the dark brown near the top of the composition with a mix of black, burnt umber and Prussian blue. This helps to keep the rug back behind the flowers.

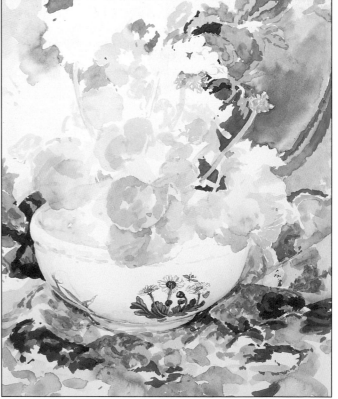

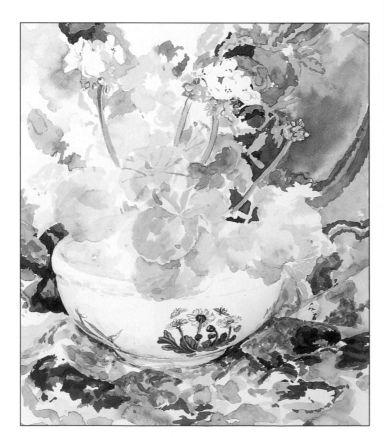

10 Continue to work on the leaves, flowerbuds and flowers, again putting in the colours of the background cloth to bring them into relief. Use the point of the No.4 brush and a mid-green wash to stroke in the leaf vein pattern on one or two of the leaves in the centre. Use a strong wash of cadmium orange and rose madder to dot in the flower centres.

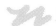

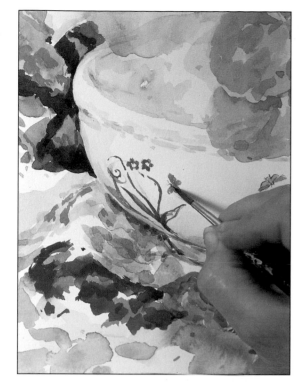

◀ **11** The motif on the left of the bowl has been neglected for a while, so finish it with the No.3 brush, working carefully to darken the leaves with a dark leaf mix. Put in the petals with cerulean blue and use the same colour for the butterfly. Use the red-blue mixes for the pink flowers (see step 12).

Still working carefully with the tip of the brush, put in the pattern on the rim of the bowl with a deep brown made by mixing rose madder and sap green.

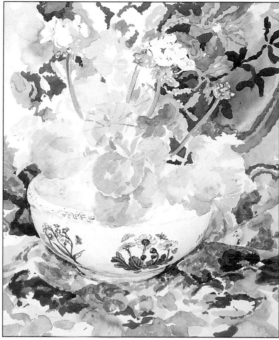

◀ **12** Return to your deep mix of black, burnt umber and Prussian blue for the dark patterning on the rug behind the flowers. Also carry on developing the leaves – at this stage you should be working on all areas of the picture so you can bring them all up to the same finish.

▼ **13** Fill in the pattern on the rim of the bowl with a mid-green mix. Now use your red-blue mix of crimson, ultramarine and sap green to enrich the colour on the right. Balance it by using the same mix in the centre, the left and the bottom right of the composition.

Since watercolours dry lighter, you may wish to go over some areas to darken and enrich them. By strengthening the colours at the back you are creating a rich and vibrant backdrop which throws the flowers and bowl into greater relief.

▶ **14** In step 10 you put in the leaf veins on two of the leaves. Now put in some more, this time by painting the negative spaces around them with strong greens.

Use a wash of cerulean blue and raw sienna for the greyish colour on the top left of the rug. Then mix up a rich, dark green-black from sap green and alizarin crimson for the black areas on the rug. Paint this carefully around the flowers on the left, sharpening up the shapes of the flowers at the same time.

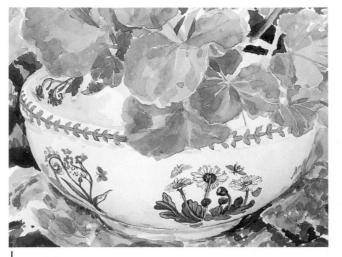

▶ **15** Work up the pattern inside the bowl. This is in shadow, so it shouldn't be as fully resolved as the motifs on the front. Use fairly neutral mixes from your palette for these. At the same time, darken the tone inside the bowl to invite the eye in.

▶ **16** Fill in any remaining white areas on the rug – the only white in the painting should be on the bowl, the flowers and a few highlights flickering over the geranium leaves.

Our artist put a wash of lemon yellow on the lower left of the rug and a dark brown mix of alizarin crimson, Prussian blue and sap green on the lower right. Put more colour on the leaves if you think they need it.

▶ **17** In the final picture you can see how well the artist has rendered the shape of the bowl – all done by putting in the elaborate pattern of the rug around it and by carefully depicting the floral motifs so that they follow the curve under the bulge of the bowl.

Notice the interesting contrast between the three types of flowers in the picture which first attracted our artist to the set-up. The loosely applied colour on the rug suggests a rich abundance which contrasts beautifully with the tightly illustrated motifs on the bowl and the freshness of the geraniums.

Another aspect of the composition is that of pattern on pattern. While it is possible to separate out the different elements, the picture also reads as an all-over surface pattern.

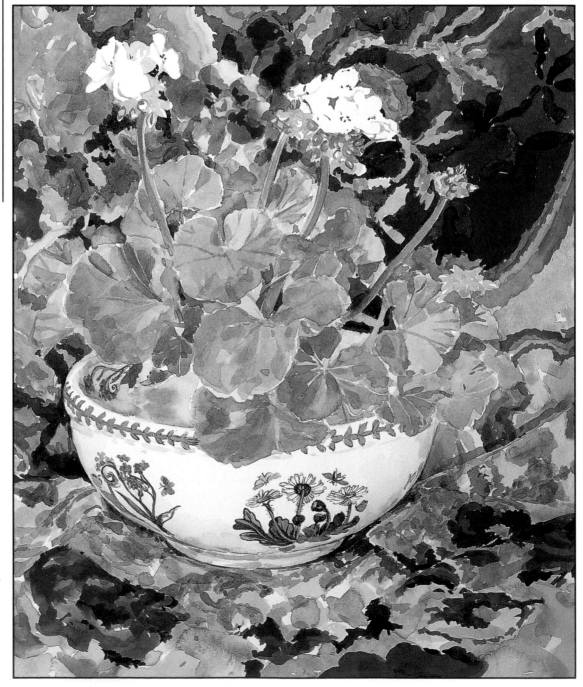

East coast seascape

Wet, wet, wet – join our artist as he takes a 'family' of washes for a day down by the sea and find out how you can bring a breath of fresh air to your own watercolour paintings.

In this project our artist uses variegated washes as the basis for a misty seascape.

The broad plan was to work wet in the early stages, allow the washes to dry and then build up some structure by working wet-on-dry.

The secret to this approach lies in the washes. It is important to execute them quickly but thoughtfully – be ready to respond if a new colour suggests itself and apply it while the paper is still wet enough to move the paint about.

As the paper dries, the paint becomes harder to manipulate – so in a sense, water is your ally. However, if the paper becomes too waterlogged, you'll find the paint almost impossible to control. It's all a matter of striking the right balance.

Have a go at the following exercise. Use good quality, heavy watercolour paper and prepare all your washes beforehand (see steps 3 and 4 – working wet, you need to paint in the washes as quickly as possible).

For the early stages you need to apply the paint with what our artist calls 'reckless abandon'. For this you have to be mobile and you might find it helpful to stand. The wet-on-dry moves at a much more sedate pace and requires a steady hand. So for this you can sit down.

Finally, it's worth noting that our artist's mixes are variations on a theme – often containing one or more of the same colours. This means that the colours knit together naturally, none of them jumping out – something to bear in mind when you are mixing washes for your own subjects.

▼ There's always more than one way to tackle a subject. Here our artist masked out the light areas, laid washes and then crisped up the picture with some wet-over-dry. But equally he might have chosen to apply body colour for the light areas later or painted in an entirely different medium – oils perhaps. The important point is to plan your campaign carefully and then carry it out. *'The Millpond, Tickhill' by David Curtis, watercolour on paper, 13 ½ x 20 ½in*

Staithes from the Cleveland Way

Staithes is a fishing village on the coast of North Yorkshire and at the turn of the century it had its own group of artists – The Staithes Group. The group consisted of twenty or so members who painted in the English Impressionist style.

Our artist knows Staithes well, but up until this time he had only painted it once before – in oils. Here he uses a snapshot to help jog his memory. Your own holiday snaps might serve equally well for a similar picture.

YOU WILL NEED

- A 20 x 40in sheet of 300lb Arches NOT watercolour paper
- A 3B pencil
- Sponge or a polisher's mop
- Masking fluid and an old brush
- Three brushes: Nos. 12, 8 and 5 round
- Nine watercolours: cerulean blue, cobalt violet, yellow ochre, raw sienna, cobalt blue, permanent magenta, light red, Indian yellow and cadmium red. (You could also add viridian as a short cut to a clean, blueish green.)

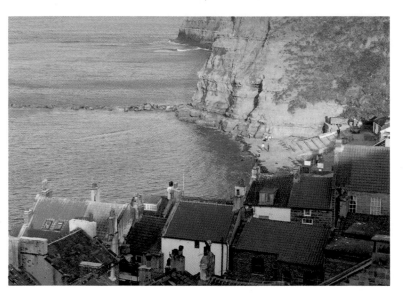

◀ **The set-up** Choose a subject in which you can see an obvious application for the variegated wash technique. This view of Staithes from the Cleveland Way inspired our artist's painting. Flat areas such as the sea and soft forms – such as the cliffs – are obvious candidates for wet treatment, but you can also extend the approach to the more definite forms of the buildings.

Our artist found the large triangular shadow across the foreground particularly interesting and you'll see how he uses it in his composition.

▶ **1** The general plan is to cover the paper with very wet paint and work back into it when dry.

Underpin the whole thing with a careful pencil drawing first. You'll find it serves not only to demarcate areas for masking out but acts as a guide for your washes and overpainting too. Use a soft pencil such as a 3B and draw lightly so you don't bruise the paper. Take your time to make a good drawing.

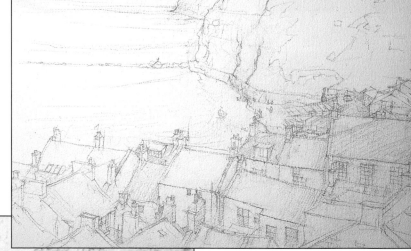

◀ **2** Now mask out any areas you want to keep white. A few of the walls, chimney stacks, window frames, distant figures and boats and flecks of rock along the waterline will benefit from fresh treatment on pristine paper later (see step 7).

Keep the edges of buildings straight and crisp. Make sure the masking fluid is completely dry before the next stage.

◀ 3 (Prepare your washes for this part beforehand. Once you start you need to work quickly.)

Wet the whole surface of the paper with a sponge (our artist used a polisher's mop). Then, using the No.12 brush and working from the top, apply your washes.

For the sea, our artist used cerulean with a little cobalt violet. For the cliffs and beach try yellow ochre with a touch of cerulean; for the warm shadow in the sea drop in a little raw sienna. The main ingredient, throughout, though, is water.

Keep the brush well loaded – don't worry if the colours run.

▶ 4 You can encourage the colours to run by tilting your board – as our artist has. Be ready to pop in new colours quickly when you see an opportunity. For the pantiles on the roofs try warm colours – yellow ochre with a touch of cerulean (the roof on the left) and raw sienna with permanent magenta (the roof in the middle) – and then, bearing in mind the shadow, dip back in here and there with a cool colour such as cobalt blue.

If the paint starts to spread outwards rather than down (starts to 'tree'), then you're getting about as wet as you can go and that's the point to lay off. The whole lot should take no more than two or three minutes to complete.

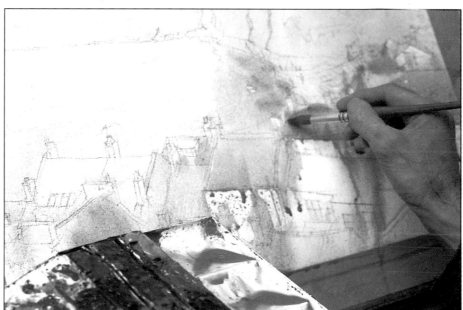

◀ 5 The colours come into focus rather like those in a Polaroid snapshot. As they merge, you'll see (to your dismay) some lovely effects vanish before your eyes, while exciting new ones come into being. The process is random but you do have a degree of control which you can develop with practice.

As the paint dries, revisit some areas with another wash – a blue-green such as viridian on the roof on the right here, for example. (Squint at the picture and you can already see the shadow across the foreground.)

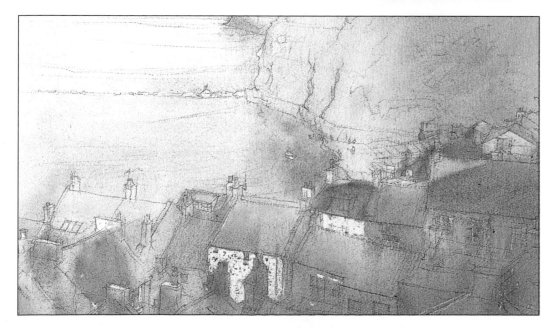

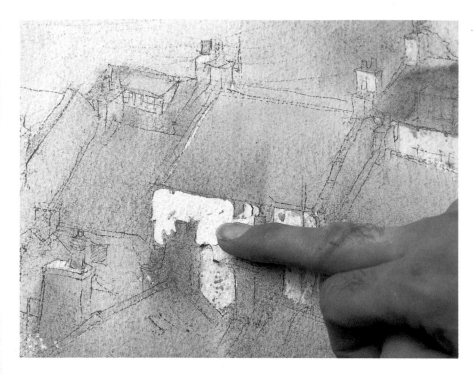

6 When the washes are completely dry, rub away the masking fluid. (You can see that the colours dry much lighter.) Cobalt blue over the yellow ochre on the roof to the left gives a rather good grey. By comparison, the raw sienna/permanent magenta in the middle looks much warmer – as does the yellow ochre roof on the right.

Notice too how the quality of the pencil drawing appears under the paint – not too obtrusive, still satisfyingly crisp and tight enough to hold together the washes.

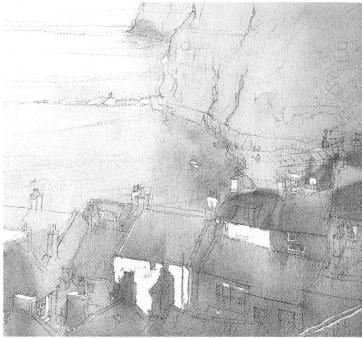

7 After all that frantic activity, it's rather reassuring to be able to return to dry paper, subdued neutrals and tranquil whites. Our artist says that everything is won or lost in the early stages and if you are happy with your washes, the rest is mostly a matter of careful observation and steady painting. Look for the largest area of midtone – in this case the sea – and start with that. This should provide a tonal 'key' for the rest of the painting.

8 Now, using the cerulean/cobalt violet mix, work back into the sea with the No.12 brush. Overall you might grade the tones from light at the top to dark at the bottom, say – depending on your own subject – but in any case, leave a few breaks so that the first wash shows through. These provide crisp shapes (here, waves) and add interest. For the warm reflection of the cliffs, drop in some raw sienna.

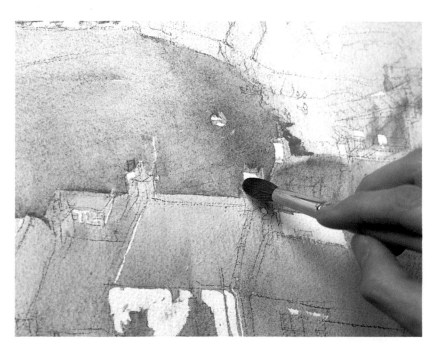

9 Seas can be rough or calm and vary in colour depending on the time of day and the colour of the water and sky. The North Sea is usually thought of as grey but here the sky is clear, the water quite blue and its surface untypically calm (see set-up). You might try a little drybrush work here. Let the previous wash dry and then, using a No.8 brush, stroke on some cobalt violet.

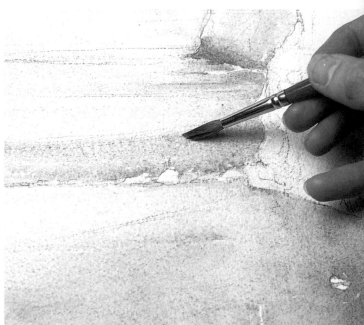

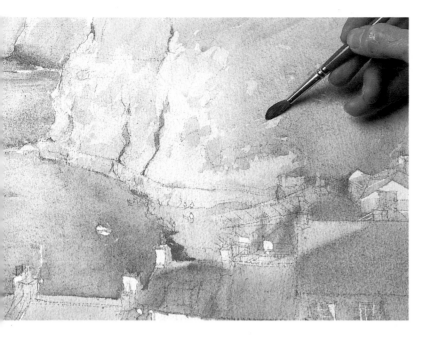

◀10 Yellow ochre and cerulean make a natural-looking green which is perfect for the grass on the crumbly sandstone rocks. By dabbing on the paint using the side of your brush, you can create a texture that approximates closely to tufts and patches.

For the darker areas, try a blue-green mix (or viridian) and raw sienna. Pick out the crevices in the rocks with a plummy mix of raw sienna and permanent magenta with a little cobalt blue.

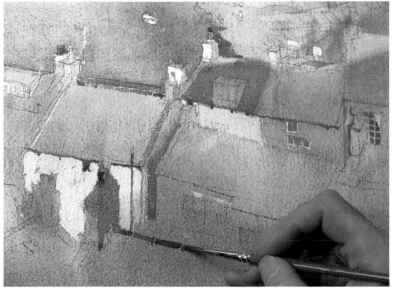

▶11 Before starting to work back into the buildings, our artist put a steely blue wash right across the diagonal shadow in the foreground. If you decide to follow suit, try a dilute mix of cobalt blue, raw sienna and light red.

Crisp up the edges of the roofs (so they don't look quite so woolly) by painting in the ridge tiles and gable ends. For this, use a mix of cobalt blue, raw sienna and permanent magenta and a smaller brush – such as a No.5. While you are about it, paint in a few of the windows too.

◀12 Compare this stage with step 7 and you can see that the colours – hues – have stayed pretty much the same. The tonal values, however, have changed.

Overall, they are darker but the darks in the buildings are stronger than those in the sea and cliffs. Notice too that the lightest tone – the wall of the house – is also in the foreground. In other words, the greatest tonal contrasts are in the foreground which, due to the effect of aerial perspective, is what you'd expect.

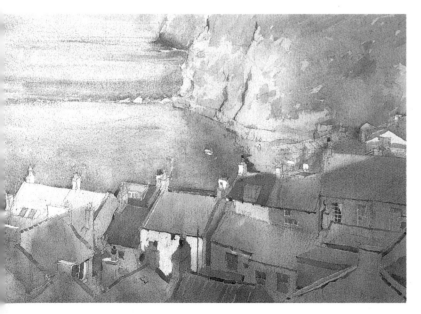

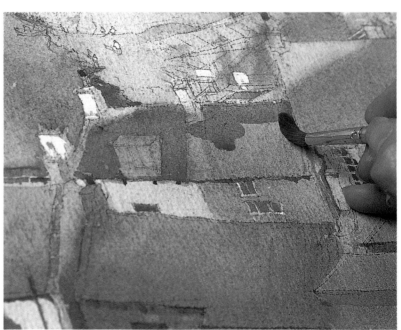

▶13 Now bring up the colours to their full value. For the amber roof here, try a mix of Indian yellow and cadmium red. For the one our artist is painting, add more cadmium red and a little cobalt blue to the mix. It's surprising what a varied range of colours you can produce by changing the proportions of the mixes. One of the beauties of this approach is that because the colours are related, they tend not to fight with one another.

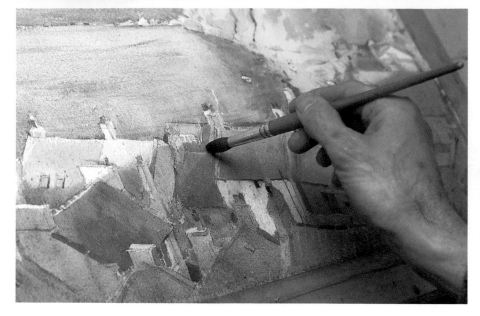

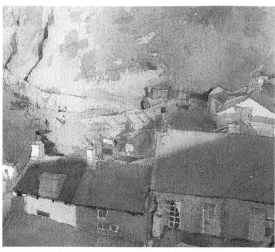

▲**14** Our artist says that when painting shadows, you should make them of a colour that is related to the true colour of the object. He calls the true colour 'the parent colour' and says that the shadow should 'honour the parent colour'. The roof here is the same colour as the roof to its right (raw sienna/permanent magenta). So for its shadow you might add a bit of cobalt blue to darken and cool the mix.

▲**15** The distant figures give a sense of scale and depth. Since they are so tiny you can afford to drop in some pretty pure colour (raw sienna, say) to draw your eye. You might, as our artist has, leave parts of the clothing white. Don't forget to put in the shadows.

▼**16** To complete his painting, our artist decided to put another glaze (a transparent wash) over the shadow in the foreground. You'll have to judge for yourself whether your own picture needs similar treatment. For this, our artist recommends cobalt blue. This is a reasonably transparent paint, so it cools the colours underneath without muddying them.

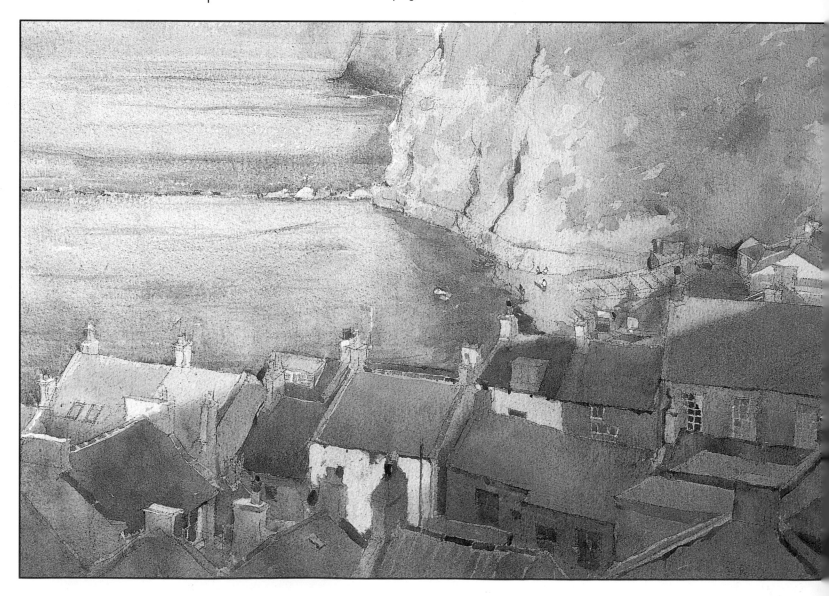

Building up colour: still life

For deep yet translucent colour, try building up successive layers of watercolour. The secret, if you want to avoid dull, dirty colours, is to use many thin washes.

Working up a watercolour is often a recipe for a dull and over-wrought painting. However, if done well it can add a sense of weight and solidity to your painting.

Our artist used many washes for a stunning still life without losing the freshness associated with watercolour. Very watery paints produced an exciting combination of wet-on-dry and wet-in-wet effects. She used wet-on-dry paint to define the basic shapes of the objects and put in the detailed work, and wet-in-wet washes to produce rich, voluptuous colours.

You can see the best examples of wet-in-wet on the plum and uncut pomegranate skins. The colours run into each other, creating subtle tonal changes which perfectly describe the rounded fruits. (Note the merging of the yellows, oranges and reds on the uncut pomegranates.)

The loose handling of the paint also allows you to introduce reflected colours without their appearing forced or contrived. On the nearest uncut pomegranate, for instance, there are deep violets and olive greens. And a deep red has been

used on the nearest plum to indicate the reflection of the wine and pomegranates.

Care and precision, though, are the watchwords when working wet-in-wet in such an intricate still life. On occasion, you'll need to blot out surplus paint with a clean cloth. If you find that hard edges appear, work them out with a brush dipped in clean water. And, most importantly, make sure you use very thin paint – otherwise the colours will become muddy.

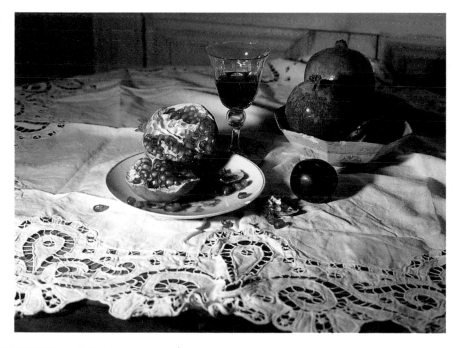

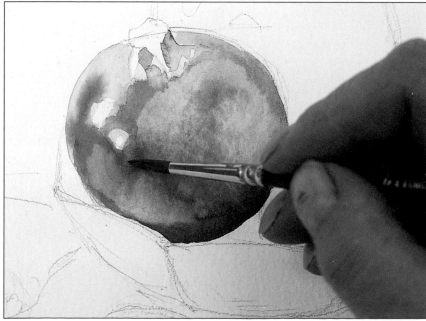

▲ **The set-up** Our artist took some time choosing her objects. The ornate lace tablecloth, the china plate and bowl and the wine glass demanded a precise and light touch. The fruit, on the other hand, offered deep colours which allowed the artist to experiment with wet-on-wet techniques. Cutting one pomegranate in half provided some interesting detail.

◀ **1** Draw the set-up in pencil, including the outlines of the highlights to remind you to leave them white. Start on the dominant pomegranate using the No.5 brush and watery washes of alizarin crimson. Then add washes of yellow ochre, burnt umber, cadmium orange and crimson lake. Apply these washes wet-in-wet, so they merge into one another. Use ultramarine-violet at the base of the pomegranate to indicate colour reflected from the plums.

YOU WILL NEED

- [] *A 20 x 16in sheet of NOT 240lb watercolour paper*
- [] *Drawing board*
- [] *A 2B pencil*
- [] *An eraser*
- [] *Two jars of water*
- [] *Tissues*
- [] *Five watercolour brushes: Nos.00, 1, 3 and 5 round, and a ½in flat*
- [] *Sixteen watercolours: cadmium yellow, raw sienna, burnt sienna, yellow ochre, cadmium orange, cadmium red, scarlet lake, crimson lake, alizarin crimson, alizarin carmine, ultramarine-violet, cobalt blue deep, viridian, raw umber, burnt umber and blue-black*
- [] *Permanent white gouache*

▶ **2** Paint thin, initial washes on the other items. Mix yellow ochre, burnt umber and a touch of alizarin crimson for the skin of the large piece of pomegranate, and alizarin crimson with burnt umber for its flesh. The skin of the small piece is in shadow, so add raw sienna over a wash of alizarin crimson/burnt umber.

Mark the rim of the glass in burnt umber and use crimson lake for the wine. Start with ultramarine-violet for the front plum and then add crimson lake. Use pure crimson lake for the red reflection on the top. Brush clear water in a curved line to create the plum's crease.

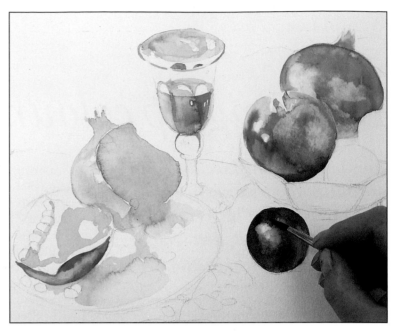

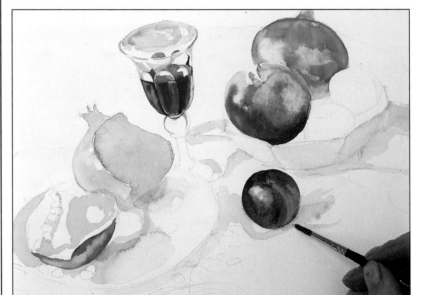

◀ **3** Build up the wine using a mixture of crimson lake and cadmium red. Add a small wash of cadmium orange on the facet of the glass facing the pomegranate halves. Mark the angles of the glass with a touch of blue-black, using the No.1 brush.

Next add some shadows to the tablecloth. Use the No.5 brush and a weak wash of burnt umber, adding some watery ultramarine-violet to this wash when working around the plum.

▶ **4** Now paint in the seeds of the pomegranate in alizarin carmine with the No.00 brush. Start with pale washes, then work over some of these with less dilute paint to define the shape of the seeds and emphasize the highlights in the centre. Use pale burnt umber with a touch of alizarin carmine for the cavities without seeds.

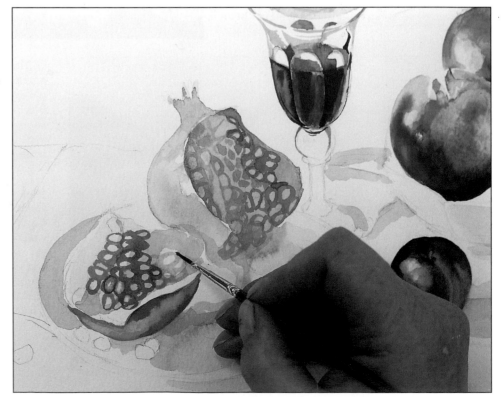

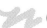

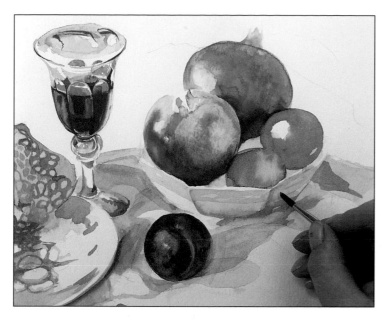

◀ **5** Intensify the shadows on the tablecloth with further washes of burnt umber and then with ultramarine-violet. Also use some ultramarine-violet to put in the initial washes on the plums in the bowl. Use greys from the shadow washes to paint the stem of the wine glass.

Apply strong, dark burnt umber to the plate to indicate the shadows cast by the fruit, and dilute viridian to pick up the colour on the china bowl.

▶ **6** All the objects are now in place, so it's a good time to stand back and assess the colour and tonal values.

Our artist decided that the pomegranates required more washes to emphasize their rich colours and that the plums would also need work. Remember that the colours will dry lighter.

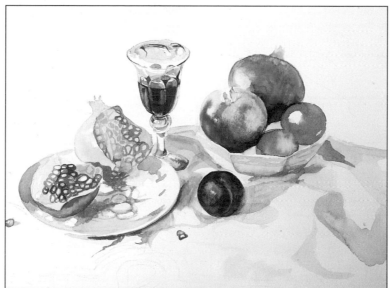

Tip

Rubbing out
Pencil lines look obtrusive in this type of delicate watercolour. So once the paint is established, begin

erasing the drawing gently with a kneadable putty rubber or eraser. You'll find that you can even remove the pencil lines underneath dry washes.

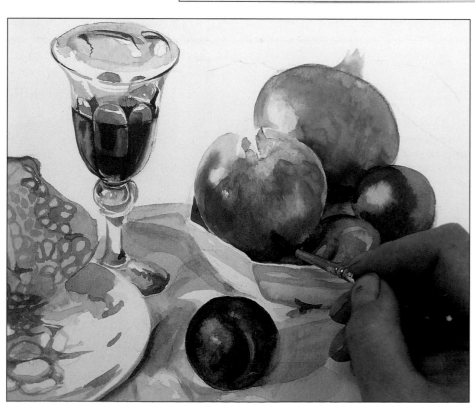

◀ **7** Use the No.3 brush to add a pale wash of alizarin crimson to the uncut pomegranates. Re-wet the underlying washes with a damp brush so the new colours 'sit down'.

Apply another wash of ultramarine-violet on the plums, and also add a wash of cobalt blue deep on the front plum. With the No.00 brush, apply a mix of cobalt blue deep and viridian to the inside of the bowl.

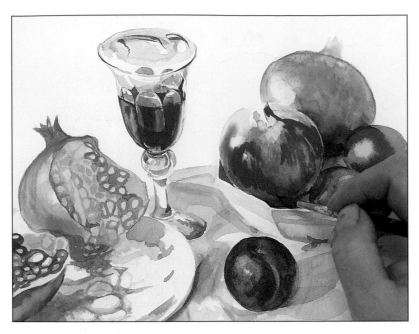

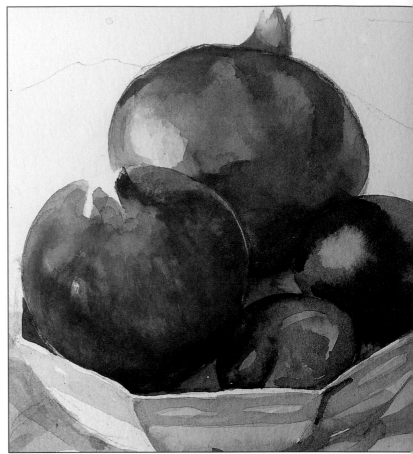

8 Work on the skins of the pomegranate halves with yellow ochre, cadmium yellow and your warm red mixes.

Add a strong cadmium red wash to the pomegranates to capture their inviting, shiny surface. This colour now gives the pomegranates as much 'weight' as the wine in the glass.

9 Make sure the highlights on the fruit aren't too sharply defined. Use a piece of paper tissue or paper towel to take back some of the last layers of red so that you attain a seamless sequence of tones from white to gold to deep red.

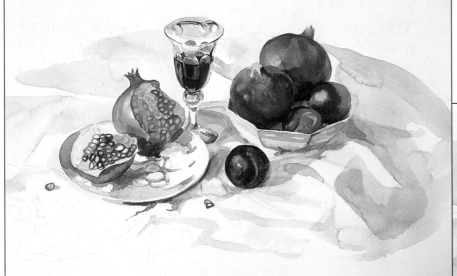

10 Step back and review the painting. The next stages are to build up the detail of the cut pomegranates, and put in some of the intricacy of the lace pattern of the tablecloth and the designs on the plate and the bowl. Paint the shadows and pattern on the plate with the No.00 brush and a mix of raw sienna, burnt sienna and ultramarine-violet.

11 Develop the plate using the same colours. Rework some of the seeds in the cut face of the pomegranate in scarlet lake, and add some loose seeds on the plate.

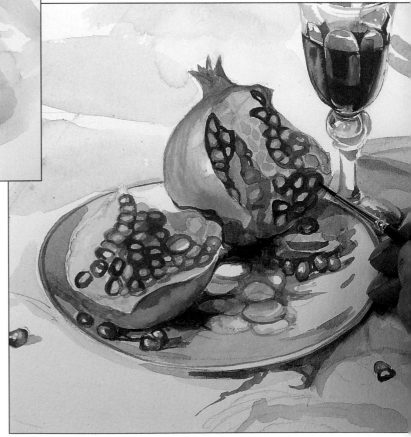

▶12 Continuing with the No.00 brush, paint the pattern of lacy holes in the tablecloth using burnt umber with a touch of alizarin crimson. Don't put in the complete pattern – otherwise it will compete for attention with the main subject. Vary the strength of the wash to show the different depth of the shadows underneath.

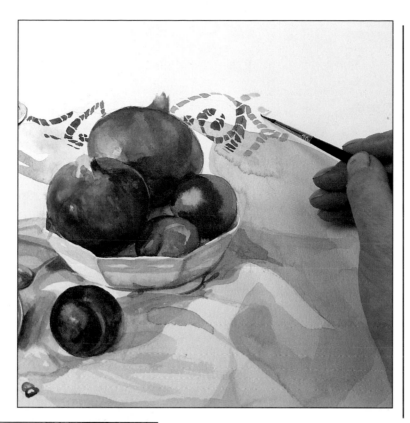

Tip

Smoothing out smudges
It's all too easy to smudge the foreground while concentrating on a detail in

the centre. Here, our artist smudged the red lace pattern, so she washed off the area with water and overlaid a wash of burnt umber. The mistake then becomes part of the shadow.

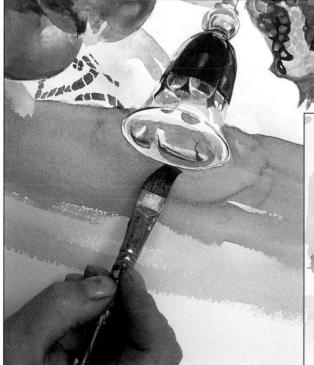

◀13 To help 'ground' the tablecloth, paint the wooden backdrop with a mix of raw umber and a touch of alizarin crimson. Use broad strokes with the ½in flat brush – this contrasts well with the detail of the still life. Turn the paper upside down to do this so you don't smudge the rest of the painting.

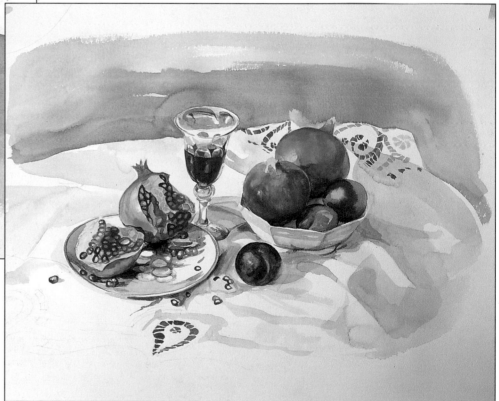

▶14 Turn the picture the right way up again. Add the loose pomegranate seeds in the foreground which help to strike a note of informality. Then put in the patterning of the tablecloth with scarlet lake.

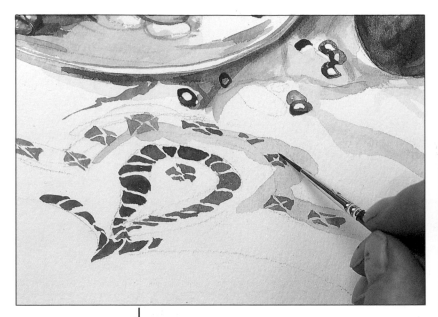

◄15 Continuing with the No.00 brush, paint in more of the foreground pattern, using alizarin crimson for the darker tones. Apply washes of watery blue-black over the cloth so it isn't too bright a white.

▶16 Now add a tiny touch of permanent white gouache to highlight some of the seeds. Note how this opaque paint invigorates the forms.

▼17 As a final touch, use the No.00 brush to paint some of the yellow pattern of the body of the bowl with a mix of yellow ochre and raw umber. Now move down to the foot of the bowl to paint the design there using a fairly thin mix of raw umber, raw sienna and alizarin crimson.

The finished painting reflects a pleasing unity between the reds of the pomegranate skins, and the wine and seeds. And the liberal use of the weak blue-grey washes on the tablecloth provides a gentle, recessive colour against which these reds really leap out.

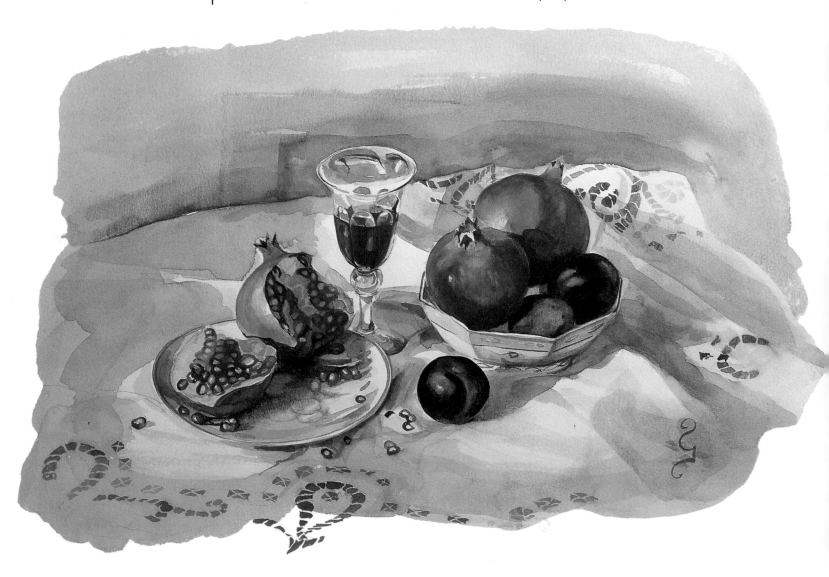

Controlled layering

Translucent veils of watercolour built up layer upon layer, produce a glowing result which cannot easily be matched in any other medium.

The strength and vibrancy of the colours in the stunning paintings shown on these pages give the pictures a wonderful freshness. And their transparency gives the images a great sense of delicacy as well as a feeling of weightlessness. To achieve these jewel-like colours, you need to build up the painting as a series of thin, transparent washes.

Our artist worked in this way for the demonstration here. She kept palette mixing to an absolute minimum, creating new hues on the paper by laying one veil of colour over another to make a third. Her working knowledge of colour theory enabled her to anticipate the way in which one colour modifies another, allowing her to work without fear of making indelible mistakes.

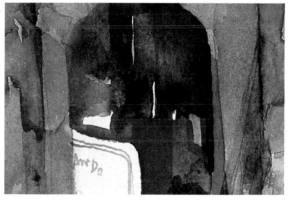

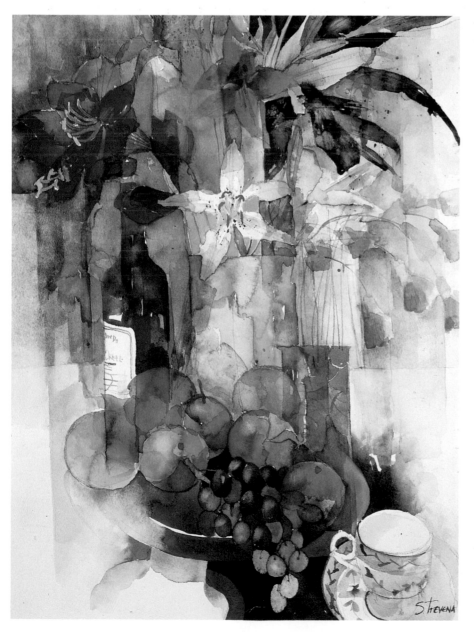

◀▲▼A series of colours built up layer upon layer on this wine bottle (above) produce variations of ruby red, giving an interesting, highly decorative impression of the depth of the liquid in the bottle. Notice how the wine label provides tonal and textural contrast and speaks volumes about the shape of the bottle.

In the detail below, the artist again uses a series of washes, this time to work up the form of the oranges. She makes no effort to conceal the perimeters of the washes, allowing them to dry as hard edges to form interesting patterns in their own right.

'Still life with grapes and oranges' by Shirley Trevena, watercolour on paper, 22 x 18in

Happy accidents

The technique of building up layers of pure, unmixed colour works well with a bold, spontaneous style. So experiment with a looser approach in which wet colours are allowed to run into each other. Unintentional marks and accidental runs of colour all enhance the delightful freshness of the painting. There are few areas of completely flat colour as our artist kept the rivulets and tidemarks of paint as attractive features of the finished picture.

Once you've applied the paint freely, you must then be ready to regain control of the painting before the washes get out of hand. With one colour flooded into another, you can manipulate the direction of the run to some extent with your paintbrush, pulling it over the side of an object – to hint at a shadow, for instance. Or you can direct it with a hairdryer or tilt the board, using gravity to encourage the direction of the run.

Another effective means of breaking up a large area of flat colour is to leave flecks of white paper showing through the paint. You can fill in the flecks with a contrasting colour at a later stage – a simple device which helps make a dull area flicker with vibrating colours.

▲▼► On the large leaves above, a broad run of colour has left dark deposits of pigment around the edges, creating a patch of mid tone and suggesting an intriguing mark on the right leaf.

The detail below shows how the flower at the base of the far apple was overpainted with the green of the apple. This shape provides a perfect shadow on the apple.

'Stephanotis' by Shirley Trevena, watercolour on paper, 24 x 20in

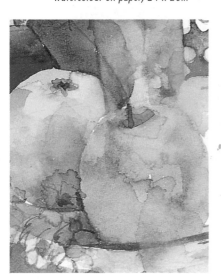

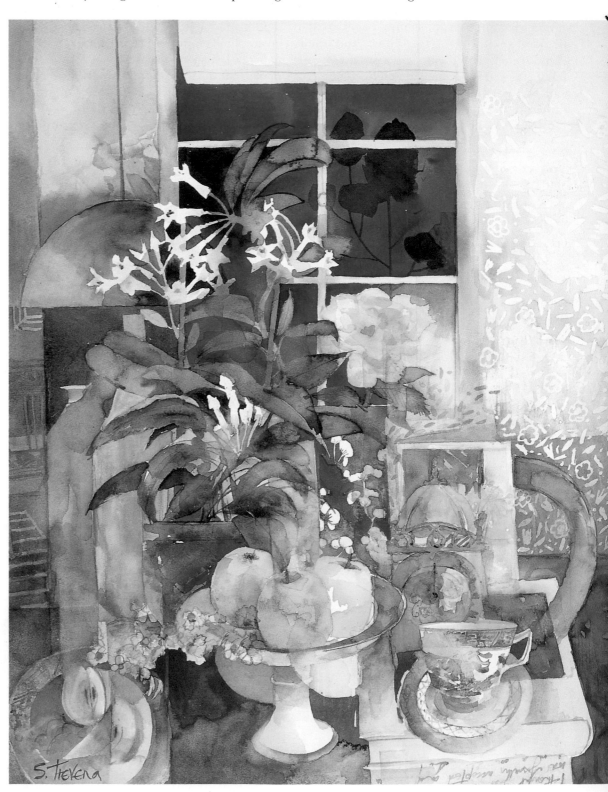

Decorative still life

In this still-life painting our artist has taken a little artistic licence – not only does she add an extra lemon and plum to improve the composition, but the perspective is deliberately distorted and flattened, with the point of view changing from object to object. The possibilities of this approach are endless, and this creative adjustment provides an innovative result.

If you work as our artist does, without a preliminary drawing, you'll find yourself making design decisions at every stage. This makes the painting process fascinating, but it does require a greater degree of sustained concentration, since you're not simply filling in an outline.

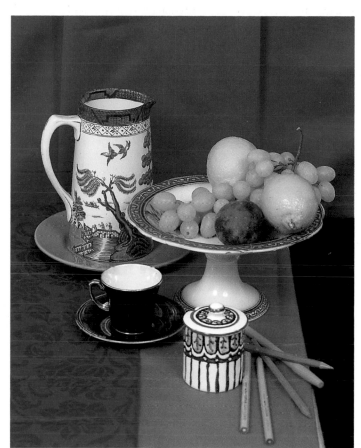

The set-up Our artist likes to start with one or two strong colours then chooses others to fit in. The plum and lemons were the starting points here, and all the surrounding objects were chosen to complement them.

Connecting links between the objects are as important here as the objects themselves. For instance, the two vertical folds in the blue background fabric and the angular shapes on the table top provide vital visual links between the rounded shapes which form the main part of the composition.

1 Work on a flat surface for this painting because this allows colours to pool more easily.

Using the No.8 brush, start by painting the shapes of the lemons in washy layers of gamboge, cadmium lemon and golden yellow. Paint one or two of the grapes in Sennelier brown pink. Blob in the warm shadows on the right side of the lemons with very dilute sepia. Dry the wet colours with a hairdryer, blowing the paint across the paper so the strongest colour collects around the edges of the shapes.

If you're working without a drawing, it's especially important to study the subject to check that everything is the right shape and in the correct place.

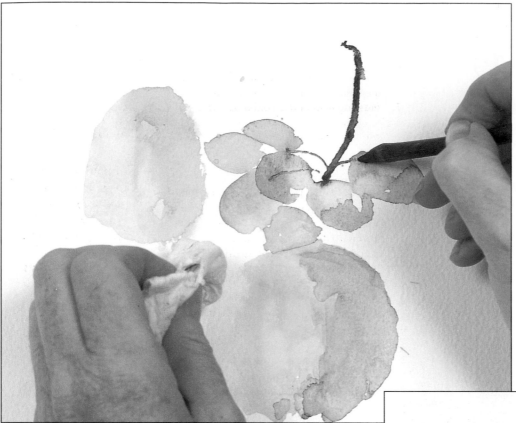

2 Paint a few more grapes in brown pink, then dab off some of the colour with a tissue to pull out the highlights. Add a few shadows with diluted Winsor violet mixed with brown madder alizarin. Next, draw the grape stalk in sepia using the sharpened twig. This rather unusual painting implement – which is excellent for creating natural jagged lines – is easier to use if the point is kept very wet.

3 Continue painting the grapes in brown pink, adding diluted strokes of permanent rose, sap green, sepia and yellow ochre to the wet shapes. The plum is painted in Winsor violet mixed with a little indigo. Leave white flecks of paper showing to represent highlights. Develop the lemons with the same colours as before, laying very dilute washes over them to mould their forms. Dot in the pointed end of the nearer lemon in sepia.

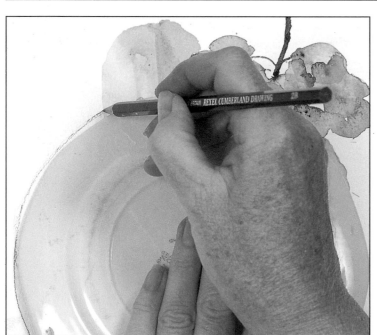

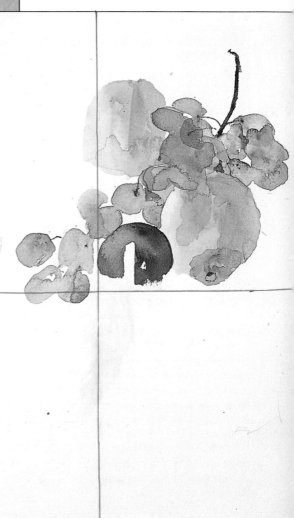

4 For the sake of composition, the bowl is interpreted as a round, flat shape. Our artist chose to represent it as if it were viewed from above because she liked the patterns and colours and wanted to show as much of them as possible. To make sure you get a perfect circle, draw in the fruit bowl with pencil, using an appropriately sized plate as a template.

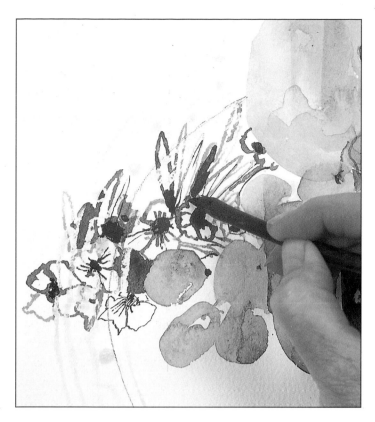

◀5 Mask out the rim of the bowl and the white shapes of the pattern with masking fluid and an old brush. Use the twig to draw the linear flower pattern on the bowl in a mixture of Winsor violet and indigo. For the finer lines change to the dip pen and blue water-soluble ink. Draw as loosely as possible and take the pattern a little outside the actual bowl area – this 'escaped' pattern will help break up the circular shape in the finished painting. Allow the paint to dry.

Dilute permanent rose for a pale wash and use this to make a broad vertical stroke with the side of the brush from the plum up to and over the grapes directly behind it. This darker tone suggests shadows.

Tip

Dramatic paint runs
If you're working very loosely with the paint, and the desired runs don't happen by accident, you can help them along by blowing wet colour across the paper with a hairdryer. This results in dramatic waves of rich, dark colour around the edge of a painted shape.

▼6 Stand back to assess the picture so you can make any necessary adjustments. Our artist added a second plum to fill an empty space on the fruit bowl. Still using the No.8 brush, dribble and drag clean water over the dried pattern to soften it a little. Now paint the part of the bowl around this pattern with cobalt blue, adding blobs of cerulean inside the bowl. When this is dry remove the masking fluid from the upper edge of the bowl.

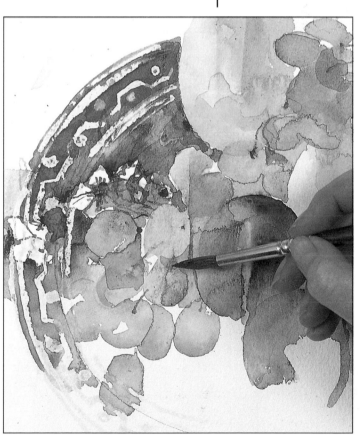

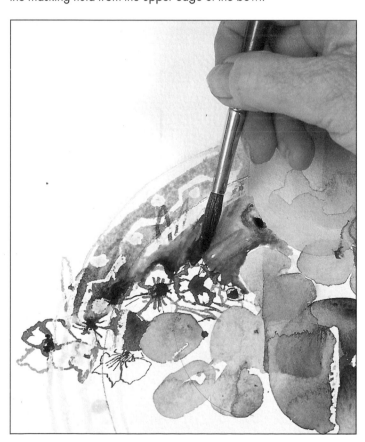

▲7 Next, develop the grapes with brown pink and yellow ochre. Drop some stronger colour into the wet paint for darker tones.

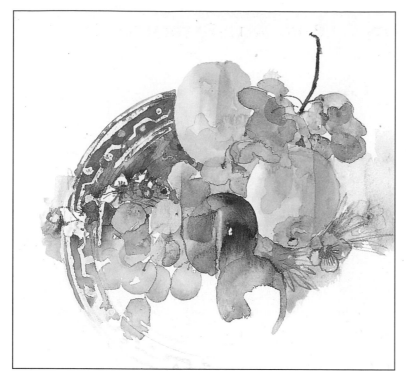

8 Work over the linear flower pattern on the same side of the bowl with clean water, softening it and taking it slightly outside the rim. Put in the lower part of the bowl with very dilute indigo. Paint the rim of the bowl to the right, and the foot of the bowl with a washy cobalt blue/Winsor violet mix (see below left). Once this is dry, drag broad stripes of diluted sepia downwards over the plums and through the lower part of the bowl.

9 Move on to the tall jug. Paint the top rim in pale sepia/indigo, then work back into this once dry with a stronger wash for the pattern. Draw the gold pattern with the twig and a yellow ochre/brown pink mix, keeping the lines spiky and irregular. Wash in a strip of the background to the right of the jug using the No.8 brush and a mix of indigo and cerulean.

Our artist now stood back to assess her painting; she decided to add another lemon to improve the background shape behind the fruit bowl. Paint this in with the same mixes you used for the other lemons.

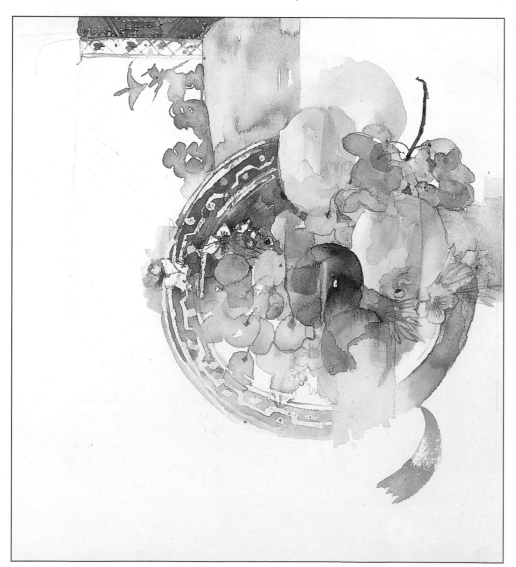

10 Continue to paint the pattern on the main body of the jug with the No.2 brush in loose strokes of indigo/cerulean. Wash over these occasionally with clean water to soften the pattern, then add touches of cerulean to indicate reflections from the bowl. Use the pattern of the jug as a starting point, letting your imagination lead the way to create exciting patterns.

▼**11** Continue painting the pattern on the jug with the same wash. When this has dried, dilute the wash a little and brush in some shadows, working right over the pattern where necessary.

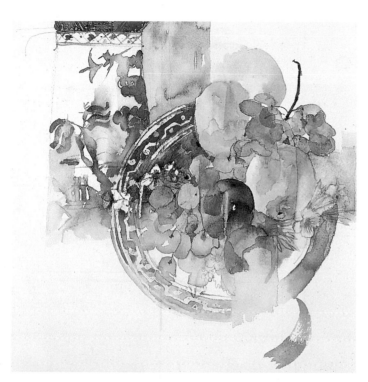

▼**12** Use indigo on the cup and thin sepia/yellow ochre inside. Paint the rim and handle in ochre. Indicate the fabric beneath the bowl with turquoise. Use the clean brush wet to echo the edge of the bowl directly next to the rim, lightening the underlying paint.

◄**13** Continue the cup and saucer with darker versions of the same colours as before, drawing the ellipse of the saucer in pencil first if you wish. Wash in the large shape left of the jug with the No.8 brush and indigo/Winsor violet/sepia. Paint the jug handle in a paler version of the background – leave flecks of white paper showing to lend sparkle to the large area of colour. Use dilute turquoise for the plate beneath the jug.

14 If you wish, use a pencil to establish the position of the small foreground pot, then start to indicate its colour in light washes of indigo and permanent rose. Draw the decorative pattern with indigo and the sharpened twig.

15 Put in the remaining background area with diluted washes based on turquoise, indigo and permanent rose. Work these in vertical bands, dividing the remaining background into three roughly equal strips. Work back over each band once the paint is dry for a darker tone, but don't aim for a flat, even colour. It will be much livelier and more interesting if it's varied.

16 The tone and colour of the foreground shapes are important. To avoid making an irreversible mistake and painting them the wrong colour, try cutting out variously coloured paper shapes – these can be cut out of old magazines – and laying them on the areas in question to see which colour suits the picture best.

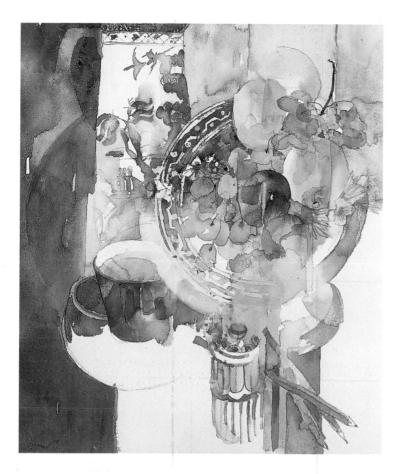

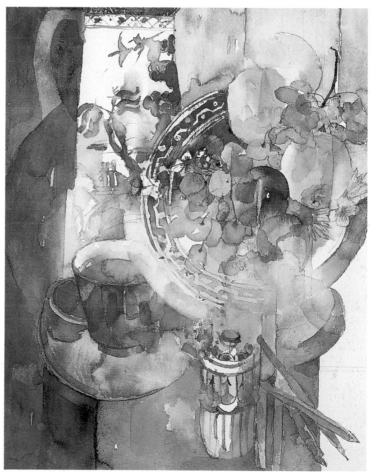

17 Paint a vertical band in the foreground left with a mixture of indigo and sepia, then paint the pencils in chrome orange, turquoise and sap green with sepia shadows. Start to paint the fabric beneath the pencils with turquoise.

Using the No.2 brush, develop the details on the foreground pot in orange, permanent rose, indigo and sepia. Once dry, remove the masking fluid from the closer rim of the bowl.

18 Finish painting the cup and saucer, then complete the foreground shape with loose washes of Winsor green and turquoise. Take some of this over the foot of the bowl.

19 Block in the two remaining foreground shapes on the right side of the picture. The narrow strip is painted in indigo mixed with cerulean; the outside shape is sepia and indigo with flecks of white showing through the paint. While the paint is still wet, dribble water over the newly painted area to create a dappled texture.

Finally, work back into the fruit if necessary, adding more layers of colour with the No.5 or No.8 brush.

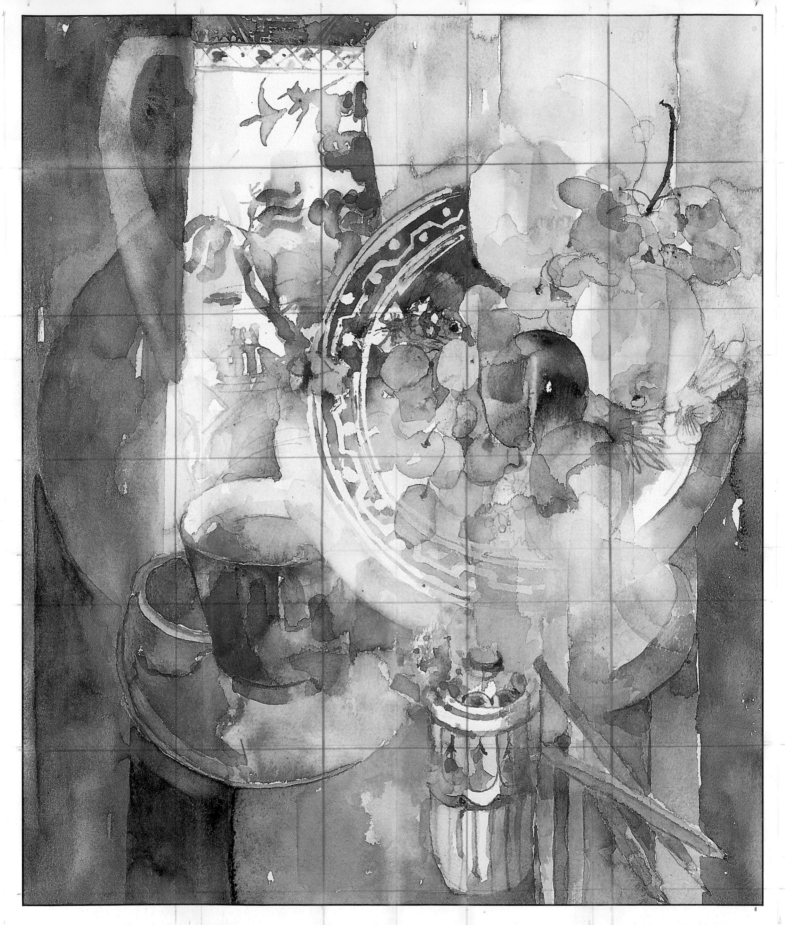

▲**20** The finished picture is a symphony of bright colours. Our artist has very successfully combined two very different feelings in one picture. She has achieved a wonderful sense of freedom with the brilliant colours, accidental runs and flares of colour, and the variation of colour and tone and speckles of white. But there are also the slightly abstract, angular shapes of the jug, cup and pot, the regular circles of the dish and saucer and the geometric bands of background colour.

Convincing colour sketching

Delicious watercolour washes can quickly suggest the human form. Try sketching directly with your brush to capture an immediate impression.

If you want to capture a slice of life on paper, you need to move pretty fast. Even a sleeping subject may move at any moment in slumber. Therefore, sketching is often a rapid process, in which you make quick decisions about your subject and then try to get it down on paper before it changes or vanishes altogether.

If you're not used to sketching with colours, you're likely to make some inaccurate judgments about tones. Like anything, it takes practice to get these right. Enticing local colours can distract you as you concentrate on mixing the exact blue-green of your sitter's shirt, say, instead of considering its tonal value.

If you find yourself falling into this trap, go back to the basics of tonal drawing – hood your eyes and assess the relative tones in your subject. Then when you mix the colour you want, compare its tone with those elsewhere in the set-up. The more you practice, the better your judgments will become, until you find you instinctively assess both colours and tones.

Always keep in mind that warm colours advance and cool colours recede. For instance, if

▼ Here, we get the impression that this girl is sleeping near a window, the warm sunlight illuminating her face and playing across her clothing. The bold use of primary colours gives warmth and brightness to the sketch.

Notice how the artist has flooded a pale blue-grey (perhaps Payne's gray) into the yellow fabric to suggest a slight shadow where the surface of the bed dips beneath the girl's legs. All these subtle changes in tone help to suggest form.

you want to convey the rounded quality of an arm, you could lay a wash of local colour over the whole limb, then use a cool hue such as blue to turn the sides of the arm. Our artist used green in this way on the arm of the toddler (left). And on page 77, she used a darker version of the colour for the girl's red top to indicate the shadowy creases. Notice the way she's used a deeper blue to indicate the form and bulk of the girl's thigh.

Watercolour sketching

Watercolours are excellent for colour sketching. They are light, portable, and you can work on a conveniently small scale. With just a few well-chosen colours, you have all you need to provide yourself with plenty of information about colours and tones – invaluable if you want to use your sketches for considered, finished paintings.

Traditionally, plain white paper is used for watercolours, and areas are left blank for the lightest tones or highlights. You can see this in the sketch on the left. But the paper is also used in quite a different way in the same sketch – it describes the white stripes on the child's T-shirt. So within the same image, white is used as both colour and tone. In the sketch below, the white paper creates yet another effect – it's used to suggest a pale flesh tone.

▼ The artist has captured the wonderful chubby cheeks of this young child. Small, well-observed areas of colour suggest the curves of the face and also hint at the colour of the skin. Notice how a light wash of blue on the wrap creates a cool contrast which brings out the warm colours of the face, hand and background.

▲ Here, the creases and shadows on the pillow and the shadows on the mask of the little boy's face all suggest the weight of his small head, and the way it sinks deep into the pillow.

Always make use of anything that helps you explain the form of your subject. Here the artist takes advantage of the pattern on the T-shirt, using the stripes to convey the rounded bulk of the torso, giving fullness and solidity to the body.

Local or reflected colour?

This artist displays excellent handling of the flesh tones of her sleeping children. She doesn't use a series of pale, pinky hues as you might expect, but instead opts for some surprising, but interesting mixes. Look at the sketch at the bottom of page 80, for instance – none of the colours on that child's face could really be called 'flesh colour.' Yet the sketch gives a very good indication of skin. This is because the artist makes the most of reflected colours.

In all these sketches you'll notice that many of the colours used to convey the skin are modified versions of the surrounding local colours. For example, the green hair of the child on the right is obviously reflecting the colours round about. And in the picture below you can see that the lips and cheek are modified versions of the colour of the pillow. Not only does this give a good impression of pale, translucent skin, it also unifies the work, since colours link up around the sketch, making for freshness and vitality.

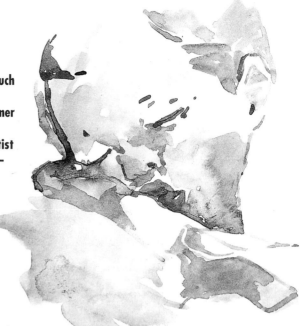

▶ Black doesn't often appear in this artist's palette – she prefers to mix her shadow tones more subtly. Here, the darker tones are based on a blue-grey such as Payne's gray, and these cool, dark tones contrast beautifully with the warmer tones in the rest of the image.

This is a very quick sketch, so the artist homed in on the most important aspect – the child's head, leaving the shoulder as blank paper, and indicating the surface of the bed with a very loose, orange-brown wash.

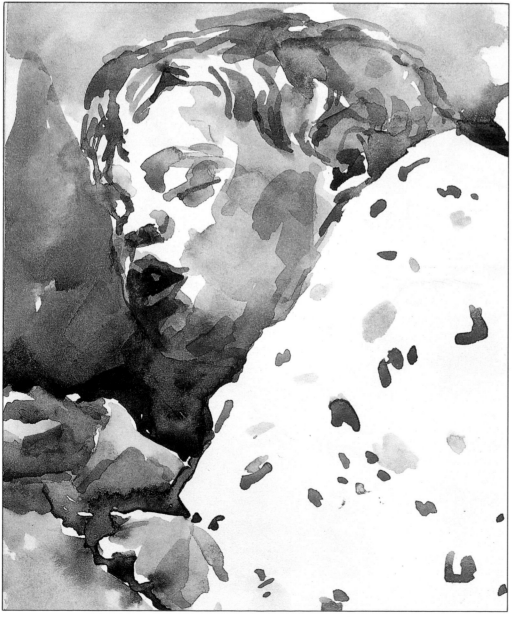

◀ Hood your eyes when you look at this sketch to pick out the wonderful tonal contrasts. Dark shadows on the side of the face become deeper as the cheek tucks down and round into the chin, and deeper still on the pillow beneath the chin. The light picks up the upper face, throwing lovely patterns of light on the snub nose, the front of the eyelid, the forehead and in the hair.

The white of the paper is used as colour for the blanket, and the artist loosely plots its bright pattern. This treatment contrasts with the careful modelling on the face above, keeping attention focused on that area.

► This artist has developed the skill of making her decisions swiftly and putting her colours on the paper quickly and proficiently, drawing with the brush as she goes rather than relying on an initial pencil drawing. She doesn't use an excess of line, but reserves it for when it's necessary.

In this sketch she works with line to delineate some of the hanks of the child's hair and for some detailing around the eyes and nose. Mostly, her sketches emerge out of blocks, washes or floods of colour – it's the delicate pink and beige tones that convey the structure of the face here.

All the watercolours on these four pages are from the sketchbooks of Susan Pontefract

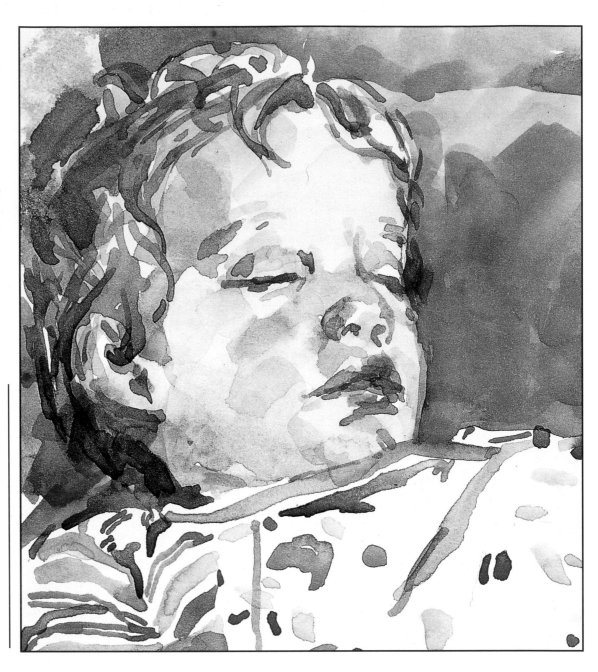

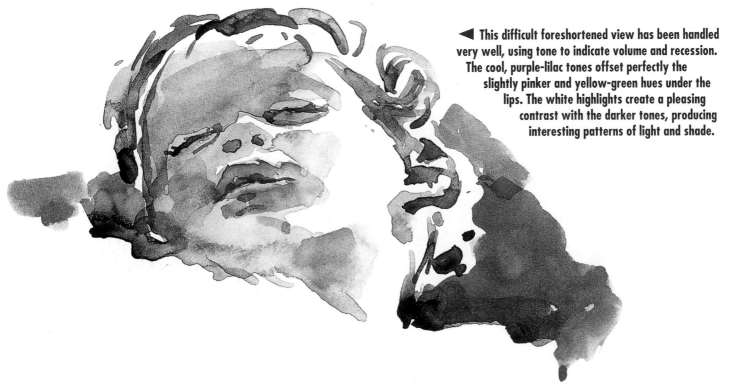

◄ This difficult foreshortened view has been handled very well, using tone to indicate volume and recession. The cool, purple-lilac tones offset perfectly the slightly pinker and yellow-green hues under the lips. The white highlights create a pleasing contrast with the darker tones, producing interesting patterns of light and shade.

Expressive portraiture

Accuracy is not the be-all, end-all in the world of portraiture. Often interesting colour choices can become the focus of the work, creating an emotional response which can breathe life into the portrait.

An artist's skill in recreating precisely the features of the sitter is something that viewers will always evaluate. However, viewers often want to see something more of the artist besides his technical expertise – his emotional reaction to the subject.

For many artists, the emotional element is the principal inspiration for painting the picture. Physical accuracy may fall to the side as features are exaggerated or distorted in order to express the artist's subjective responses. In his portrait of Betsy here, our artist's main aim was to display his impressions of what he describes as her aura, using colour for its emotional impact. He exaggerated the hair colour, brightening its shade of yellow to express the drama of its impact.

Although oils are the classic choice for painting portraits, watercolours allow you to create soft, atmospheric effects, and intense washes of colour. But every medium has its own character and if you take an inventive approach to the paint and are prepared to take risks, you'll conjure up some amazing results.

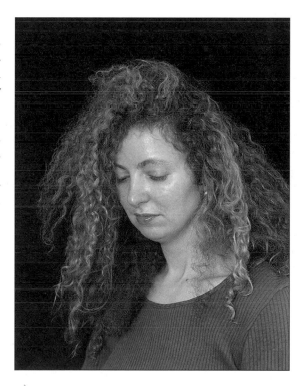

▲ **The set-up** The artist, Ken Paine, chose a classic three-quarter view for this portrait of Betsy. To emphasize her gentle, modest character, he asked her to tilt her head downwards and look at a point on the floor so her eyes appear almost shut. Her glorious mane of curly hair cradles the far side of her face and sweeps away from her high forehead.

◀ **1** The artist began with the colour which he felt best described Betsy's aura – a calm blue. Working with fairly dilute cyanine blue and the large round brush, he plotted her facial features and hair. Even with so few strokes, an image emerges that is recognizably Betsy's. With less dilute blue he very loosely scrubbed in the background at the top left of the composition.

This blue underpainting will shine through the layers of colour and condition the painting to make an emotional statement.

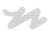

YOU WILL NEED

☐ *76 x 57cm (29½ x 22½in) 300lb Rough watercolour paper*

☐ *Three brushes: a large round, a medium flat and a large flat hog*

☐ *Six watercolours: titanium white, cadmium yellow, aurora yellow, cadmium red, cyanine blue and Winsor emerald*

▶**2** Moving on to the local colours, the first thing to grab the artist's attention was Betsy's thick red-gold hair. He chose to kick up its richness with a shimmering mixture of cadmium yellow and a touch of Winsor emerald. In response to the fullness of the hair, he scrubbed the colour on loosely and thickly with a large flat hog brush. This created a rich texture which he then contrasted with thinner veils of colour, applied with the large round brush.

◀**3** The artist diluted cadmium red and Winsor emerald for a soft flesh tone for areas of the forehead, eyes, along the nose, the cheek and neck. Inspired by the rosiness of the lips and cheeks, he added more cadmium red and, using the flat brush, scumbled this on to the lips, cheek, chin and forehead. He then diluted this new wash and scumbled it over the shadow on the hair by the sitter's right cheek.

▶**4** To bring the features into focus, the artist returned to cyanine blue to emphasize the curve of the eyelids, the arch of the brows and the shape of the nostril. Note how he left the line along the length of the nose unpainted to suggest a highlight. Since he had some blue on the brush, he used it on top of the yellow on the hair to continue the blue theme.

You can now recognize Betsy quite easily even at this early stage. The painting has an amorphous quality, the colours melting into each other giving a hazy, rather romantic atmosphere.

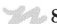

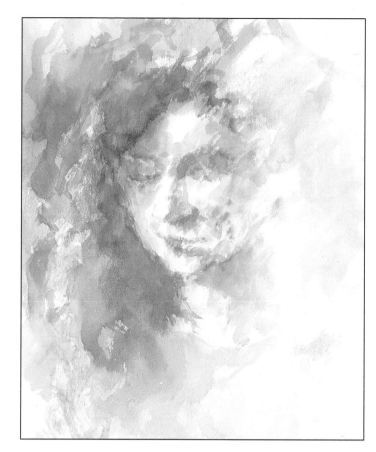

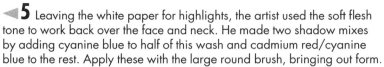 **5** Leaving the white paper for highlights, the artist used the soft flesh tone to work back over the face and neck. He made two shadow mixes by adding cyanine blue to half of this wash and cadmium red/cyanine blue to the rest. Apply these with the large round brush, bringing out form.

The artist used aurora yellow for the hair. Adding cyanine blue, he enriched the shadow by the right cheek. He loosely indicated the ribbed top with Winsor emerald, adding some of this to the hair.

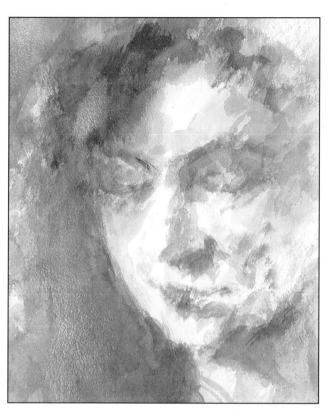

6 The artist scumbled in highlights with thick aurora yellow using the hog brush. With a range of tones mixed from 'palette mud', he began to bring out the subtleties in the shadows on the face. Using yellowish white and the medium flat brush, he outlined Betsy's right cheek to bring it further into relief.

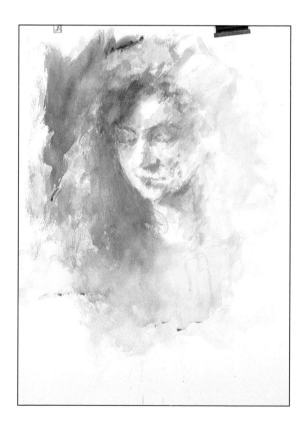

7 To anchor the image, the artist darkened the ribbed top with a strong mix of Winsor emerald, aurora yellow and a little palette mud. He darkened the background at the top left with a strong wash of cyanine blue. This pushed forward the hair directly in front of it, giving it the illusion of body and volume.

8 To strengthen the facial features, the artist mixed a dark blue-green from his palette mud. Next, he indicated the tiny delicate shadows on Betsy's face, mixing a variety of hues from the palette mud and emerald green, aurora yellow and cadmium red. He re-established the shadow on the hair by her right cheek, then mixed a strong turquoise for the background at the top left.

9 The finishing touch was to deepen the colour of the ribbed top with a blue-green mix, picking out the edge of the neckline towards the right. To keep the main emphasis on the face, he didn't put in all of the top but let it fade out below the shoulder.

10 Betsy's friends and relatives would probably recognize something of her character in this portrait. Strangers will no doubt respond to the colour and vibrancy, speculating on the romantic, wistful quality the artist has brought out. And perhaps those who know the artist will find his character evident in the painting too. Ken has departed from reality to make his point. The hair over Betsy's left shoulder, closer to the artist, should be in finer focus than that over the right. But he strengthened the right side to bring out the way the hair cradled the cheek and emphasized the outline of her face.

Painting with body colour

Some painters think that white shouldn't be used with transparent watercolour, but it does have its advantages. It makes body colour, which has special qualities of its own.

Body colour can be semi-transparent or opaque, unlike the transparent effects of pure watercolour. There's no white in transparent watercolour painting (although some artists do use Chinese white) but body colour is different – it consists of watercolours with white pigment added. This not only makes the paint opaque, it also thickens it, hence the name 'body' colour.

Gouache is body colour in manufactured form, but you can make it yourself by mixing your transparent watercolours with Chinese white watercolour paint. This is quite thin, so the body colour you make is most effective for small areas – highlights, for instance. To make the paint more opaque, mix your watercolours with a little white gouache paint.

Many artists combine the subtle, delicate nature of transparent watercolour with bold, energetic body colour to great effect. Others prefer to use body colour alone for its own character.

Perhaps the most valuable quality of body colour is its opacity. This allows you to obliterate underlying layers of paint and work light over dark. There's no need to hang on to the white of the paper, or indeed, work on white paper at all, so you can choose tinted papers or make a toned ground. Mistakes are easily and quickly covered over, and you can paint in a much more spontaneous way when you don't need to plan exactly where your whites will be.

The other plus point with this medium's opacity is that you can keep adjusting your picture, continually responding to your subject and the painting itself. You can also model forms, working dark to light as your painting progresses. And the thickness of the paint lends itself well to texture-making. For instance you can scumble over underlying colours, leave thick, juicy blobs of impasto paint or retain individual brushmarks.

▼ The opacity of body colour captures perfectly the solidity of the plinth, and adds to the sense of the model's weight against it. Yet the medium's sensitivity brings out the subtleties in the flesh tones and the silkiness of the fabric. The scintillating colour and gold trimmings of the sari add verve and vitality.

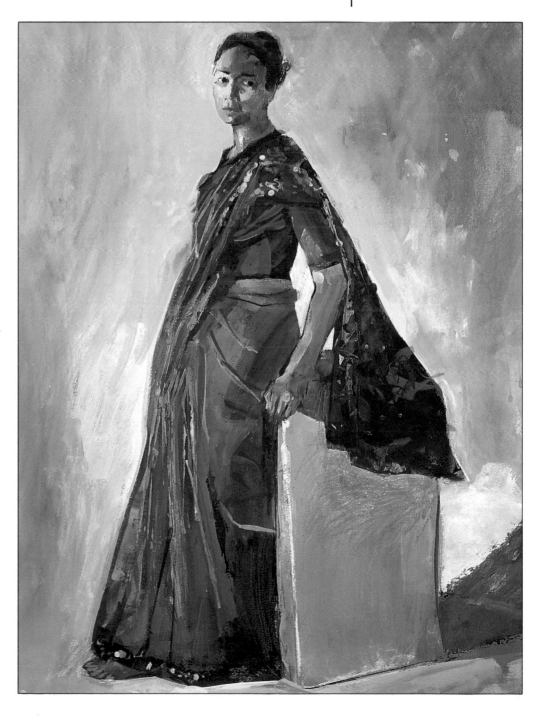

Indian lady in traditional dress

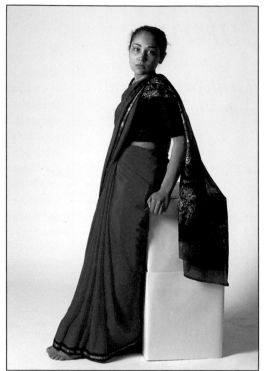

◀ **The set-up** Culture differences always fascinate our artist, so he was keen to paint this woman in her sari, a traditional form of Indian dress. He chose to paint his subject with body colour – it's subtle enough to depict the model's languid mood, while its vibrancy is ideal for the bold colour and eye-catching, decorative details of the sari.

YOU WILL NEED

- ☐ 56 x 76cm (22 x 29½in) sheet of watercolour paper
- ☐ Drawing board and easel
- ☐ Clean cotton rag
- ☐ Two synthetic brushes: No.14 round, No.10 chisel
- ☐ Ten watercolours: cadmium yellow, yellow ochre, cadmium red, alizarin crimson, Prussian blue, cobalt blue, terre verte, Payne's gray, burnt umber, black
- ☐ One tube of white gouache paint

▶ **1** Dilute plenty of Payne's gray and use it to tone your ground with the No.14 brush. (This bluish grey will complement the bluish pink of the sari well.) Stand back and make random, irregular strokes with the whole of your arm in many directions. Use different dilutions of paint.

◀ **2** Use your cotton rag to spread colour as well, making bold, broad sweeps to add energy. The idea is to create a dynamic mid-toned background out of which you can pull the lights and darks. This vigorous start should also encourage you to keep your marks lively throughout the painting.

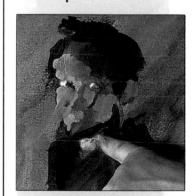

3 Place the figure, paying close attention to the contour lines. If you're painting your own model, stand far enough back for your vision to encompass both subject (from head to foot) and painting.

Use thin alizarin crimson for the sari, adding black or Payne's gray for the darker tones. Put in the head and arm with yellow ochre. (Notice how the underpainting modifies the yellow ochre here.) Paint the hair, the blouse and the end of the sari (over the model's shoulder) with black. Bear in mind that the fabric resting on the plinth takes on its shape.

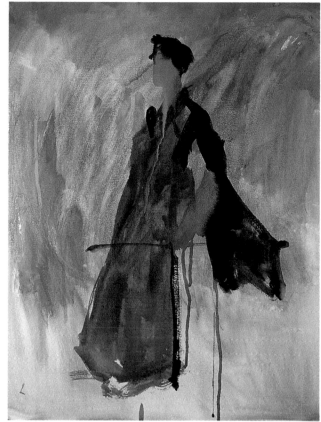

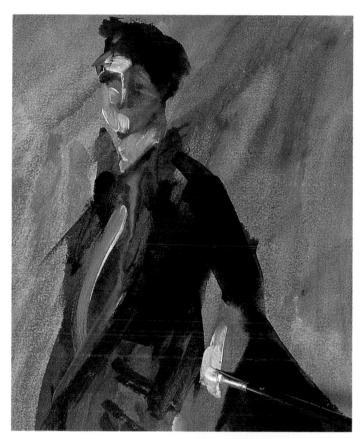

4 Hood your eyes to simplify the tones. Use yellow-tinged white gouache to block in the light areas on the skin with the chisel brush. On the face, tick in a few shadows with burnt umber. Darken the sari mix to indicate the pulls in the fabric on the hip.

Dash in a streak of whitened alizarin on the chest to remind yourself where the highlight falls.

Tip

5 Build up the tones on the face with alizarin crimson (to indicate the reflection from the sari) and terre verte, using a burnt umber/Prussian blue mix for details and shadows. Don't just plonk on these tones – draw their shapes. Develop the shape of the hair and the contour of the shoulder to the left with black. Blend in the streak of light alizarin on the chest, and place another streak farther down to stand, temporarily, for folds.

Our artist dabbed a blob of alizarin on to the forehead to remind him to use the colour there later.

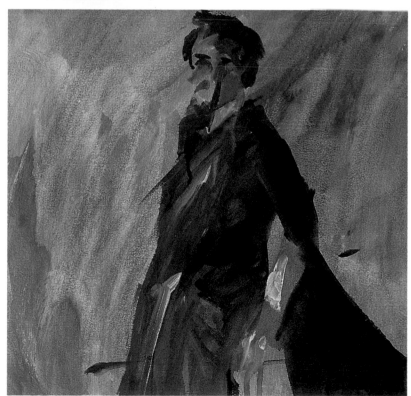

Tonal shapes
The light shines from the left, so the tones on the model's face dissolve into darkness towards the right. Look closely at the set-up and you'll see the tones have different shapes. Painting these will help you explain the form of the whole head.

▶ **6** Blend in the alizarin blob on the forehead, then model the face and neck with warm flesh tones (cadmium red, yellow ochre, terre verte and white), painting over areas to modify them. Use dark flesh tones on the arm and to put in the right ear. Paint the eyes with white and the irises with Payne's gray. Define the model's outline by painting the surrounding negatives with white.

◀ **7** Add blues and browns to your flesh mixes for the midriff and to build up the arm and face. Define the facial features and indicate shadows. Work up the sari in the same colours as before, adding more white for body. Darken the pinks for deeper tones, aiming for a sense of the fabric folds. Use a rich mix of Prussian blue and black for the darkest shadows on the sari. Add the lighter tones on the blouse with a mix of cobalt blue and white.

Redefine the outline of the model by painting the surrounding background in a watery mix of cobalt blue and white.

▶ **8** Make two bold sweeps – horizontal and vertical – to catch the shape of the head (you'll paint the outline later to define the proper shape). Re-establish the eyebrows with the burnt umber/Prussian blue mix, then continue to model the face with warm and cool tones.

Cut out the shapes of the shoulders, chest and arm using white tinged with yellow to paint the negative spaces round the model. Then use alizarin crimson with varying amounts of white to suggest the patterning on the sari. Indicate the sweep of the edge of the fabric across the model's chest with black.

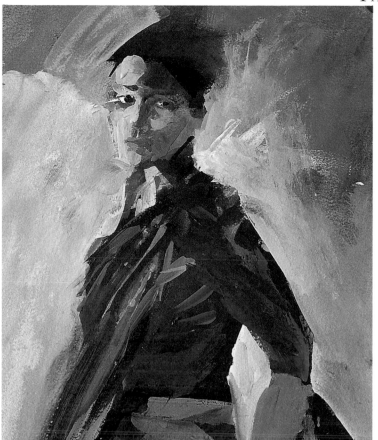

◀**9** Build up lights and darks on the sari with a variety of tones – mixes of alizarin crimson, cadmium red, cobalt blue, Prussian blue and white. Outline the shape of the head on the left in yellow-tinged white. Attending to the negative shapes helps you build up a good sense of space around the model, creating a three-dimensional image. Blend in the lighter blue on the blouse, and continue modelling the face with warm and cool colours.

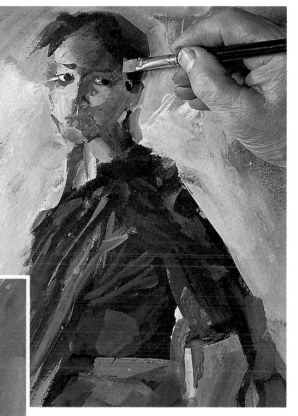

▲**10** Carry on modelling the face, using the chisel brush to carve out its shape against the hair. Mix varying amounts of white and cobalt blue for the lighter tones on the blouse. Indicate the pulls in the fabric.

Put in the patterning on the end of the sari (resting on the plinth) using darker versions of the same colours as before. Work around the painting, using warm and cool colours to bring out the rounded form of the body.

◀**11** Put in the plinth with a whitened blue, adding more blue (a different one, if you prefer) for the shadow.

Keep working around the whole painting in the same way as before, developing and over-painting areas to correct the drawing. Add white to your background colours, or use white on its own if you wish, to redefine the model's outline once again.

12 Refine and blend in the tones on the face. Then work up the sari, especially the folds on the front (see Tip below left) and the sweep of fabric across the model's chest.

13 Now that you have a solid structure, tidy up the details before adding the finishing touches. Blend the tones on the face to soften their edges. Make any necessary adjustments – indicate the feet, sharpen up edges, strengthen shadows, work up the plinth and cover up any smudges or drips.

14 The final picture (on page 1) shows how finishing details can make all the difference. Add the gold details on the sari with cadmium yellow, white and a touch of red. Use flesh tones to bring the hands and feet to life, then outline the fingers and toes with the burnt umber/Prussian blue mix. Add highlights to the arm and hand with cadmium yellow. Finally, as a last touch, sharpen up the shadow of the plinth with black, adding shadows around the plinth with mixtures of black grey, green and blue.

Tip

Improvise
Body colour is used here in a fresh, immediate way. So, to depict the many folds in the sari, don't use a brush. Match the liveliness of the medium and improvise – our artist applied paint to the edge of a card and printed with it for the fine lines of the fold edges.

Part 2

CAPTURE LIGHT ON PAPER

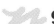

Into the light

Light – its source, its intensity and its position – is a vital ingredient in all paintings. Not only does it affect the clarity of the image, it also ultimately controls the mood of the picture.

You can learn a great deal about using light in your paintings by looking at the work of other artists, past and present. In Rembrandt's *A Man in a Room*, for instance, the subject – the man – is just a small, shadowy figure sitting beneath a window, while the light from the window itself fills a third of the canvas. And in Delaroche's *The Execution of Lady Jane Grey* the lady herself kneels in a pool of light which leaves the surrounding figures – her executioner, comforter and maids – in the gloom, as befits their lesser importance in the painting. Even totally abstract paintings use light because without light there is no form at all.

The need for light

Without light, there is only darkness. But between these two extremes, the subtle gradations of light and dark give us tone – one of the most important clues allowing us to perceive space and form. Light also gives us shadow (an area of darkness created by an object standing between the light source and the surface).

Shadows give us clues about the direction of light and its strength. On a sunny day, for example, the areas of light and dark are in high contrast and shadows have clearly defined, crisp edges. On an overcast day the few shadows that exist have soft, ill-defined edges.

Light also affects the way we see colour. Local colour (the actual colour of an object) is modified by tone, shadow and reflected light. And remember, there is rarely a single light source, so the subject picks up touches of reflected colour from all around. For painters, natural light from a northern aspect is considered the most satisfactory for working because it's the most neutral and distorts colour less than artificial light. (If you've ever worked out in bright sunshine, you'll know how different the picture looks when you take it indoors.)

Indoor light

Interiors provide some wonderful opportunities for exploiting and exploring light. Indeed, light is often the real subject of the painting – a presence holding disparate elements together,

▼ Here, the artist has captured brilliant areas of light falling on the lustrous surface of the kettle and illuminating the clarity of the glass bottle. The shadows have depth and transparency, while the highlights are laid on with a thick, crusty impasto.
'Still life with fruit and kettle by a window' by Kurt Schwitters, 1937, oil on wood panel, 625 x 740mm (24½ x 29in) © DACS 1994

an indication of mood or a suggestion of the world beyond the enclosed space.

When you are painting indoors, you can control all aspects of lighting – source, intensity and direction. So consider your options carefully. There are three basic sources of light which you can utilize: *natural light*, streaming through a window, skylight or open door; *firelight*, from an open fire, candle, gas or oil lamp; and *electric light*, from a light bulb, spotlight or neon light.

Natural light introduces a sense of the world outside. If the window or door is included in the picture you have a clue to the light source, but often you'll find that it is placed beyond the picture area – so the observed light and shadow are the only clues to its existence.

Sometimes the light is softly filtered by curtains, producing a tranquil mood, while a window without curtains might cast a bright shaft of light across the room to sparkle on any shiny surfaces it touches. And if the glass in the window is coloured, as in stained-glass, it will leave beautiful splashes of colour on floor and walls.

Firelight from a fire or candle creates flickering areas of light interspersed with rich pools of darkness. It can be used to create intimacy or focus attention, as in Joseph Wright's *An Experiment with the Air Pump* opposite, or to recreate the romance of the past. Or you can use it for drama, lighting faces and hands in strong contrast to the velvety darkness all around.

Electric light emphasizes the self-contained nature of an interior – a world within a world. Its great advantage is the degree of control it offers. You can increase the level of illumination, raise or lower it, move it around, create a shaft of light which falls directly on to the subject or soften the light by bouncing it off an adjacent surface. A shaded light bulb creates a pool of bright illumination with a more diffuse background light, while a spotlight can be used to direct a shaft of brilliant directional light.

▲ Using a muted palette, the artist has captured the diffuse quality of light filtering through muslin curtains. The dryish paint was probably applied over a toned ground to create the soft lighting effect. The simplicity of the composition and the softness of the colours and lighting make for a beautiful picture with great – though understated – charm.
'A corner of the artist's room in Paris' by Gwen John, oil on canvas, 12½ x 10½in

◄ Warm sunshine coming through a large sash window splashes on to surfaces, sometimes revealing form and sometimes dissolving it. The figure occupies an important position in the painting, but because she is seen *contre jour* (see page 96), the light sparkles in her hair and on her shoulders while the rest of her figure is in shadow.
'Valerie, Morning Light' by Ken Howard, oil on canvas, 48 x 40in

◄ Joseph Wright was described by a contemporary as 'the most famous painter now living for candle light' and here you can see why. In this painting the artist uses light to achieve a heightened sense of wonder. The faces of the onlookers are illuminated with theatrical intensity, and all our attention is focused on the experiment and the people.
'An Experiment on a Bird in an Air Pump' by Joseph Wright of Derby, oil on canvas, 72 x 96in

▼ Using fluid paint in warm browns and ochres, this artist conjures up the flickering quality of the candlelight. The bottom of the painting is in velvety darkness while colours in the shadows are muted and ill-defined. Only in the light areas can you make out any details.
'A candlelit interior' by Niels Holsoe, oil on canvas, 19½ x 17½in

The intensity of the light is also something to consider. To an extent, this depends on the source – candlelight is going to be softer than electric light, and a 40 watt bulb softer than 100 watts. But by bringing the light closer to your subject you make it look more intense. Bright light illuminates all the details of your subject, allowing for photographic clarity, while in soft lighting conditions edges are blurred, creating mystery or ambiguity.

The position of the light affects mood too. As a child, do you remember putting a flashlight or torch under your chin so that your face was lit from below, terrifying a sister or brother? The effect can be quite disturbing in a painting too. For less dramatic effects, you might decide to light the subject from one side to create strong directional shadows, or you could use several light sources to reduce the amount of shadow. Try it for yourself to see which lighting best suits your subject and mood.

Outdoor light

When you are outside, the light may come from the sky – sun, moon and stars – or from man-made sources – a bonfire, street lamps, car lights or neon advertisements. It might even stream out of an open door or window, creating the reverse of daylight coming into the home.

▲ **Turner is above all *the* painter of light, and here the whole image is held together in a blazing, glowing envelope of light. He painted this picture when he saw the old sailing ship being towed into Deptford to be broken up, and he was so fond of this painting that he refused to sell it or put a price on it.**
'The Fighting Temeraire' by Joseph Mallord William Turner, oil on canvas, 91 x 122cm (36 x 48in)

▼ **In this magical evocation of Venice at twilight, the deep shadows on the left are built up with successive scumbles and glazes. Thick impastoed blobs of red and yellow describe the lights gleaming out of the darkness.**
'The Dark Canal, Venice' by Terrick Williams, oil on canvas, 10 x 15in

When you're painting outside you're faced with new problems. You can't manipulate the lighting in the same way as you can indoors – you just have to try to capture what's there or wait until the light is right and then rush out and paint it. Many great artists, such as Monet and Turner, made a point of studying light, making many sketches and paintings which show the light at different times of day.

The weather and the season also affect the quality, colour, direction and strength of the light. At midday in summer the bright light bleaches out colour and the shadows are directly beneath the trees. Towards evening the sun casts long, dark shadows, creating interesting patterns of light and dark.

Mist casts a mysterious veil over the landscape so that forms dissolve and we catch tantalizing glimpses of distant hills or trees. Colours bleached of their intensity acquire a bluish cast, and objects appear blurred and indistinct. Tonal contrasts are minimized so that it's difficult to read forms and the landscape appears flat. Quite different effects appear at night, or when snow is on the ground, or if it is raining. In

fact, you can paint the same landscape time and time again, and never repeat yourself.

Monet (1840-1926) explored these changes in a series of paintings started in 1890. He made multiple studies of such subjects as The Houses of Parliament (see overleaf), haystacks and Rouen Cathedral, painting under different conditions and at different times of day on several canvases, moving from one to another as the light changed. He made 30 paintings of Rouen Cathedral in three months, showing how the façade altered as the sun moved round, sometimes revealing detail, at other times obscuring it.

As the sun moves through the sky, changes occur in the quality of the light and the type of shadows cast. And your position relative to the sun also affects what you see. If the sun is in front of you, buildings and objects are thrown into shadow, giving colours a cool cast. If the sun is behind you, the landscape is bathed in warm colour and you can make out most details. Side lighting creates the most dramatic shadows and throws forms and textures into high relief. When the sun is directly overhead, shadows are reduced to a minimum while forms and textures appear flatter.

A final point to remember: the nature of light varies from one part of the world to another. In Britain's moist island climate, colours tend to be soft and muted except on the brightest days. But in sunnier parts of the world the light has a special brilliance and colours appear more saturated. Artists respond to these conditions by modifying their palette and their approach.

▲ On close inspection you can see how lightly paint has been applied here. In places the brush seems to have glanced across the surface, depositing streaks of colour which recreate the scintillating quality of natural light.
'La Somme près d'Abbeville' by Eugene Boudin, oil on canvas, 24 x 19½in

► By carefully orchestrating areas of light and dark, warm and cool, the artist conjures up the heat and brilliance of a summer's day. Interestingly, the painting exudes sunshine and warmth, but you'll find a very small proportion of the picture is actually in the light. By describing shade (the dappled shadows), the artist implies light.
'A Quiet Drink' by Joseph Milner Kite, oil on canvas, 31 x 37cm (12 x 14½in)

DID YOU KNOW?

Chiaroscuro

Chiaroscuro (bright-dark) means the balance of light and shade in a picture – particularly when they are highly contrasting – and the skilled rendering of shadows. It's a term often used to describe the work of such great masters of light as Rembrandt and Caravaggio.

▲ Although the sun is still quite high, it has turned the sky and water into a wonderful range of oranges which Monet enriches with complementary blue and violet shadows.
'London, Parliament, sun shining through a gap in the fog' by Claude Monet, 1904, oil on canvas, 32x 36in

◀ Compare this painting with the one above. The artist has swirled the crisp, yellowish gleams of light in the sky, and dabbed the colour in the river where it is reflected on each ripple.
'Houses of Parliament, stormy sky' by Claude Monet, 1904, oil on canvas, 32 x 36in

▶ On a misty day, forms are blurred and colour contrasts reduced. Monet captures this expertly, yet he still shows where the light is coming from — the left.
'Seagulls over the Houses of Parliament, London' by Claude Monet, 1902, oil on canvas, 32 x 36in

Painting dappled light

The transparency of watercolour and the range of hard and soft edges it brings are ideal for interpreting the effects of sunlight. Combined with masking techniques, the results can be highly dramatic.

When tackling a subject with lots of shadows and dappled light, it's vital to establish the direction of the light – this brings both logic and unity to your work. Next think about the relative warmth of the shadows and light areas. A shadow will almost certainly be made up of a coloured grey rather than a grey mixed from white and black. Likewise, most of the areas of dappled light will not be as white as your paper and therefore need an overall delicate warm wash before they are covered with masking fluid.

In this demonstration, our artist worked in two stages, first laying thin washes of colour wet-into-wet, then allowing these to dry before adding stronger elements of detail. The direction of his brushstrokes is important, helping to establish the direction of the light and giving the work a bold, confident feel.

◀ **The set-up** Our artist painted this wonderful series of covered archways from a sketch he'd made in a monastery in Paleokastritsa on the Greek island of Corfu. This was an ideal setting for capturing the dappled patterns cast by the Mediterranean sun shining through a vine trellis. In his sketch, he carefully noted the areas of strong shadow and dappled light.

▶ **1** Begin by lightly sketching the basic composition with a soft pencil. Use a large brush to paint a delicate wash of vermilion and Naples yellow on the walls and floor of the patio and arches, leaving a few arches as white paper. The wash will give warmth to the patches of dappled light and will also unify the different coloured shadows on the walls. Leave to dry, then add a wash of Payne's gray mixed with a little viridian to the trellis area. Wash the yellower areas with raw sienna and terre verte. Stop any unwanted runs with a tissue and allow to dry thoroughly.

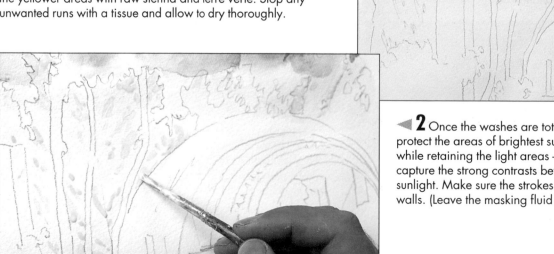

◀ **2** Once the washes are totally dry, apply the masking fluid to protect the areas of brightest sunlight. The mask lets you work freely while retaining the light areas – it also gives crisp edges which capture the strong contrasts between areas of light and shadow in sunlight. Make sure the strokes all follow the direction of light on the walls. (Leave the masking fluid to dry completely.)

YOU WILL NEED

- ☐ *A sheet of 45 x 36cm (18 x 14in) 140lb Canson paper*
- ☐ *Two brushes: a large wash brush and a No.10 round sable/synthetic*
- ☐ *An old brush for applying masking fluid*
- ☐ *Tinted masking fluid*
- ☐ *Putty rubber/rubber eraser (optional)*
- ☐ *Two jars of clean water*
- ☐ *A soft pencil*
- ☐ *Roll of tissues*
- ☐ *Eighteen watercolours: Naples yellow, yellow ochre, Indian yellow, cadmium red, alizarin crimson, vermilion, French ultramarine, sap green, Hooker's green dark, viridian, olive green, terre verte, permanent mauve, raw sienna, burnt sienna, burnt umber, brown madder alizarin and Payne's gray*

▶ **3** Use the large brush to put in a loose, wet wash of brown madder alizarin and alizarin crimson on the left side of the arch wall. Apply a wash to the wall on the left with sap green at the top, yellow ochre in the middle, and a mix of sap green and viridian along the bottom.

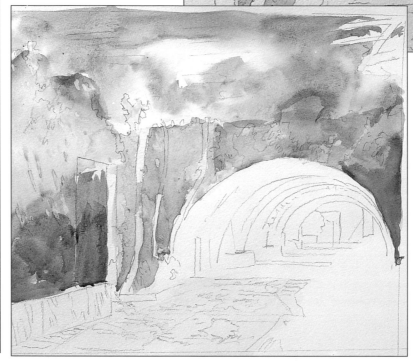

◀ **4** Continue to paint along to the right of the arch wall using a wash of Payne's gray, Hooker's green dark and viridian. Drop some yellow ochre and olive green into this wash while it is still damp. Use the same wash for the doorway on the left, adding more Hooker's green to finish the bottom of the wall on the left.

These washes are laid down as an underpainting before adding darker details over them, so make sure they are dry before continuing.

▶ **5** Remove the masking fluid by rubbing gently with a putty rubber/rubber eraser or with your fingers. This gives a clearer idea of the dappling effect on the wall. Mix a number of strong greens to paint the vines – use the natural shape of the No.10 round brush to create the crisply defined leaf pattern. Start with a light green mixed from sap green and yellow ochre. Follow this with straight sap green, and a mix of Hooker's green and Payne's gray. Paint in the blue-green leaves with a mix of viridian and French ultramarine, and the wooden trellis in burnt umber.

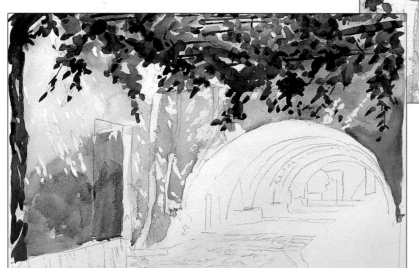

◀ **6** Paint in an Indian yellow wash for the wooden support on the left. Allow this to dry before painting over it in burnt sienna and burnt umber. Don't cover up the Indian yellow entirely – leave some showing for a dappled effect. Mix burnt sienna and Indian yellow for the fruit on the vine.

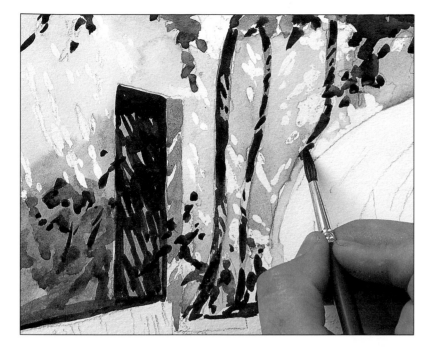

7 Put in the thin trunks of the vine with a mix of Naples yellow and raw sienna. Allow this to dry before going over the trunks with burnt sienna – again don't cover the Naples yellow/raw sienna completely. These brushstrokes should describe the patterns of light through the canopy of leaves to create a dappled effect. Paint applied wet-on-dry gives neat, clearly defined edges which capture the quality of the light.

Use a mix of viridian darkened with Payne's gray to paint in the doorway, leaving some areas unpainted to suggest patches of light. Then put in the basic shape of the bush on the left using sap green, again keeping the patterns of light and dark firmly in mind.

8 At this stage it's a good idea to let the whole picture dry before continuing. Then paint the underside of the arches in a wash of Naples yellow with some raw sienna and olive green added in places to tone down the colour and suggest shadow. Put in the plant beds between the arches in a wash of French ultramarine. When this is dry go over it again to strengthen the blue.

9 Paint the broad areas of shadow on the floor with a wash of French ultramarine mingled with raw sienna. Then mix what our artist describes as a 'palette grey', using French ultramarine and permanent mauve, and paint in the dappling of the leaf shadows – working wet-on-dry. Change the emphasis of this grey in some places by adding more French ultramarine to make it bluer. Add a few light brown leaves too.

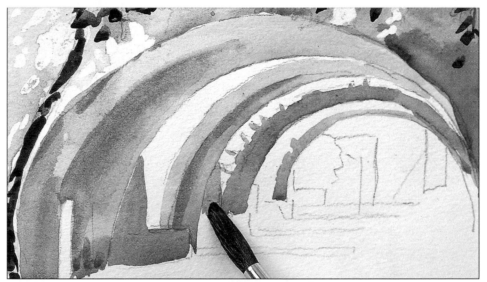

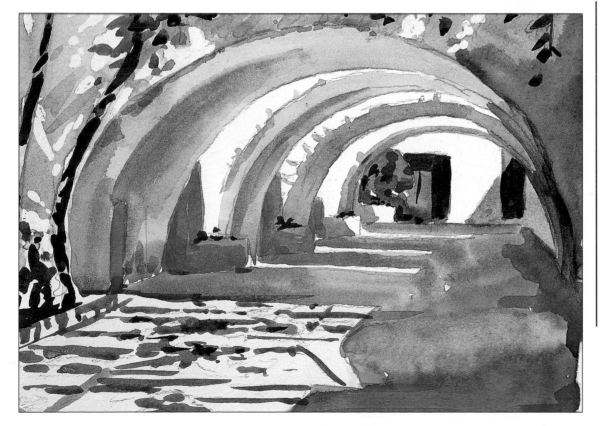

Tip

Coming unstuck with masking fluid

Masking fluid sticks very firmly to damp paper and can tear the paper when you attempt to remove it. It's essential to allow your washes to dry completely before applying it. Dry the washes with a hairdryer if you are in a hurry, but be careful not to blow areas of wet paint across the support.

▶ **10** Add more detail to the bush on the left and below the vine trunks with a mix of viridian and French ultramarine. Put in a few spots of Indian yellow and cadmium red to suggest flowers. Notice the way the warm colours sparkle against the cool greens.

Mix some permanent mauve with the 'palette grey' to warm it, and use this to describe the broad shadows on the low wall on the left.

▼ **11** The final picture shows why watercolour is such a perfect medium for capturing the effects of light. The variety of greens emphasizes the dappling effect of light and dark and helps to create visual chatter, while the extensive use of Payne's gray to darken some colours maintains a pleasing unity throughout the picture.

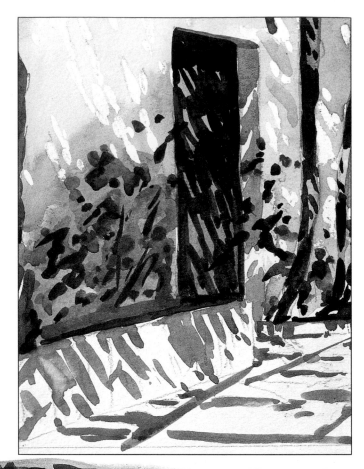

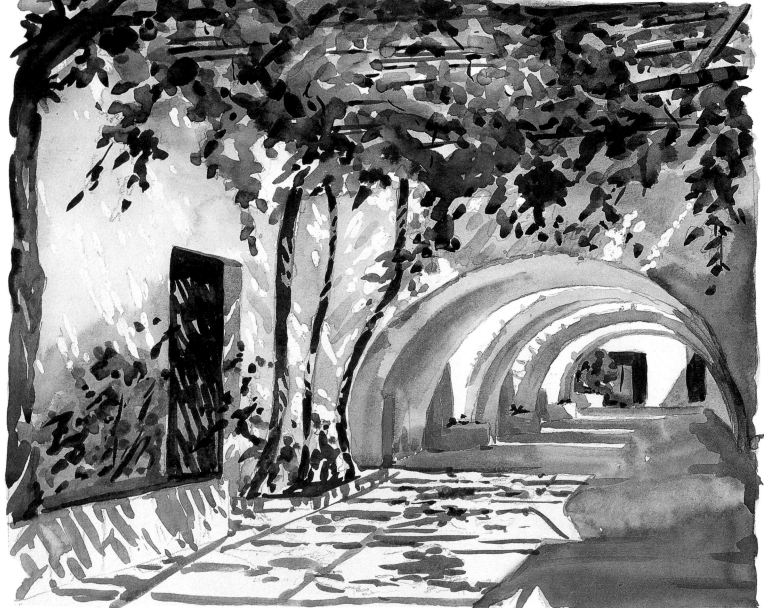

Painting interior light

Paint can never be as brilliant as pure light, so when your main light source is part of the subject, you need to exaggerate the tonal contrasts to convey the brightness of light.

It isn't just for reasons of flattery that many people favour the softness of gentle lamplight over the glare of an overhead bulb. In lamplight, mysterious veils of shadow contrast with warmly lit objects, creating a romantic corner of your room that makes a most appealing subject for a painting.

When your main source of light is included in the picture, you must make sure the general balance of light in the room is right. You need an alternative source of light so you can see your own painting, but you must also be in sufficient gloom to see the lamplight. Our artist worked on a cloudy day – the light from the window was enough for him to work by, but not strong enough to affect his set-up.

To give a convincing portrayal of lamplight, kick up the tonal contrasts – exaggerate the lights and deepen the darks. For instance, if your light is in front of a white wall, ignore the colour of the wall and concentrate on its tone, using colour to make it dark enough to bring out the brightness and glare of the lamplight.

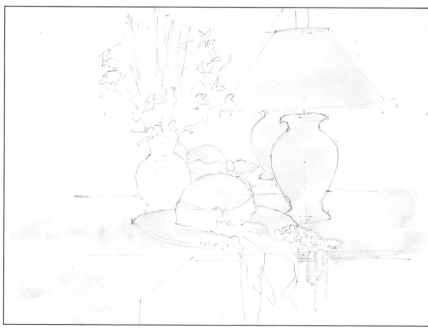

▲ **The set-up** Here the lamplight creates quite distinct areas of light and dark for the artist to work with.

The mirror creates an interesting ambiguity, since at first glance it looks as if you're seeing double. The reflections echo the objects, creating a wonderful pattern of shapes.

◄ **1** Draw the elements of the set-up and their reflections in pencil. Check your ellipses and proportions. Measure the relative sizes of the objects and the spaces between them to help you position them correctly.

Mix a wash of yellow ochre and cadmium yellow for the palest areas – the tablecloth, the highlit parts of the hat and their reflections. Work with the No.8 brush, cutting around the shapes of the lamp base and beads. Add more yellow ochre for the lamp base, diluting the mix for the shade. Pull out paler tones on the lamp by dabbing with fairly wet cotton wool.

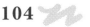
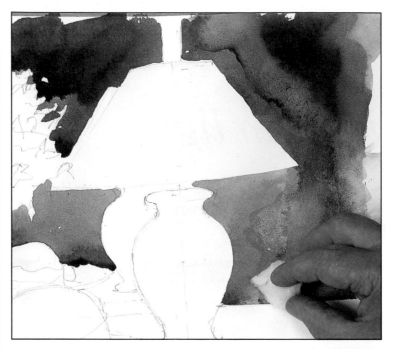

YOU WILL NEED

☐ *A 55 x 41cm (21½ x 16in) sheet of Saunders 140lb HP watercolour paper, stretched on to a drawing board*

☐ *A 3B pencil*

☐ *At least two jars of water; cotton wool*

☐ *Three round sable brushes: Nos.8, 2 and 00*

☐ *Twelve watercolours: yellow ochre, cadmium yellow, aureolin, cadmium scarlet, cadmium red, rose carthame, Indian red, ultramarine, indigo, cobalt blue, cobalt green and burnt umber*

☐ *White gouache*

◀2 Loosely mix indigo and cadmium scarlet to paint the surface of the mirror on the right side, cutting around the shapes of the lamp shade, the hat and their reflections. Deepen the mix to paint the wall to the right of the mirror, leaving a blank strip for the mirror frame. Again, pull out paler tones with wet cotton wool.

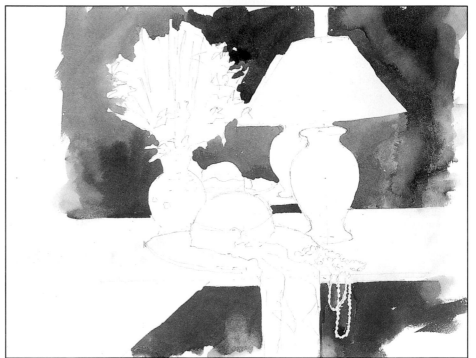

▶3 Add aureolin to the mirror wash of indigo and cadmium scarlet and use the mix to paint around the flowers, adding more indigo as you paint around the vase. Add a touch of ultramarine for the shadow beneath the table to the left of the overhanging scarf.

Add more ochre to the yellow ochre/cadmium yellow mix and paint in the beads using the No.2 brush. Then work around their edges, defining shapes with the fine brush and the background mix. Switch back to the No.8 brush to fill in the shadow beneath the table to the right of the scarf. Deepen this mix with plenty of indigo and cadmium scarlet for the mirror frame visible between the hat and lamp base.

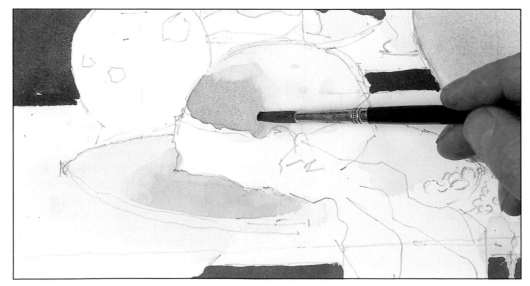

◀4 Add more yellow ochre, cadmium scarlet and a little indigo to the yellow mix for a beige neutral. Use this to paint the lamp base. Then make a fresh mix of these same colours for a darker, greenish neutral for the shadow at the top of the lamp base and its reflection. Vary the same mix to paint the shadows on the hat.

Go back to the lamp base – the edges of the first wash have dried quite hard, so soften them with a piece of fairly wet cotton wool.

5 Add ultramarine and rose carthame to the shadow mix for a purplish hue. Use this to paint the left side of the vase with the No.8 brush. For the warm areas where the lamp light hits the vase, apply a mix of yellow ochre and indigo. Try a mix of cadmium scarlet, aureolin, cobalt green and yellow ochre for the brilliant reflection of the lamp base.

Use a pale version of the first vase wash to paint the shadows of the hat and vase on the table, using the second vase colour for the deeper shadow directly beneath the brim. Mix rose carthame, yellow ochre and ultramarine with lots of water for the shadow on the tablecloth hanging over the edge of the table. Paint the table edge with a pale mix of ultramarine and indigo.

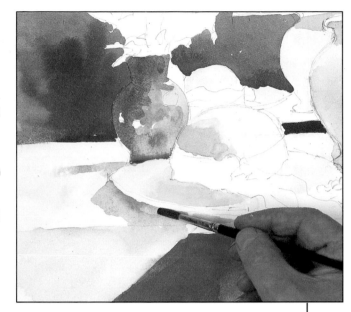

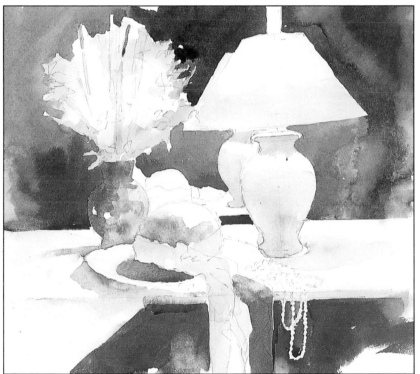

6 At this stage the artist is dealing with fairly light tones so he mixes very dilute washes – it's easy to darken them later if necessary.

Mix a tiny touch of cobalt green with aureolin for the palest dried flowers. Add yellow ochre and cadmium scarlet to paint the scarf over the edge of the table. Warm the wash with a touch of cadmium red for the part tied around the hat. A touch of indigo turns this mix into a grey neutral – use this for the shadow of the lamp base. Darken this further for the shadow on the crown of the hat.

Add indigo and ochre to the mix for the lamp shade and its reflection. Mix rose carthame and yellow ochre for the long, thin dried flowers.

Mix a much stronger wash of Indian red, aureolin and indigo for the purplish scarf.

7 You need to deepen the background now so that the light from the lamp really sings out. Mix cadmium scarlet, Indian red, cobalt blue and ultramarine to darken the surface of the mirror beneath and around the edges of the lamp shade and its reflection. Add some cadmium red and more aureolin for the background between the dried flowers.

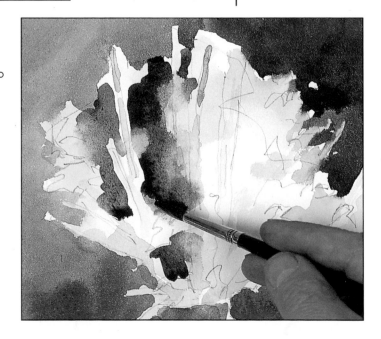

▶8 Pick out the pink flowers in rose carthame. Indicate the pattern on the scarf. Use various mixes – cadmium scarlet/rose carthame/ultramarine; indigo/Indian red; cadmium yellow/cadmium red; rose carthame/ultramarine. Touch in the scarf's reflection too. Paint the mirror frame to the left of the vase with a deep mix of indigo/ultramarine. Use pale indigo for the shadow under the hat in the reflection.

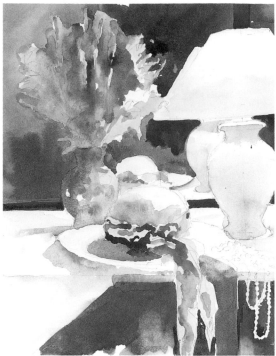

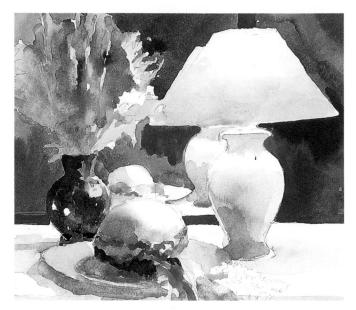

◀9 Put in the dark shadow on the left of the vase with a deep purple (ultramarine/indigo), working around the highlight. Lighten this and add more indigo for the shadow at the base of the lamp, softening any hard edges with wet cotton wool. Now use a range of colours, mixing your palette mud for neutrals, adding burnt umber for the subtle shadows on the hat, lamp base and their reflections. Work over the washes on the hat, softening their edges.

▶10 Define the edges of the lamp base and shade by painting between them with the deep background mix. Darken the neutral grey/brown you used on the lamp base to strengthen the tone, and soften any hard edges with fairly wet cotton wool. Continue with mixes similar to the ones you've used already to develop the hat and its reflection. Mix aureolin with the background colour and use varying dilutions of this to develop the dried flowers. Use a bright yellow for the highlights on the vase.

Wash over the scarf with very dilute blue where it hangs over the table, away from the light source, and over the adjacent tablecloth. Darken the shadow beneath the table with a deep mix of ultramarine, indigo and yellow ochre, adding cadmium scarlet as you work towards the right.

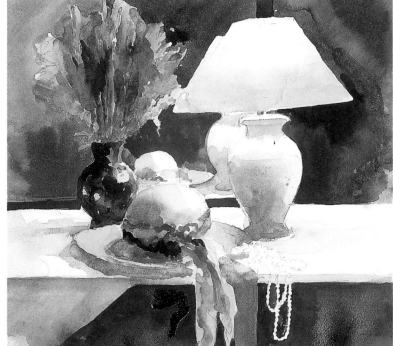

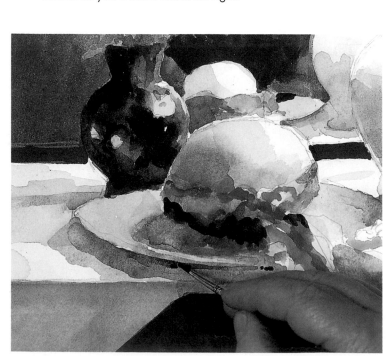

◀11 Continue with the subtle shadows on the hat, this time using reds (cadmium scarlet and rose carthame) more freely. Don't neglect the hat's reflection. When painting the reflections, remember that they shouldn't be exactly the same as the objects they reflect. They show the sides of the objects we cannot see which, in this case, are lit more brightly. Develop the shadows around the whole painting.

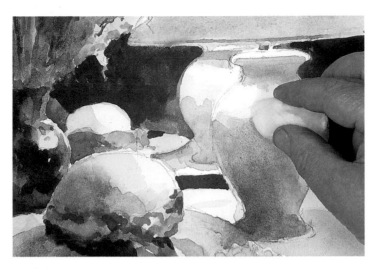

▶12 Use a grey neutral to pick out the trimming on the lamp shade. Mix aureolin with a touch of cadmium scarlet for the beads. For the shadows on the pearls mix yellow ochre and indigo. Add a wash of yellow ochre and cadmium scarlet, with a touch of palette mud, for the shadow on the lamp base. Use a wet wad of cotton wool to pull out the highlights.

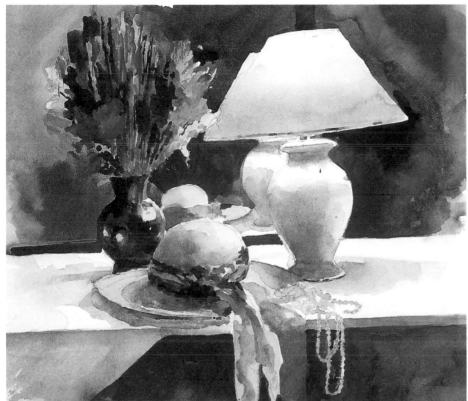

◀13 Work up the shadows around the painting, especially on the tablecloth and within the flowers. Now that you have nearly finished the painting, stand back as far as you can and assess the balance of tones. What you're aiming for is a good contrast.

▶14 Continue to work around the painting, developing the lights and darks until you're happy with the final tonal balance. Now see to the details, such as the pearls. Mix a deep pinky purple and wash this in carefully between them. Now, using the No.00 brush, add the highlights on the pearls with tiny dabs of white gouache mixed with yellow ochre.

►15 To soften the image and add further interest, our artist decided to add some dribbles of water. Hold the painting upright and squeeze a wad of wet cotton wool near the top of the page to release a drip that runs down the page. If you like, touch a little paint into the drip, so that it is carried down the page. Our artist did this in places with yellow ochre and rose carthame. Don't overdo it – you're after subtle results, not striking ones which would upstage the image itself.

▼16 Touch in any necessary finishing details – our artist added strong patches of indigo mixed with aureolin in background areas.

If you look back at the set-up, you'll notice that our artist's version of the interior scene is a little different. Instead of a flat, dark background, the mirror and backcloth in the painting are rich and varied in tone. We get a wonderful sense of the diffuse light filtering through the shade, as well as the stronger light that hits the tops of the lamp base and hat. Note how the pale tablecloth reflects the light, providing one of the palest tones in the picture.

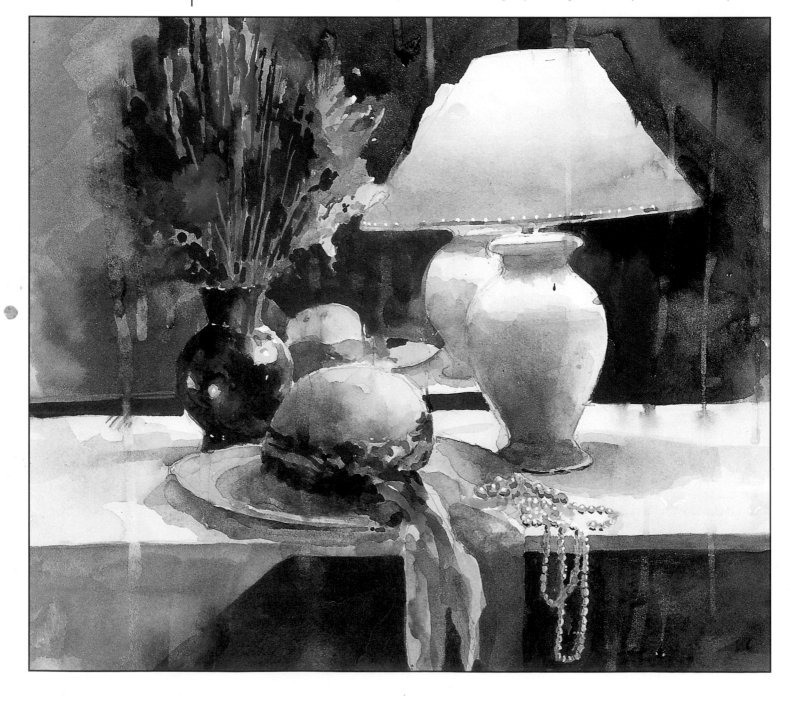

Painting contre jour

The amorphous effects of wet-in-wet watercolour complement contre jour compositions very well, creating impressionistic paintings full of depth and mystery.

Beginners sometimes unwittingly neglect one of the most valuable mood-making devices available to the artist – light. Its position and quality help to determine the atmosphere of your painting, so it's well worth looking at some of the established compositional approaches to light, and considering how to use them in your own pictures.

Contre jour is one such approach. Roughly translated, it means 'against the day' – or light. With your subject placed with the light behind it – in front of a window, say – its silhouette is clearly illuminated, while the front of it is in shadow. This obscures details and creates a soft, mysterious effect with great depth and richness of tone.

When working in this way, you are not only painting an interior, you also bring in a sense of the world outside. You can make a virtue of this in your composition, as our artist does overleaf, and paint your subject in front of a bare window on a bright, sunny day. Or you can go for a softer, gentler effect with a curtain that diffuses the light.

When painting a subject *contre jour*, start in the background with the palest washes. Move towards the foreground, gradually building up the strength of the colours and tones, so the various shapes that emerge suggest space and distance.

► The translucency of honesty seedheads makes them particularly attractive when viewed against the light – *contre jour*. Here the artist depicts them so they seem to shimmer in the sunlight, making a dramatic contrast with the deep, solid colours of the vase. Notice how the violet on the vase enriches and enlivens the complementary yellow of the sunlight.
'Honesty' by Stan Smith, gouache on paper, 20 x 15in

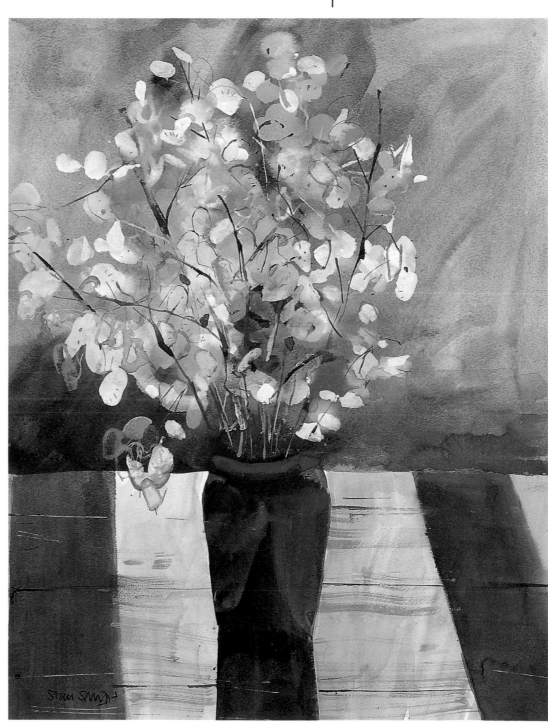

Flowers by a window

The Impressionist painter Claude Monet once said he was trying to paint 'the sensation of leaves'. Rather than create a realistic image of leaves, he wanted to express his feelings about them – the qualities that interested him, their leafiness, their colours and shapes as he saw and felt them. He also said paint was not simply a medium, but that the actual paintmarks could be interesting in their own right.

Our artist worked in the same semi-figurative vein for the following painting. His aim was not to copy the flowers exactly, but to look at the flowers, then paint semi-abstract marks to suggest them. The marks are as interesting – perhaps more interesting and satisfying to the viewer's imagination – as a straightforward, figurative painting of flowers.

To do this, he works wet-in-wet, in a non-linear way, with colours laid on to describe tonal areas, not outlines. When dry, however, the paintmarks make outlines naturally. This method should be fun but not haphazard – you need to look extremely carefully at each part of your subject, so that every mark will say something about shape, texture, colour, the interplay of light and dark and so on.

This can be a risky way of painting – it either 'works' or it doesn't. It's a good idea to do one or two quick versions to warm up and crystallize your ideas.

▶ **The set-up** Our artist wanted to place this full bunch of flowers in front of a window, but found his table was too low, so he made a makeshift one with a pile of books and a plain cloth. This raised the flowers high enough for the light from the window to shine directly behind them, illuminating their silhouettes and casting the front of the bunch into shadow. In this photograph we have arranged the lighting so you can see what the artist is painting, but in fact you wouldn't be able to see the flowers as clearly as this.

Because it is impossible to copy such a loose, free style of painting, it's best if you set up a similar bunch of flowers in front of a window and use the steps below to guide you.

◀ **The sketch** Tape the sheet of paper to your board and lightly draw in the basic shapes of the composition. You can make use of a ruler to help you draw the window frame straight, especially if your window has glazing-bars between the panes.

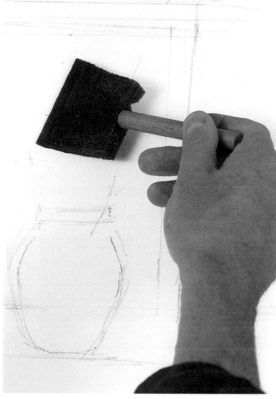

◀**1** Dampen the entire paper surface with the wash sponge, ready for painting wet-in-wet.

◀**2** Work quickly and loosely, using large brushes to put in some colour. Our artist used No.10 and No.14 brushes, mixing cobalt blue and mauve to paint the vase and the fabric beneath it. He suggested the sunshine coming from the window on each side of the vase with Naples yellow, and used a complementary mauve for the wooden glazing-bars.

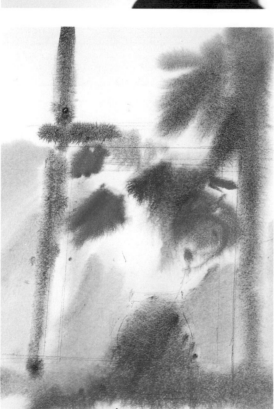

◀**3** When you paint the flowers, start at the back of the arrangement and work forward. Apply the paint freely and broadly, using brushmarks which suggest the shapes of the flowers and foliage. At this stage don't concern yourself with exact descriptions of petals and leaves. The stem of delphiniums was laid in with cobalt blue; a bright orange mix of yellow ochre, cadmium yellow and cadmium red was used for the other flowers.

▶ **4** Indicate the view you see through the window. Make the colours here slightly stronger than they appear, bearing in mind that they will fade as the paint dries. Our artist placed the roofs of the buildings opposite in mauve and cobalt blue.

Begin to darken the shadows. Here, our artist mixed his bright orange with the blue-mauve mix for the darker flowers towards the front, then used cobalt blue for the shadows on the window frame. Don't work too quickly – although you are not rendering every detail with life-like accuracy, you don't want your marks to be too general. They should be carefully observed. Add a smudge of shadow here and there, building the tones bit by bit. These bring out the light areas through contrast.

Tip

White test
If you find it hard to decide whether your tones are dark enough, place a little test spot of white gouache beside them. Stand back and see how strong your dark tones appear compared with the white.

◀ **5** Paint in some stems. Our artist used sap green and the No.4 brush for these, working wet-in-wet – notice how the colour flares. Look at your arrangement and decide which ones to include and where to place them to add energy to the composition.

▶ **6** Turn your attention back to the front of the composition to work up some shadows on the vase, window frame and table. Here, areas of strong cobalt blue bring stability to the base of the painting.

If the surface of the paper becomes too dry for working wet-in-wet as you progress, spray it lightly with the atomiser.

Notice the way the brushmarks have spread, the colour bleeding into surrounding areas. This takes nerve because the very wet paint can go where you don't want it to go, but if it works, it looks wonderful. Be bold and paint what you see.

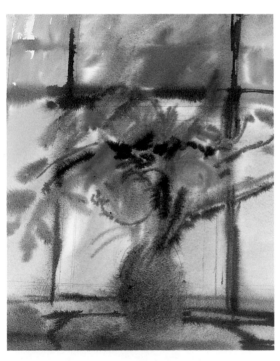

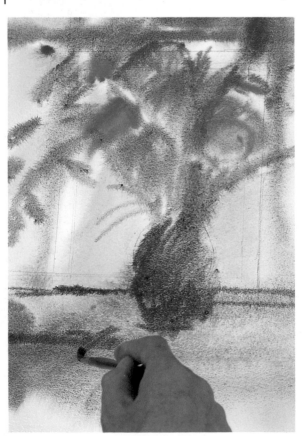

▲ **7** Now concentrate on developing the dark tones around the picture. Here, the artist strengthened sap green with ultramarine to add some shadowy stems and leaves to the arrangement, then he used a strong, warm mauve mix for the shadows on the window frame. Notice how this creates the illusion of space, pulling the window frame in front of the pale, cool yellow light outside. He then loosely dotted in the berries with Indian red.

Allow your eyes to dart about, considering shapes and the overall balance. Dab in colours and marks so the vase and flowers emerge clearly.

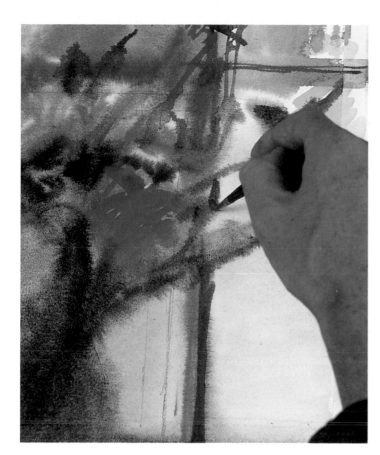

8 Begin to define the flowers using more opaque colours. Give them more shape by hinting at the petals. You may want to use stronger colours – this intense orange on the flowers was mixed from yellow ochre, cadmium red and cadmium yellow. Put in the delphiniums with a deeper, less dilute cobalt blue. With these stronger colours in place, re-adjust the shaded tones of the window frame with a variety of colours, leaning your brush against a ruler where you want quite straight lines.

9 This is a good point to stand back from your painting to assess how it's working. Our artist felt his picture needed a little more definition, so he brought out the edge of the vase and the books beneath the fabric quite delicately. These details are put on wet-on-dry for precise control. In comparison, he put in the details of the buildings opposite in distinct red-brown and cobalt blue – these were in strong daylight.

Now go back to the flowers to develop the shapes of the leaves and petals. Rather than drawing them, try to feel their shapes with your brush. Don't be afraid to use quite strong colours if you wish.

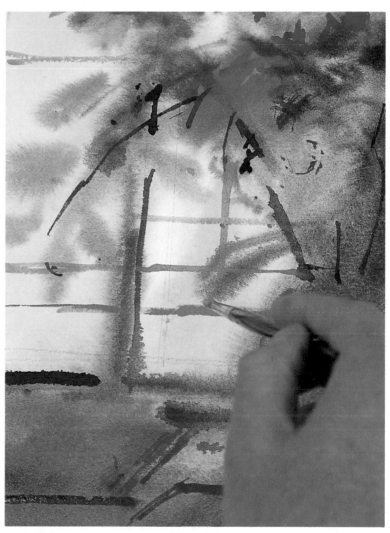

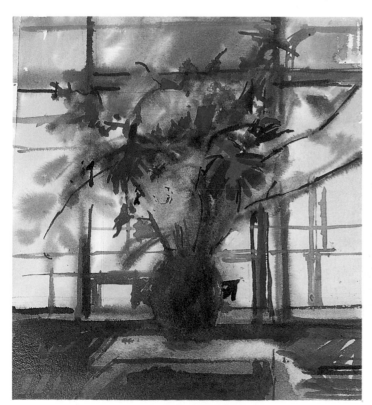

10 Our artist framed his image with a card mount and stood back once again to have another look. He decided to darken all the colours in the foreground. This has the effect of intensifying them, creating a strong contrast with the light shining behind.

Consider which areas need to go darker on your own painting. Here, the artist touched in the darkest patch of shadow at the centre of the vase with a rich mix of Indian red, mauve and cobalt blue. While it was still wet, he laid a wash of cobalt blue and ultramarine over the left side of the vase, dragging it up into the arrangement to darken the stems and leaves further. He also put a deep shadow on the front of the makeshift table and on the wall beneath the window.

▶**11** Continue to work up the details of the view outside your window. Our artist put in the sides of the buildings opposite with thin washes of warm grey made from cerulean and Indian red. Don't be too precise – the emphasis should remain on the flowers.

Having added more background details, look again at the foreground to see if it needs adjustment. Our artist deepened the tone of the wall beneath the window frame and picked out more leaves and stems with various mixes of greens, mauve, Indian red and blues.

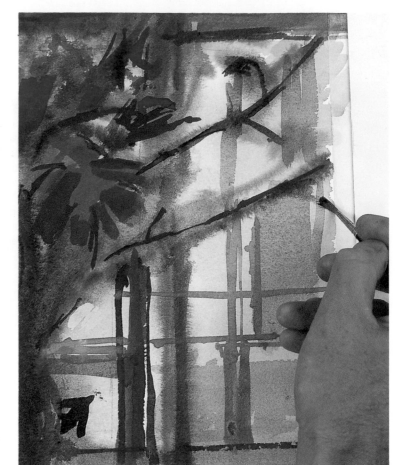

▼**12** The foreground should now be dark enough to bring in a little white gouache. Knock back its brightness with a pale hue (our artist used Naples yellow) and use it quite sparingly to emphasize the edges of some flowers and reflections on the window panes. Do the same around the window frame and the fabric beneath your flowers, using a different mix for these darker areas – here, white with some cobalt blue.

Tip

Spray bottle

An old plastic squeezy paint bottle with a flip lid can be recycled into a good alternative to a spray atomiser. Unlike the fine spray of an atomiser, you get

a quick rush of water when you squeeze the bottle, so work in short, sharp bursts to avoid overdrenching your paper.

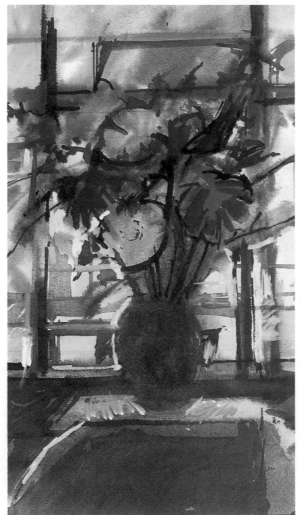

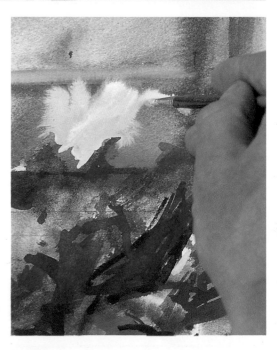

▲**13** At this point, our artist felt the painting was not focused enough, with too many stray marks. To remedy this he sprayed water over the entire picture to allow him to re-work it. Before you do this, think how you want to re-work your painting, so you are ready to start once you dampen the surface.

As here, you may want to define the view through your window. Our artist gave shape to the roofs of the buildings by painting the negative shapes around them with Naples yellow, then picked out bright areas on the roofs with a mix of white, cobalt blue and ultramarine.

◀14 Here our artist is redrawing and reshaping the flowers. He simplified and softened their shapes with a wet sponge, taking paint off and redrawing them simultaneously with the smudged paint on the sponge.

▲15 Brighten the areas of sunlight outside the window with body colour – here a mix of Naples yellow and white. Watery areas of pale blue on the window frame and around the flowers intensify the sense of space. Blue is generally recessive, so these dabs sit behind the flowers, bringing the arrangement forward.

◀16 Look at your flowers – do they need any finishing touches? If so, try to make your brushstrokes as confident and expressive as possible, since they will be evident in the finished painting. Make your marks quite abstract, in keeping with the style of the painting.

Here our artist overlays the delphiniums with strong cobalt blue, the leaves with sap green and the vase with an indigo and sap green mix. Notice how, by building up the colours in layers of paint, they become strong and vibrant.

▶**17** To add vitality and emphasize the sunlight on the window and walls outside, our artist dabbed the white/Naples yellow mix on the roofs, sky and between the flowers.

▶**18** Work around your painting making final adjustments. Our artist softened the edges of the fabric beneath the flowers, then decided to define the flowers more fully and dab in the lost berries.

It's possible to carry on painting indefinitely, adding layer on layer of colour, leaving traces of the previous colours showing, sponging off areas, washing over the top, and waiting all the time for just the right marks to appear to bring the painting to life. It's up to you to decide when this has happened. (The more you paint, the easier this sort of decision will become.)

This painting has a free, charming vitality, achieved with strong colours and confident brushstrokes. The pleasing contrast between bright lights and deep darks brings it to life. And notice that the artist also plays off complementaries – blues against oranges and violets against yellows – giving sparkle, energy and vibrancy to the picture.

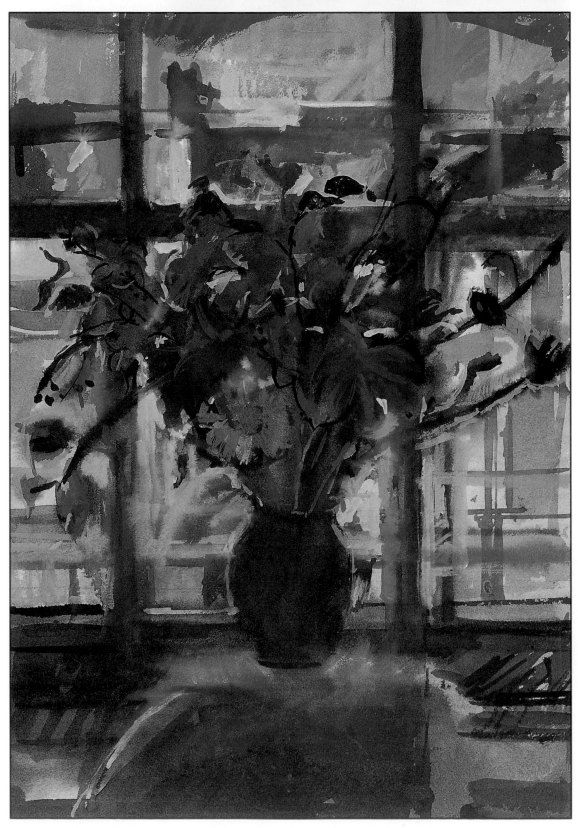

Winter sunshine on the farm

This project uses traditional watercolour techniques to depict a Kentish landscape with farm buildings, barns and oasthouse – all bathed in the late light of a January afternoon.

Our artist approached this project in a very methodical, traditional way, starting with a pencil drawing. Then, beginning at the top of the page, he worked his way down to the bottom using light washy colours and tones for the distance and stronger colour for the foreground. Wherever possible he used paint straight from the palette, only mixing colours when necessary. Notice too that he used few overlaid washes, only doing so when he needed greater depth – as in the bushes

behind the trees. This accounts for the clarity of colour in the final picture.

It's important to get the tones and the density of washes right, so our artist used a piece of scrap paper for testing his washes. If you do this, always wait until the paint is dry, since dark colours dry to a lighter shade and pale colours dry darker.

▲ **The set-up** Our artist used a small snapshot as the basis for this painting.

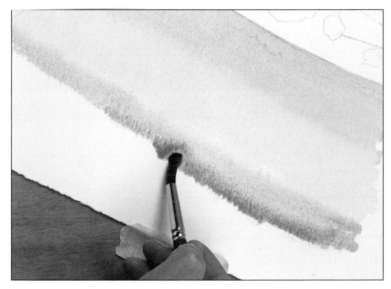

▶ **1** Depending on the grade you are using, pin (or tape) your paper to the drawing board and stretch it if necessary. Sketch your composition with the HB pencil.

Turn the paper upside down and, with the No.10 brush, carefully paint a pale wash of light red along the horizon line. Making sure the edge stays wet, repeat this until the light red wash is about 5cm (2in) wide. Paint in another band with a yellow ochre wash, then a third band with a French ultramarine wash. Leave to dry completely.

◀ **2** Turn the page the right way up, then mix another pale wash of olive green and yellow ochre. Paint this wash carefully up to the horizon line and then work neatly round the buildings and bushes as you progress down the page. Allow to dry.

YOU WILL NEED

- ☐ *A sheet of 300lb Arches watercolour paper (or choose a cheaper, lighter weight and stretch it)*
- ☐ *Three round brushes – Nos.10, 7 and 5*
- ☐ *Drawing board plus drawing pins and/or sticky tape*
- ☐ *HB pencil; ruler*
- ☐ *Three jars of water*
- ☐ *Twelve watercolours: light red, yellow ochre, French ultramarine, olive green, raw sienna, Vandyke brown, burnt umber, black, Hooker's green, viridian, burnt sienna and Payne's gray*

► **3** In this traditional way of working in watercolour, the colours used so far are all pale, thin washes. Don't worry if it looks very pale – darker tones are added later.

Tip

Choosing your paper
Our artist preferred to use a very heavy weight (300lb) paper, which meant he didn't have to stretch it – but it is expensive. You could easily use a lighter weight paper, but if it is below 140lb in weight you will have to stretch it.

Another reason our artist used the paper he did was so he could turn it round frequently – his hand was then comfortable and not in danger of smudging areas which were damp or wet. Lighter paper would have to be pinned or taped to a drawing board, which makes it much less manoeuvrable.

▼ **4** Fill in the bushes behind the trees using a wash of raw sienna. Take care to leave white areas for the highlights on the tree trunks. Leave the edges of the bushes quite loose since they are part of the background and don't need to be so well defined.

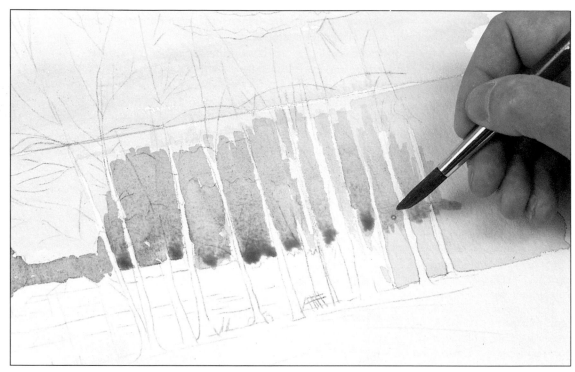

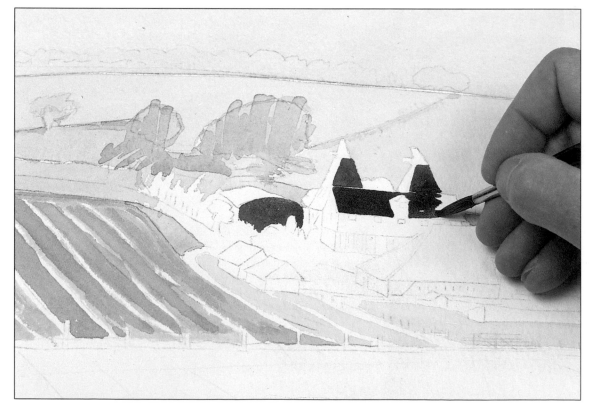

◄ **5** Put in a pale wash of Vandyke brown in the background. When this is dry, apply another wash of the same colour over the top to give the bushes and trees some depth.

Use a strong wash of olive green for the field, applying it with a fairly dry brush so the paint drags over the paper to give some texture. Mix a pale wash of viridian and olive green and use for the areas above the field and below the buildings.

Add detail to the oasthouse roof with the No.7 brush and a dark wash of burnt umber and black.

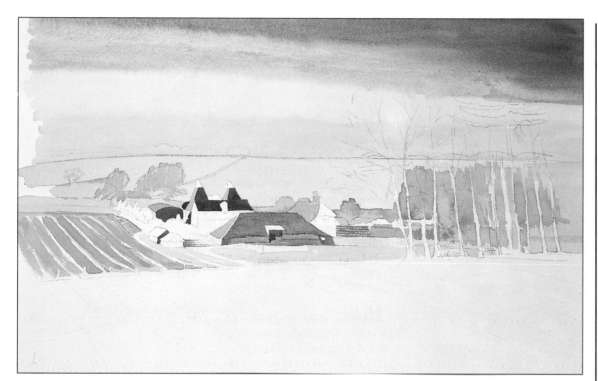

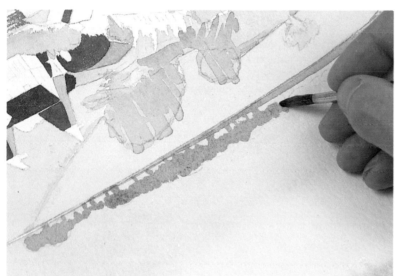

6 Gradually put in more details, waiting for each area to dry before you add another wash. Use Payne's gray for the barn roof.

7 Turn the paper upside down and paint a thin line of Payne's gray along the horizon line. Now paint the generalized tree shapes, adding darker spots of colour to vary the wash. Turn the paper round to prevent your hand smudging any wet areas.

Tip

Keep track of your paints

Make a colour chart of the pans in your watercolour box so you can check the colours and gradations of the paints. You should label them too, so you become familiar with your paints. Colours appear darker in the palette than as a wash on the paper so this is a good way of helping you to recognize them.

8 Now put in the trunks and branches of the clump of trees. Use burnt umber and black and paint in the trunks, leaving highlights along the left side – this helps to make the trunks appear round. The branches fan upwards and outwards from the trunks, giving the trees energy and a sense of growth.

This is one of the few areas in the painting where the artist used overlaid washes. Here he puts a wash of Vandyke brown over raw sienna to create a feeling of depth behind the trees.

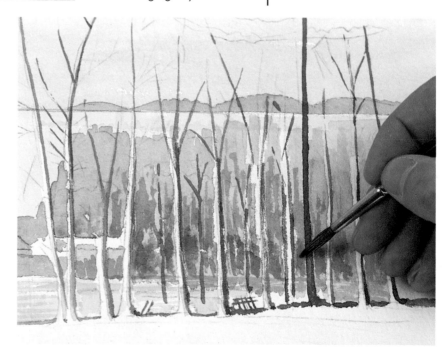

▶ **9** Now you can work on smaller details in the middle area of the painting. Put in the tiny windows with the No.7 brush loaded with a dark wash of burnt sienna and black.

◀ **10** Paint in the pine trees, using a dark wash of Hooker's green, viridian and Payne's gray. Leave to dry.

▼ **11** The pine trees provide a strong focal point in the composition and draw your eye irresistibly towards the white oasthouse.

All the different tones of the buildings have been created using different washes and mixes of Vandyke brown, light red and Payne's gray. Notice that the roofs and walls facing you are darker than those on the side facing the light.

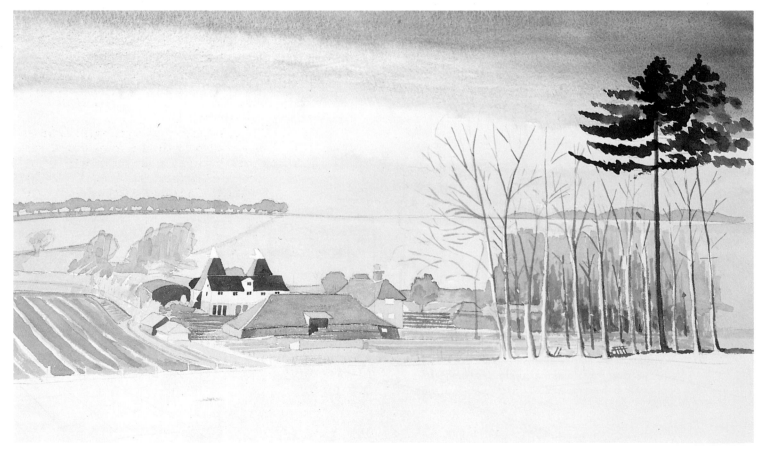

Tips for Washes

1 The difficulty with large washes is not mixing up enough paint, so make sure you have plenty of old saucers or individual palettes to hold the amount you need.

2 Remember to keep the edge of a large wash wet at all times, otherwise you'll find the wash won't dry flat.

3 Don't overwork the paint. A wet wash always dries flatter as the paint settles.

4 Use three jars of clean water; one for cleaning your brush and a second for the final rinse, and a third for mixing colour.

12 When the trunks and branches are dry, paint in the general shape of the trees by applying thin, subtle washes in rounded blobby shapes where the smaller twigs would be. Mix the washes from dilute Vandyke brown and yellow ochre and make some lighter and some darker to indicate different depths and to add 'roundness' to the tree shapes.

13 Paint in the smaller twigs using the No.5 brush for the finer branches. Paint in a few tiny spots of pure Vandyke brown. This adds interest and emphasis to the trees and makes them look more intriguing.

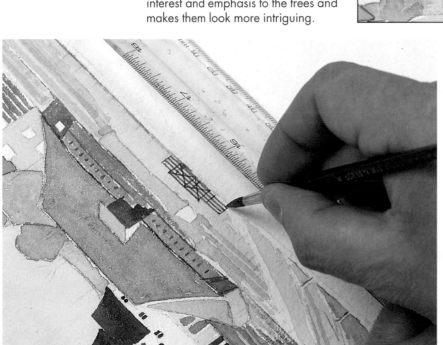

14 Turn the paper round so you can paint the very fine lines of the barred gate – use Vandyke brown for this. Tuck your fingers under the ruler so that it doesn't lie flat on the paper. Use the ruler as a guide for your little finger and carefully draw the paint brush towards you. (Practise on a spare sheet of paper first – the idea is to avoid blobs. You can use a ruling pen if you prefer.)

► **15** When you have completed all the areas in the middle distance, paint a wash of raw sienna in the foreground. Add some burnt sienna to vary the colour. Paint the furrows in a stronger wash of raw sienna.

◄ **16** Finally add some burnt sienna with a touch of raw sienna to add strength to the foreground. Use a dry brush loaded with paint and blend it in with your finger to soften it where necessary.

▼ **17** The final picture perfectly evokes a Kentish landscape basking in the pale light of a late winter afternoon. Very pale washes added to the whites of the trees and other areas give prominence to the main focal point – the white oasthouse.

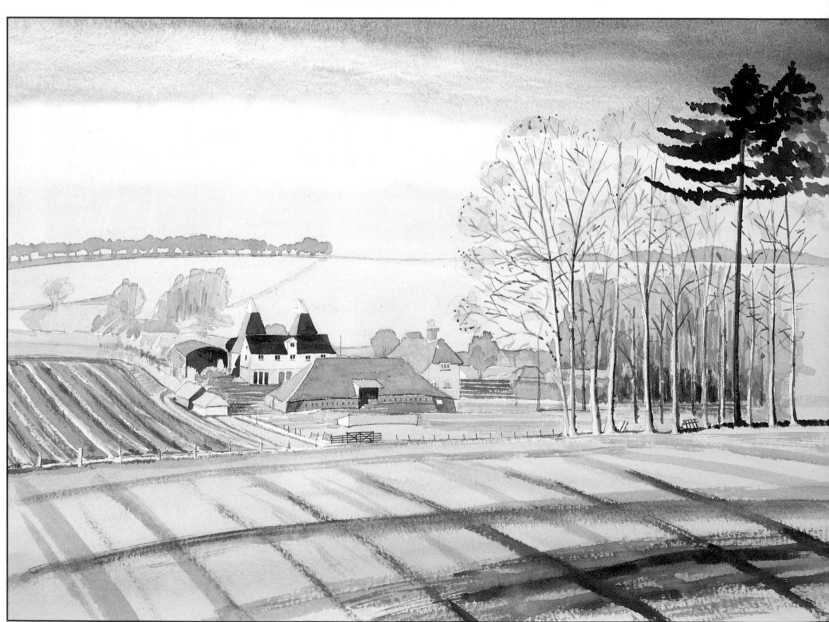

Westminster by night

This project shows how colour, tone and technique can be used to capture the warmth of a night scene illuminated by floodlighting.

There is very little linear definition in this painting. Wet-in-wet watercolour washes admirably capture the mysterious atmosphere.

The palette is generally warmer and stronger than for a daytime scene – notice how the warm, bright reflections on the surface of the river create a wonderful sense of movement.

▼ **The set-up** It's difficult to paint a night scene on site unless you can cope with colour mixing in poor light. So you may prefer to make sketches and take a few photographs to work from. Here, our artist combined several photographs to provide good detail of the panoramic scene.

▶**1** Lightly draw the main outlines of the composition in pencil. Decide where you are going to place the brightest lights on the buildings, boats and bridge, and the brightest reflections in the water. Paint these out with masking fluid applied with an old brush. Rinse the brush immediately to remove all traces of fluid.

You need to establish the darkest tone – the sky – early on, or your lights won't read as lights.

Tilt the board at a slight angle, then dampen the entire sky area with a wet brush, working around the roofs, spires and turrets. With your No.6 round brush, mix a watery but strong wash of dark, inky blue from Prussian blue and a little alizarin crimson. Then take a deep breath and plunge in, rapidly sweeping the colour on and moving the brush this way and that, so the paint floods the wet paper and forms into lovely swirls and pools of colour.

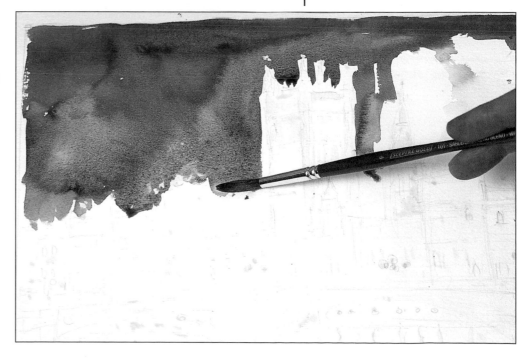

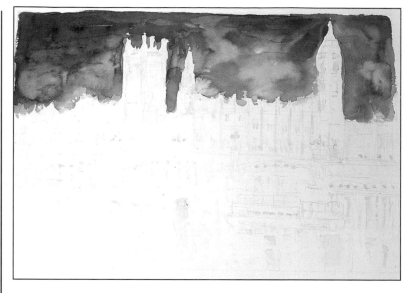

2 While the blue wash is still wet, flood a new wash of Hooker's green into it, above the line of the buildings, and allow the colours to mingle wet-in-wet. Here you can see how the swirling marks left as the washes dry add drama and texture to the sky. You can also see how much lighter the colours appear when dry – take this into account when mixing your washes, and make them a little darker than you think you'll need.

YOU WILL NEED

- ☐ *A 22 x 15in sheet of 140lb NOT watercolour paper*
- ☐ *An HB pencil*
- ☐ *Three round watercolour brushes: Nos.4, 6 and 8*
- ☐ *Tinted masking fluid and an old brush*
- ☐ *Eight watercolours: aurora yellow, raw sienna, cadmium red, alizarin crimson, Prussian blue, Hooker's green, burnt sienna and raw umber*

3 Now put in the tones of the buildings – these will form a half-tone against which the lightest lights will sparkle. With the No.4 round brush, paint the floodlit sections of the buildings with a fairly pale wash of raw sienna, aurora yellow and a little Hooker's green, leaving flecks of white paper showing through as highlights.

For the darker tones of the nearer buildings, mix burnt sienna with a touch of Hooker's green, varying the tones a little. Leave to dry.

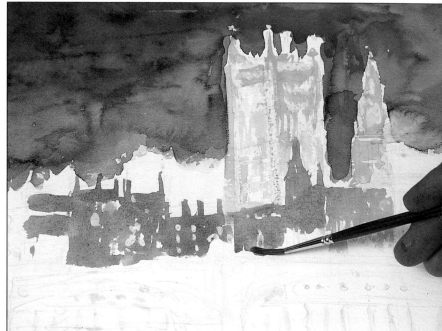

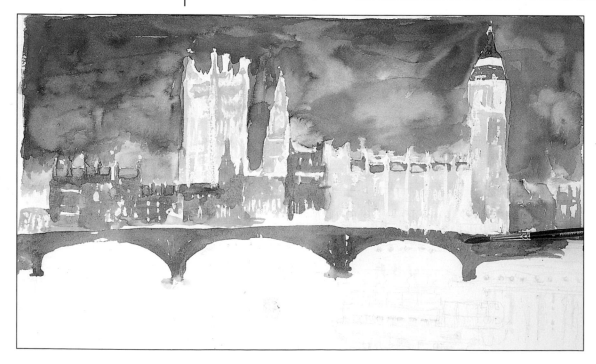

4 Mix Prussian blue, Hooker's green and burnt sienna to a blue-grey and paint the dark rooftops and the top of the clock tower, using the No.6 round brush. Add a bit more Hooker's green to the mix to warm it and paint the dark silhouette of Westminster Bridge, again leaving tiny specks of white paper here and there to suggest reflected light.

Once this paint is dry, mix burnt sienna and a little Prussian blue and paint the arches beneath the bridge with your No.6 brush (see step 5).

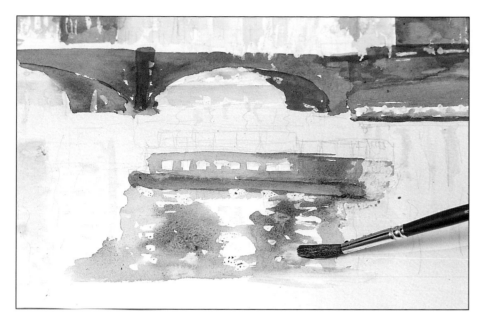

5 Block in the boat on the right using the No.8 brush and a light tint of Prussian blue and Hooker's green. Start to paint the reflections on the river with varied mixtures of raw sienna, raw umber, burnt sienna, Hooker's green and Prussian blue, letting the colours bleed wet-in-wet to capture the effect of the hazy reflections.

6 Continue painting the reflections, using well-diluted raw sienna for the lighter ones. Charge the No.8 round brush with plenty of colour and hold the body of the brush flat against the surface, gently pushing it back and forth to create ragged-edged shapes that suggest the undulating movement of the water. Strengthen the tone of the water beyond and under the bridge with a wash of Hooker's green.

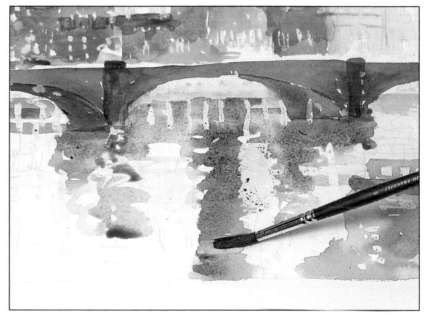

7 Now stand back and take a good look at your progress. Already, the painting is taking shape. The loose washes on the river's surface qualify the objects they reflect – in step 4 the bridge and buildings look as if they are hovering in mid air. The loose brushwork and the wonderful contrast between the dark sky and floodlit buildings give the painting a mysterious night-time atmosphere.

8 Strengthen the reflections, then work on the boats in Prussian blue, cadmium red and a Prussian blue/Hooker's green mix. Leave to dry. Remove the masking fluid and paint the reflections of the lights – except those under the central arch – with aurora yellow warmed with cadmium red. Use Hooker's green for the water beyond the bridge.

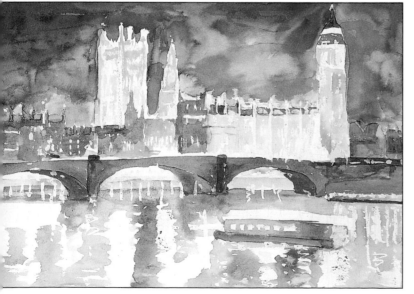

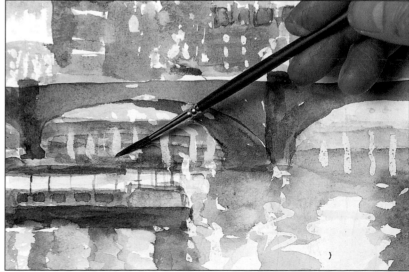

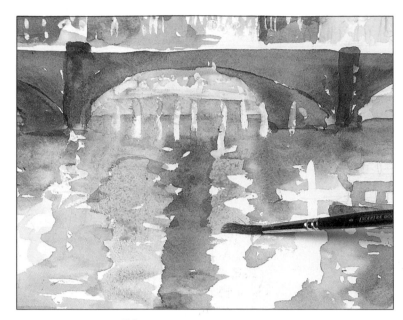

9 Paint in the brightest reflections under the central bridge, again with aurora yellow and a touch of cadmium red, this time using a stronger mix.

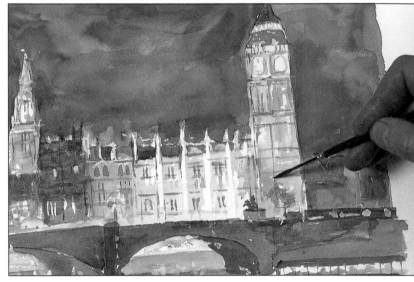

10 Using the No.4 brush, strengthen the dark tones of the buildings with a wash of diluted Hooker's green over the brown underlayer. Then use the tip of the brush and a wash of raw sienna to touch in the architectural detailing, including the windows.

11 Finally, darken the sky with a wash of alizarin crimson and Prussian blue. Use your No.8 round brush for this.

Wet-in-wet blending captures the way the city lights glow in a dark sky. The strong tonal contrast between the buildings and the sky gives a dramatic impact, while the shimmering reflections in the water create a sense of fluid movement.

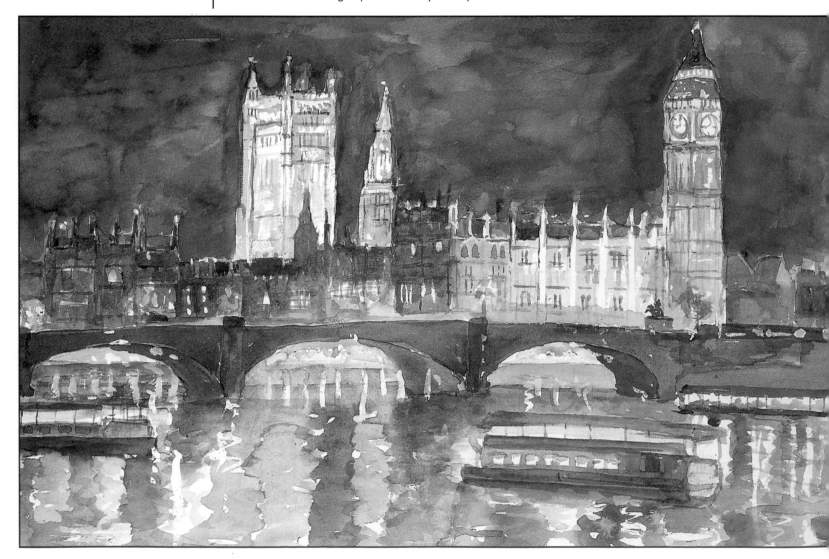

Index

Acknowledgements

Artists

Gillian Burrows 7; Donald Hamilton Fraser 9, 10(l); Ian Sidaway 10(tr); Donald Hamilton Fraser 10(br); Gillian Burrows 11-16; Roger Sampson 17; Louise Hill 18-24; Polly Raynes 25-28; Stan Smith 30-32; Shirley Trevena 33; Stan Smith 35-40; Alison Musker 41; Keith Noble 42-48; Susan Pontefract 49-54; David Curtis 55-60; Sue Groom 61-66; Shirley Trevena 67-76; Susan Pontefract 77-80; Ken Paine 81-84; Stan Smith 85-90; Victor Willis 91; Christies Images/Kurt Schwitters 93; Bridgeman Art Library/Gwen John 94(t); Ken Howard 94(b); Bridgeman Art Library/Joseph Wright of Derby 95(t); Christies Images/Niels Holsoe 95(b); Bridgeman Art Library/Joseph Mallord William Turner 96(t); Christies Images/Terrick Williams 96(b); Christies Images/Eugene Boudin 97(t); Bridgeman Art Library/Joseph Milner Kite 97(b); Bridgeman Art Library/Claude Monet 98; Mark Topham 99-102; John Lidzey 103-108; Stan Smith 109; Francis Bowyer 110-116; John Harvey 117-122; Victor Willis 123-126.

Photographers

Gillian Burrows 11(c); LouiseHill 18(tl); Graham Rae 29 (t, br); Nigel Robertson 29(bl); Ian Howes 30(t); Mark Gatehouse 34(c); Nigel Robertson 50(t); David Curtis 56(t); Nigel Robertson 61(t); Shirley Trevena 69(t); Julian Busselle 81(t); Martin Riedl 86(tl); Julian Busselle 103(t); John Harvey 117(t); Julian Busselle 123(t).